W9-APG-395

PAINTING THE WARMTH OF THE SUN

ST IVES ARTISTS
1939 – 1975

1. Bryan Wynter and *Imoos*, 1974.

Painting the Warmth of the Sun

ST IVES ARTISTS
1939 – 1975

TOM CROSS

2. Patrick Heron, *Harbour Window with Two Figures, St Ives*, July 1950. Oil on canvas

WESTCOUNTRY BOOKS THE LUTTERWORTH PRESS

First published 1984 by Alison Hodge
Revised edition 1995 published by Westcountry Books
in association with The Lutterworth Press

Note: dimensions of works are given in centimetres,
height before width.

CIP Catalogue Record for this book is available from the British Library.

WESTCOUNTRY BOOKS
Halsgrove House
Lower Moor Way
Tiverton, Devon EX16 6SS
Tel: 01884 243242
Fax: 01884 243325

ISBN: 1 898386 18 8 (flexi edition)
1 898386 19 6 (cased edition)

THE LUTTERWORTH PRESS
PO Box 60, Cambridge CB1 2NT
Tel: 01223 350865
Fax: 01223 366951

ISBN: 0 71882 942 5 (flexi edition)
0 71882 941 7 (cased edition)

Printed and bound in Singapore by SNP Printing Pte Ltd

Contents

3. Bryan Wynter, *Carn Cottage*, 1946. Gouache

Preface to the second edition

Painting the Warmth of the Sun, St Ives Artists 1939–1975 was begun shortly after my arrival in Cornwall in 1976. At that time it was clear that the momentum of painting and sculpture in St Ives had been checked. Three notable deaths had occurred in the year before, those of Barbara Hepworth, Roger Hilton and Bryan Wynter and I can well remember Terry Frost saying that 'it was all over,' a mood shared with others. However I was also aware that many of those artists who had contributed so vividly to the movement which is now known as 'St Ives' were still working at the highest level. It was also apparent that the progressive work produced in St Ives during the post-war years was not the product of an elite few. Rather it was the achievement of many talented and creative individuals. This book was a response to the variety and singularity of this achievement.

I was encouraged to write the present account by Lord Bullock, who was Chairman of the Trustees of the Tate Gallery when we first discussed this project, and by Paul Barnicoat. The publication of the book was a joint venture between Television South West and the publishers Alison Hodge and Lutterworth Press. I am grateful to them, and to Johnathan Harvey and Kevin Crooks for their support throughout this project. I am also indebted to Simon Butler and Westcountry Books together with the Lutterworth Press for the production of this second edition.

The origins of the book may be traced to the exhibition 'British Art and the Modern Movement, 1930–40' which I created for the Welsh Committee of the Arts Council in 1962, in collaboration with Philip Barlow and Alan Bowness. Of the greatest value at that time was the advice and assistance given by Dame Barbara Hepworth, Ben Nicholson and Sir Herbert Read.

Much of the information contained in the book came from the many conversations, formal and informal, with those artists who were happily still working in Cornwall. I am indebted to Terry Frost, Denis Mitchell, John Wells and Patrick Heron, and to the families of other artists, particularly Sheila and Andrew Lanyon, Monica Wynter and Rose Hilton. I am also grateful to many others including Dr Roger Slack, Brian Smith of the Hepworth Museum and David Brown of the Tate Gallery.

Finally, and most particularly, I wish to express my gratitude to my wife Patricia for the preparation of the manuscript and for her continued support, without which this book would certainly not have been written. All opinions expressed, and any errors made, are of course mine alone.

The remarkable contribution made by this group of radical and forward looking artists in St Ives has now justly been marked, first by a major exhibition at the Tate Gallery, London in 1985 and most significantly by the creation of the Tate Gallery in St Ives which opened in 1993. The enormous initial success of this fine gallery is a measure of the significance of the work produced in this remote town.

<div align="right">

TOM CROSS
PORT NAVAS, CORNWALL, 1995

</div>

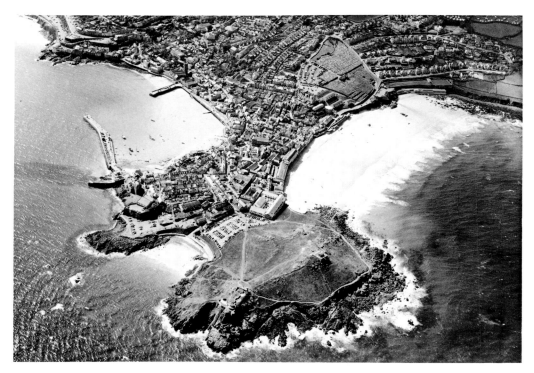

4. St Ives from the air.

Introduction. Early Times

Seldom have I enjoyed a sea view more than when descending the hill that overlooks the town of St Ives, which town looks beautiful from the said hill, situated as it is on a finely curved bay whose sands are very white. But he who wishes to think well of St Ives should depart without entering it; when fairly (or partly) in it you find it to be a small old narrow unpaved (or only paved with flats) hole of a town. From one side to the other of it, in every corner, cottage, lane, loft, room, inn, chapel, and church thereof there is but one odour, and this is the reeking odour of pilchards.[1]

The town of St Ives stands on the Atlantic coast of the Penwith district of west Cornwall, the most westerly neck of land in England. To the south, outcrop granite rises high in the open moors to Penbeagle, Halsetown and Trencrom Hill. To the east, the dunes of St Ives Bay are broken by the broad estuary of the Hayle River; while to the west, granite cliffs rise sheer from the sea to a patchwork of farms and moorland. The town is a horn curving westward from the mainland, between the slopes of Stennack and the sea, rising at its tip to form the rocky promontory known as 'The Island', a conical hill almost cut off by the sea, upon which stand the last cottages of the town and the square stone chapel of St Nicholas. The Island gives natural protection to the inner harbour, where hundreds of seine boats were once drawn up on the beach. The lower town, or 'Downalong', fringes the water's edge; cottages crowd and tumble in a confusion of granite and whitewashed cob walls. Gardens are a hidden treasure. For artists this town has long been full of fascination, in the intricate pattern of its houses, fishlofts and alleyways, the life of its harbour and its spectacular coastline; above all, in the unique qualities of the brilliant light, reflected from all sides by the sea.

The scars of a hard past now sit lightly upon this remote peninsula. Along the southern coast, where deeply cut valleys are dominated by the movement of birds and rapidly changing weather, standing stones are witness to forgotten beliefs. The battle that went on underground to mine rich seams of copper and tin is marked by the multitude of derelict mine workings behind St Just and Cape Cornwall. Along the high coast road through Zennor to St Ives, a medieval lacework of grey stone walls fringes high moorland and sculptured granite tors. This exposed coast at its final meeting with the sea, brought continuous hardship to the fishing communities working from its few sheltered harbours.

Cornwall had no early tradition in art: its landowners and mine financiers looked to London to portray their families and possessions. The one native genius, John Opie, soon departed from his birthplace near Truro, to train and establish a famous reputation in the capital. Early visitors came as if to a foreign land, making the hazardous crossing of the River Tamar by ferry,

negotiating the awesome moors and rutted lanes, and marvelling at the evidence of heavy industry in so remote a region. The first major pictorial record of the coastal towns was made by Joseph Faringdon, Royal Academician and student of Richard Wilson, who came in 1809 to make sketches for *Britannica Depicta*. His view of St Ives is the earliest known, in which the present form of the town, harbour and The Island is clearly seen.

His more famous contemporary, Joseph Mallord William Turner, came two years later on an extended journey through the west country between July and September 1811. Turner was then beginning to enjoy success at the Royal Academy and would shortly achieve those remarkable visual discoveries that were to make him England's greatest painter. He made more than two hundred sketches in pencil and colour on this tour in preparation for his handsome *Picturesque Views of the Southern Coast of England*, published between 1814 and 1826. Turner was indifferent to physical comforts, preferring to travel alone, and prepared to walk up to twenty-five miles a day undeterred by wind, rain or storm, taking such lodgings as were available.

He followed the southern coastal route and returned via Redruth, Bodmin and Tintagel. His concentrated observation drew essential qualities from the coastal scene: St Michael's Mount floats in splendour above the clouds, and in huge seas off the Lizard a poor sailor is glimpsed for a brief moment before finally joining the wreckage of his lost boat. St Ives is shown from a high point above Stennack — town, harbour and coast in one panoramic view. Tintagel Castle becomes a wild and remote hilltop fortress, a pink acropolis perched on corrugated cliffs on which miners toil among swirling clouds. Turner made a second visit to the west country in 1813, penetrating only the most easterly parts of Cornwall. This tour inspired the painting *Crossing the Brook*, shown at the Royal Academy in 1815. The lonely landscape of Plymouth Sound with Calstock Bridge seen between banks of trees is an Italianate perspective with the classical harmony of Poussin. Turner drew upon Cornish subjects for many years, reworking these early impressions in oils, watercolours and engravings. His vision of Cornwall embraced the gentle tranquilities of misty water and sun-flashed beaches as well as the grandeur of its stormy coasts, turbulent seas and historic legend. He created a climate of romantic associations which strongly coloured the work of later artists.

Thomas Rowlandson, known for the sharp wit of his caricature drawings, also made a coastal tour of Cornwall and was a frequent visitor to Hengar near Bodmin where he sketched the high tors of the moors and the wooded valleys of the River Camel. He used the church of St Breward as the setting for *Dr Syntax Preaching*, published in the first volume of *Dr Syntax's Tour* of 1812. William Daniell, one of the eighteenth century's finest engravers, viewed the Cornish coast from the sea when he set sail from Land's End in the summer of 1813 at the start of his long *Voyage Around Great Britain*. He

5.
J.M.W. Turner,
Crossing the Brook,
exhibited 1815.
Oil on canvas,
193 x 165cm.

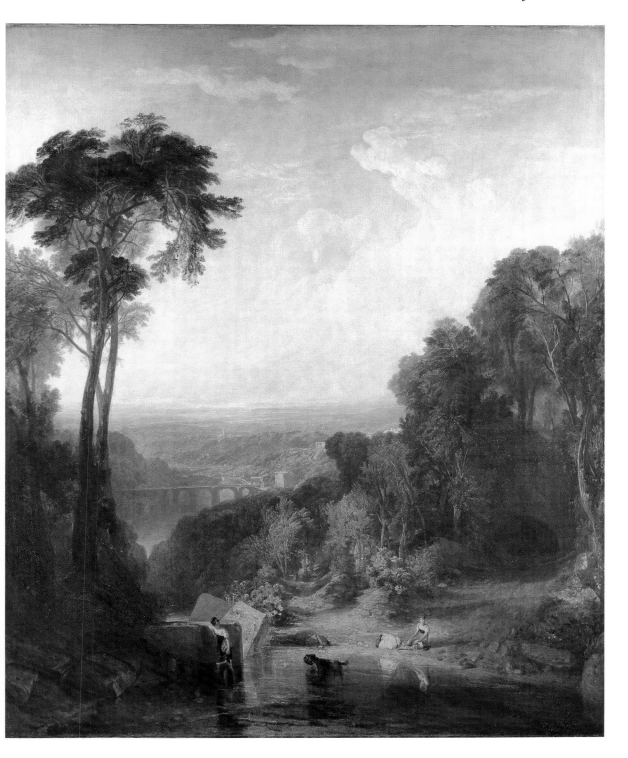

later recorded the voyage as a series of three hundred and six aquatints, published in parts between 1814 and 1825.

Cornwall gained a reputation as an artists' sketching ground in the early years of the nineteenth century. Thomas Lumley made many studies of St Michael's Mount and the Britton-Brayley drawings of St Ives illustrate the earliest guide to Cornwall. One of the most flamboyant groups, two poets and three artists, made a slow circuit of Cornwall in the late summer of 1860. The group included Alfred Lord Tennyson, the Poet Laureate, then engaged on his epic Arthurian poem *Idylls of the King*, who came in search of the romantic legends associated with Tintagel Castle, and William Holman Hunt, one of the founders of the Pre-Raphaelite Brotherhood, who made many crisp watercolour studies of the coastline.

Easy access for travellers came only with the development of the railway from London. It was not until 1876 that a full service from Paddington to Penzance was possible, and even then it took six and a quarter hours to reach Plymouth and another four, across Brunel's last great masterpiece, the Royal Albert Bridge at Saltash over the River Tamar, to Penzance. A year later St Ives was connected by a branch line and in 1878 the Great Western Railway's hotel, the Tregenna Castle, was opened above the town. For the first time in its history Cornwall was in direct and convenient communication with the rest of England, and tourist traffic began.

Both St Ives and Newlyn started to receive regular visits by artists in the early 1880s, but it was Newlyn that first attracted major attention. Almost all the young men and women who formed the 'Newlyn Group' had worked in Europe. News of the great debates that had affected artists in France, the advance of Realism and the more recent and bitterly contested triumph of Impressionism, had filtered to England in the peace following the Franco-Prussian War. Those with the means to do so continued their artistic study in Paris or Antwerp where the ateliers offered a training based upon the observation of nature. The most decisive influence upon many of the younger artists was the French painter Bastien Lepage, who adapted studio techniques for painting outdoor subjects and peasant scenes and was regarded as a *plein air* painter. His example helped to establish a tradition of outdoor naturalism that can be traced through the artists' colonies at Barbizon and in Brittany at Pont-Aven, Concarneau and Quimperlé. Many young English artists visited these colonies, attracted by the idea of shared work in a rural setting. Returning to their home countries they set up groups in remote centres such as Newlyn in Cornwall, Staithes in Yorkshire and Cocksburnpath in Scotland.

Newlyn was then an unspoilt village, the chief port of Mount's Bay for a large number of small boats engaged in pilchard and mackerel fishing. It lacked proper protection for its fleet, and in bad weather the boats sheltered in Penzance harbour. In good weather they were drawn up on the beach and fish were sold on the shore. The artists came first on sketching visits, much as they had gone to the small ports of Brittany. They found their subjects in the

6
Frank Bramley
A Hopeless Dawn, 1888
Oil on canvas
122.5 x 167.5cm

life of the fishing community set against the landscape of west Cornwall.

Thomas Gotch and Henry Tuke visited Newlyn in 1879, Walter Langley in 1880 and Edwin Harris in 1881. They returned and were joined by others who made up the large and changing group of residents, regular visitors and friends. Stanhope Forbes, who was to be the most prominent and longest established, came in 1884, as did Frank Bramley and Chevallier Tayler. They were followed by Fred Hall and Percy Craft (who also worked in St Ives), and Elizabeth Armstrong (who married Stanhope Forbes). Norman Garstin came in 1886 and he, Forbes and Langley remained in the area for the rest of their lives. In 1887 they were joined by F.W. Bourdillon.

Their pictures were tonal and silvery, painted out of doors whenever possible. Authenticity was important, as was the story-telling role of the painting, so dear to the British public. Their subjects were drawn mostly from the life and character of Newlyn and they used local models. *Plein air* painting was so well established in Newlyn that it was not unusual to see several painters working in the streets or on the beaches, their easels weighted down with stones against the wind. Large group portraits such as Stanhope Forbes' *The Health of the Bride* and *A Fish Sale on a Cornish Beach*; story pictures of disaster and shipwreck, including Frank Bramley's *A Hopeless Dawn* and *For the Men Must Work — Women Must Weep*; the idyllic

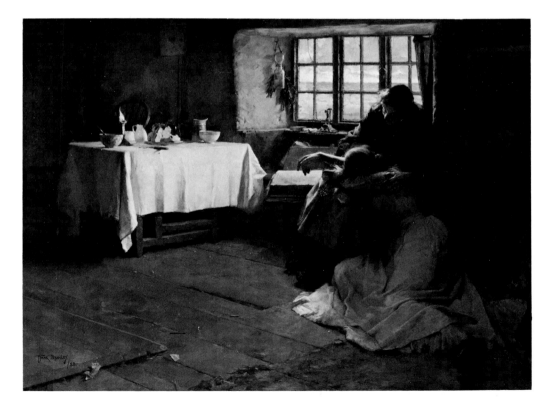

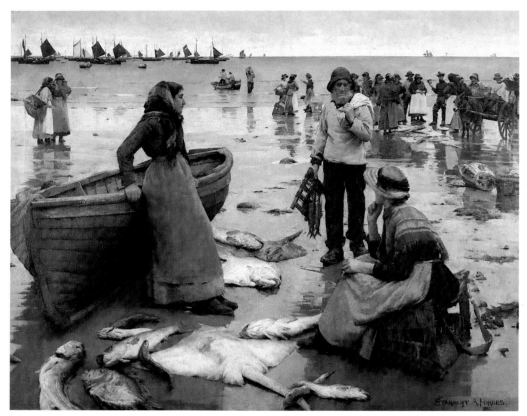

7. Stanhope Forbes, *Fish Sale on a Cornish Beach*, 1885. Oil on canvas, 121.25 x 155cm.

summer days of Thomas Gotch's *A Golden Dream*; evocative views of the town by Ralph Todd, and beach scenes by Henry Tuke — all form a part of what became known as the 'Newlyn School'. The artists found considerable success in the exhibitions of the Royal Academy, where year after year in the 1880s and 1890s an important group of the most prominent work came from Newlyn. In 1885 Stanhope Forbes received great acclaim for his *A Fish Sale on a Cornish Beach*, and in 1886 he described the Academy's spring exhibition as 'a triumph of Newlyn'. But before the end of the century Newlyn was remodelled as a working port and became less picturesque and less interesting for artists. A few remained permanently in the Newlyn area; some returned to London and others found St Ives a more attractive alternative.

In the early years of the twentieth century, Lamorna Valley on the south coast became home for its own group of artists who owed much to the Newlyn painters, but whose work explored the more acceptable conventions of landscape and portraiture. Samuel John Birch, who took the name of

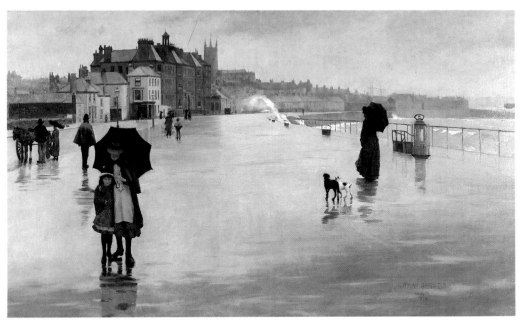

8. Norman Garstin, *The Rain it Raineth Every Day,* 1889. Oil on canvas, 94 x 162.5cm.
9. Percy Craft, *Tucking a School of Pilchards,* 1897. Oil on canvas

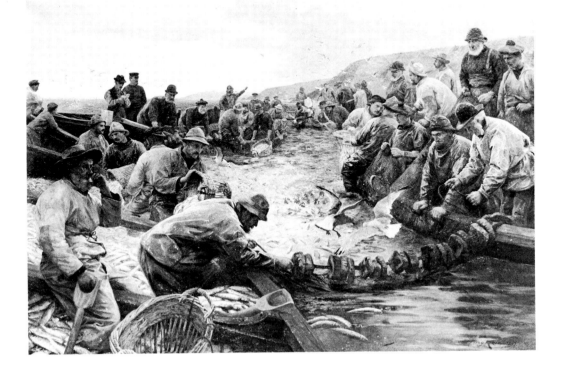

'Lamorna' Birch came in 1902 after a number of years in Newlyn. Harold Knight and his wife Laura Knight arrived in 1908, having worked in Staithes, and were resident until 1919. Alfred Munnings, who later became President of the Royal Academy, was a regular visitor in the early years, as was Augustus John whose activities at the centre of the avant-garde in London and Paris made him the subject of endless fascination.

The beginning of the artists' colony in St Ives may be said to date from the visit in the winter of 1883-4 by James McNeill Whistler and his two young assistants, Walter Richard Sickert and Mortimer Mempes. Whistler was a Europeanized American, an important contact with Manet and the Impressionist painters in France, but at the time of his painting trip to Cornwall he was recovering from a serious setback to his career following the lawsuit of 1878 in which John Ruskin had accused him of 'flinging a pot of paint in the face of the public'. (Although eventually successful in law, Whistler was awarded the derisory damages of one farthing, and the trial brought him to bankruptcy.) In St Ives, Whistler worked on a series of small sketches of sea and sky seen from the beach, swift colour sketches that Sickert so much

10. Laura Knight, *The Beach, c.* 1912.

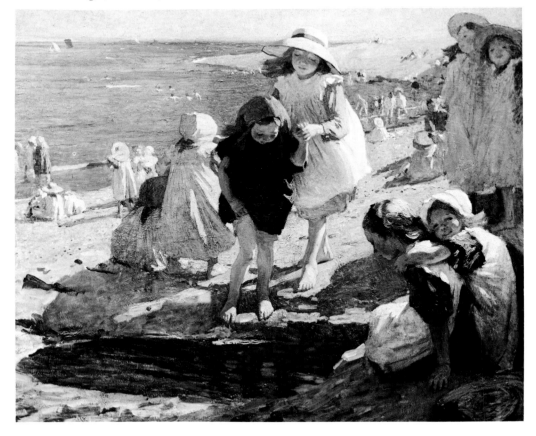

11.
James McNeil Whistler,
Cliffs and Breakers,
1884. Oil on canvas.

admired. 'I have seen a wave that Whistler was painting hang dog-eared for an incredible duration of seconds while the foam curled and creamed under his brush',[2] recorded Sickert. In the years immediately following this visit St Ives became a magnet for a group of artists who owed much to Whistler's impressionistic colour. Their subjects were the sea and the busy life of the town.

As early as 1888 an informal Artists' Club was formed in St Ives by Louis Grier, followed two years later by the 'St Ives Arts Club', housed in permanent premises on Westcotts Quay. This became the convivial meeting place for a group of sea painters which included Julius Olsson, a romantic naturalist who became well known for his moonlight seascapes; Adrian Stokes, who had for a short time worked in Newlyn, Arnesby Brown and Algenon Talmage, all prominent Royal Academicians. In the years leading up to the First World War the art colony in St Ives grew considerably, the charms of Cornwall were often compared with those of the Mediterranean countries, and each year between two and three hundred pictures were sent by special train to the Royal Academy summer exhibitions.

By 1918 St Ives had a long tradition as an artists' community, and was a centre for the scattered groups in Newlyn and Lamorna. However, it was neither forward-looking nor progressive, and far removed from the radical movements in the European capitals. It took as its standard the Royal Academy which retained great popular appeal, but reacted strongly against experiment or innovation of any kind.

In 1920 St Ives became the permanent home of one of the great innovators of the twentieth century, the potter Bernard Leach. At the outbreak of the Second World War it provided shelter for a small group of the most progressive painters and sculptors, including notably Ben Nicholson and Barbara Hepworth, already leaders in the advanced art movements of the

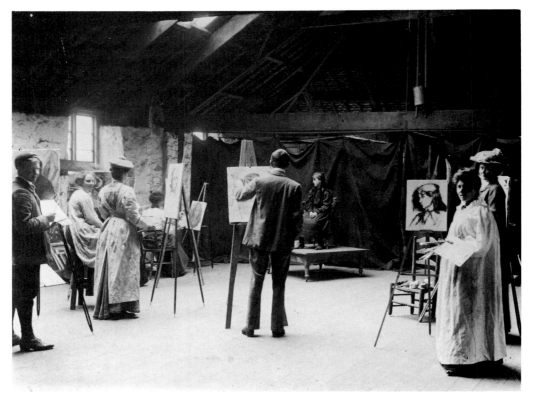

12. An art school in St Ives, *c.* 1900.

1930s and committed to the principle of abstraction described by Ben Nicholson as a 'powerful unlimited and universal language'.[3] In the 1940s and 1950s a remarkable group of younger artists came together in and around St Ives, making it a centre of avant-garde art activity, expressive of a newly-found exhilaration and physical enjoyment.

This book is concerned with those artistic events, especially during the years from 1939 to 1975, and the larger circumstances in the world of art by which they were affected, or which were affected by them.

1 Nicholson, Wood and Wallis

On a casual visit to St Ives in the summer of 1928 two young and talented artists chanced upon a group of naïve paintings made by an illiterate fisherman who had recently started to paint. Ben Nicholson and Christopher Wood recognized in the work of Alfred Wallis a creative innocence that contained an intense primitive energy. For Christopher Wood this visit to Cornwall established a new serenity in his painting. The work of Alfred Wallis, an untutored man who drew like a child, held a freshness of vision that he had sought in his recent years of travelling in Europe. Nicholson recognized in Wallis' work poetic qualities and an economy of statement that gave an inner life to his naïve paintings of boats bobbing on the sea, their movement, colour and texture related to the irregular shapes of his roughly cut board, which Nicholson later captured in his own more complex forms of expression.

Alfred Wallis was of the generation of the early Newlyn painters. Born in Devonport in 1855 — the year of Sebastopol — he was the son of a master paver. He grew up in poverty, experiencing great misfortune and emotional and physical deprivation. At the age of nine he made his first trip across the Bay of Biscay in a schooner. He taught himself to read and write and worked for some years on schooners as a cabin boy and cook. At eighteen he was making trips from Penzance to St John's, Newfoundland, in ships that brought to England cod caught off St John's. He came to live in Penzance, and at the age of twenty married Susan Ward, a widow twenty-one years older than he was, whom he had met through one of her sons. She had already had seventeen children, and bore Wallis two, both of whom died in infancy. Wallis was accepted into her large family more as a child than a parent, yet he remained deeply attached to Susan during their long life together, and to her memory after her death.

In 1890 Wallis moved to St Ives from Penzance to open a marine and rag and bone store on The Wharf. 'A. Wallis, Dealer in Marine Stores' was crudely painted on its door, and he became a famous figure in the streets, known as 'Old Iron', calling out for scrap metal and dealing in iron, rope, sails and odds and ends. In 1912, when he was fifty-seven, and Susan, who had acted as business manager, seventy-eight, they closed the store and moved to number 3 Back Road West. During the First World War, Wallis worked on The Island, building government huts. After that he did odd jobs, mostly for an antique shop in Fore Street. It was after his wife's death in 1922, aged sixty-seven, that Wallis began to paint, as he said 'for company', although there is some evidence that he had drawn in earlier years.[1] His decision to start painting was remembered by Mr Edwards, the watch-maker in Fore Street:' Aw, I dono how to pass away time', said Wallis, 'I think I'll do

13.
Alfred Wallis,
Houses in St Ives, n.d.
Oil, chalk and pencil
on card,
19.5 x 26.5cm.

a bit of paintin' '. He returned next day with two or three paintings of boats done in house paint. 'What do 'e think on they?', he asked Mr Edwards, who examined them and showed them to Mr Armour, the antique dealer. 'Well. H'all I can say, me lad, is you done a might fine job by 'en.' With this encouragement, according to Mr Edwards, Wallis 'wen' on paintin'.[2]

'I am self taught', wrote Wallis to H.S. Ede, 'so you cannot like me to those that have been taught both in school and paint. I have to learn myself, I never go out to paint, was never show them.' His paintings have the directness and simplicity of a child and draw upon the imaginative world of childhood that usually disappears about the age of eight or nine. His fantasy is coloured and deepened by knowledge, experience and personal hardship. He painted from memory rather than observation, drawing on his knowledge of St Ives and its harbour, or of his earlier life at sea. His pictures are of specific events, vividly laid out in a clear design with all their incidental detail. He invented his own techniques to capture the moods of the sea, boats far away from land menaced by icebergs, or packed in harbour. He had no knowledge of perspective or proportion, but a great feeling for the motion, isolation and danger of the sea. The sea was his preferred subject and he translated its motions and moods into liquid transparencies of thickly scumbled paint, on tinted base-colours of blue or green. His colours were few; he would often be given the last part of a used tin of boat paint. There is a strong geometry of design in his paintings of ships: he would frequently enclose the whole outline of the boat, masts, rigging and sails against the white sea, with great attention to the correct set of the sails and the details of ropes and rigging.

14.
Alfred Wallis,
St Ives Bay, n.d.
Oil and pencil on card,
7.5 x 31 cm.

His other main subject was the town of St Ives with its principal areas and landmarks, the parish church of St Ia, the lighthouse, individual houses in and around Porthmeor Square, the terraces of cottages with the harbour and open sea beyond. He often displayed buildings as in an ancient map, from the centre towards the edge of his painting. The importance of the objects was indicated by their size: boats were shown much larger than neighbouring houses, not because they were nearer, but because they were the principal subject of the picture.

Wallis had very distinctive skills as a painter, all of them natural gifts developed by practice rather than by instruction. His strong sense of design shows in every piece of work, from his most important paintings to the painted decorations he added to every surface — the walls of his room, the table upon which he worked, jugs, bellows, even cups in his own house. He painted mainly on scraps of cardboard of different sizes and textures given to him by Baugham the grocer. Wallis used the shapes as he found them, often with rough, torn edges or missing corners. Sometimes he exaggerated the shapes, giving them a more interesting appearance with scissors. He also painted on any other surface he could get hold of — trays, box lids, jars, canvasses by other painters which he would 'improve' by painting out parts he did not like.

The tension and energy that flow through Wallis' work come from the conflicts within the man of little education, undersized, friendless, adopted as a son by his older wife, surrounded by her family whom he came to hate and suspected of cheating him of his possessions. He became desperate, poor in health and troubled in mind by real or imagined persecution. With only the technical equipment of a child to express his feelings, and no knowledge of art except the most superficial, he produced a masterly group of work. Ben Nicholson wrote of Alfred Wallis in 1943 that, 'using the materials nearest to hand is the motive and method of the first creative artist. Certainly his vision is a remarkable thing, with an intensity and depth of experience which makes it more than childlike'.[3]

Nicholson and Wood first saw Wallis' work when he had been painting for about three years. Ben Nicholson admired the quality of the work itself, and of the imagination that produced it. His own work had been slow to

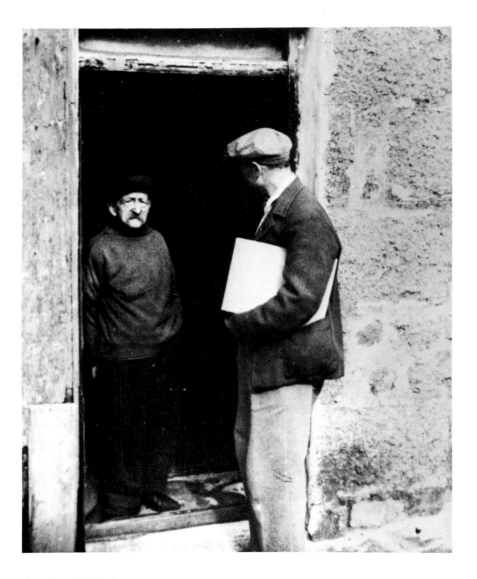

develop. He had reacted so strongly against his family's artistic involvement that it had seemed he might not become a painter at all. Of his time at the Slade School, one painting only remains — a still life of a striped jug. Significantly the jug is that prominently displayed in the best known painting by his father, Sir William Nicholson, *A Hundred Jugs* (1916). Ben Nicholson spent the years immediately before the First World War abroad. He produced very little completed work, but began to realize the significance of some of the modern paintings he saw which helped him to break away from the family tradition of painting, or 'to bust up the sophistication all around me', as he put it.

15.
Alfred Wallis and
Ben Nicholson at the
door of no. 3 Back Road
West, St Ives, *c.* 1939.

Ben Nicholson's early background had placed him centrally in the progressive art circles of the time. His father, Sir William Nicholson, a painter of portraits and still life was a friend of Whistler. Sir William was a dandy, dressed always in the latest fashions, yet he had a great capacity for work and an understanding of his own gifts. His wife, Ben Nicholson's mother, was born Mabel Pryde, and was also a painter, a granddaughter of the Earl of Carlisle (himself a patron of art and a Pre-Raphaelite painter). Her Scottish background was firmly rooted in common sense and she was a stabilizing influence in the heady circle of family and friends which included such notable talents as Max Beerbohm, Constance Collier and Marie Tempest. Ben Nicholson remembered that his mother, 'distressed by high flown talk would find herself wanting to scrub the kitchen table'.[4] The marriage of William Nicholson and Mabel Pryde also created an artistic partnership between William and James Pryde, Mabel's brother. Calling themselves the 'Beggarstaff Brothers', for several years the two brothers-in-law designed some of the best prints and posters that had been seen in England up to that time.

Rejecting this cultivated and sophisticated world, Ben Nicholson sought his own areas of interest and tested his own responses. He was not academic by nature and remembered his school days chiefly in terms of the games he played. His early training in art was limited to one year at the Slade, in 1911, when he was more interested in the billiards tables at the Gower Hotel than in the life room at the Slade. He did, however, work from the antique, drawing with a hard profile from early Italian examples. Nicholson was to remain critical of the part played by the Slade in his development; his true training as an artist came later with travel. For about seven years he lived mostly out of England, for reasons of health, making extensive visits to Madeira and then to Pasadena, California. On the death of his mother in 1918 he returned to England and from that time on England was his base. Soon after he met Winifred Dacre, herself a painter of considerable talent, and in 1920 they were married.

At about this time Ben Nicholson's artistic detachment began to break and his reluctance to commit himself to a statement gave way to continuous creation. The years that followed were wonderfully productive and the work he did then has all the verve of the young man's spirit that suddenly found the means to realize his dreams. The Nicholsons continued to travel and for three years spent each winter at Castagnole on the Italian border of Switzerland where Ben Nicholson's landscape paintings acquired a Cézannesque purity of lightly stated form. He found another subject in the hills and farms around his wife's family home in Bankshead, Cumberland, where he produced romantic paintings with an intimacy and warmth, sketching in the autumn chill around groups of oaks or pines, the contoured hills, farm buildings with grazing animals close by. Much is understated and colour is of a limited range rubbed on to a warm ground.

Visits to Paris between the years 1920 and 1930 were a prominent part in

16. Ben Nicholson, *Porthmeor Beach, St Ives*, 1928. Oil and pencil on canvas, 90 x 120cm.

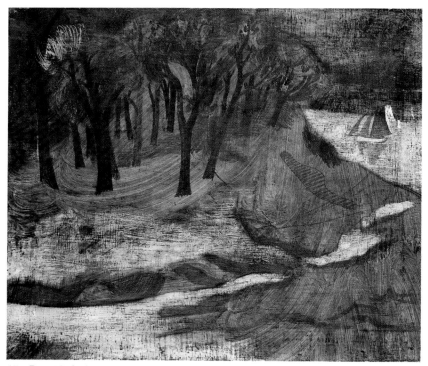

17. Ben Nicholson, *Pill Creek*, 1928. Oil, pencil and gesso on canvas, 48 x 61cm.

the search for direction, as Winifred Nicholson described, 'years of inspiration — fizzing like a soda water bottle'.[5] The Great War was over — the war to end all wars — and poverty and tyranny were things of the past, or so it seemed then. The future was unknown, but it would surely hold an expansion of thought on all sides. Boundaries and horizons were to be broken down and the vista ahead was light and sunny. Winifred Nicholson wrote of these years:

> We lived in white houses with new large windows, we ate simple foods — the fruits of the earth. We wore sandals and ran barefoot along the boulevards. We talked in the cafés of the new vision, the new scale of music, the new architecture — unnecessary things were to be done away with and all was to be functional. How young we were!

She described the first meetings with artists:

> great giants of innovation — our contemporaries. We could go on a bus on which Picasso was also travelling and see him, his eyes like black raisins, leap off into the traffic, disappearing with the movements of a panther. We could go to the large empty church where Corbusier had his architects working on the balcony. We could go to the Trois Quartiers shop opposite the Madeleine and buy steel chairs by the Bauhaus, tablecloths from the Basque country and glass and chinaware, all with the simple modern lines that we had begun to worship, a salvation from all the chaos of civilisation.[6]

Visits were made to Brancusi at the Impasse Ronsard where you announced yourself by striking a great Chinese gong 'that carried you away to Tibet even before you entered the magic studio', or up the many flights of steps to Mondrian's studio. 'Almost everyone one met was expressing genius, inventiveness, dedication to that vision and sharing it with their friends',[7] she wrote. This apprenticeship was of remarkable quality and pursued with great energy.

In August 1928 Ben and Winifred Nicholson visited Cornwall at the invitation of friends from the Hampstead Tennis Club, Marcus and Irene Brumwell. They stayed at a cottage in Pill Creek, a tributary of the Truro River near Falmouth. Christopher Wood was one of the party and on the second day of his stay he and Ben Nicholson went over to St Ives. Wood had already painted in St Ives, and his enthusiasm led Nicholson to wish to see it. They set out (according to Sven Berlin)[8] in an old-fashioned 'T' model Ford, driven by a man sitting bolt upright on the high seat behind the wheel, a bowler hat on top of his head. When they reached the Malakoff and could look down upon St Ives, the car was dismissed and they parted company, each with his drawing things, arranging to meet on Porthmeor beach at the end of the day. Looking back, Ben Nicholson wrote:

> This was an exciting day, for not only was it the first time I saw St Ives, but on the way back from Porthmeor Beach we passed an open door in Back Road

West and through it saw some paintings of ships and houses on odd pieces of paper and cardboard nailed up all over the wall, with particularly large nails through the smallest ones. We knocked on the door and inside found Wallis, and the paintings we got from him then were the first he made.[9]

A younger member of that summer's party was the painter John Wells, then still a medical student with a developing interest in art, who had been invited to Cornwall by his cousin, Norman Williams, to meet a 'real artist'. During the long weeks of this summer the young John Wells participated in Nicholson's first exploratory visits. He remembers the atmosphere of quiet concentration, Ben Nicholson with his big drawing book, Winifred carrying on with her own work, somewhat remote. He found their pictures difficult to understand, but was aware of their dedication and sincerity. He also remembers the lighter moments: on one occasion, sailing with Christopher Wood in rough weather, their mainsail was torn and they had to put in to Falmouth for repairs. Wood, who spoke French, fell into conversation with some French sailors from whom they purchased a lobster. They completed their journey to Helford with the lobster kicking in the bottom of the boat. John Wells returned to his medical studies at the end of that holiday, but kept in touch with Nicholson and exchanged letters with Wood who was to die so tragically two years later.

Christopher Wood had been a student of architecture at Liverpool University, when he met Augustus John at the Sandon Club. It was John who first encouraged Wood to paint seriously, and who later, in London, introduced him to other artists. Wood's short and erratic training took place in Paris, at the Académie Julian and the Grande Chaumière. Wood was by then the companion of a wealthy Chilean diplomat, Antonio de Gandarillas, who housed and supported him during this period and introduced him to the social and artistic life of his wealthy friends. Together they travelled extensively in Europe, particularly in the Mediterranean lands of Greece and Italy, and in North Africa.

Wood was surprisingly prolific during his first five years of painting, but was continually diverted from finding a true direction for his work. He was much affected by early meetings with Picasso in 1923, and Jean Cocteau in 1924. Both friendships were to last for the whole of his short life, but Cocteau was the greater influence and led him to develop a form of linear drawing as an equivalent for poetic feeling. It was Cocteau — it is supposed — who introduced Wood to opium smoking. These heady years spent out of England in the company of such internationally famous artists, developed a precocious and sophisticated talent, but produced an uneven and eclectic body of work that owed more to his fascination with the international avant-garde than to the deeper springs of his own personality.

When Wood returned to London in 1926 he was fortunate in meeting Ben and Winifred Nicholson. Their dedication to painting and their straight-forward approach to art were to have a stabilizing effect on his own work.

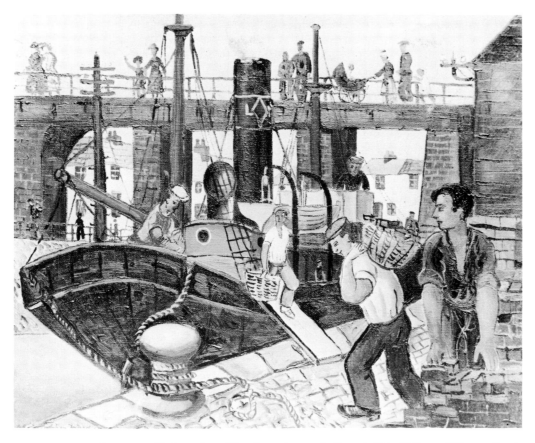

That year Christopher Wood made a painting visit to St Ives. (His mother's family, the Arthurs, had lived in Cornwall, serving the Navy and the Church for several generations.) Three of the paintings done on this visit were shown at the exhibition of the 'Seven and Five' society in January 1927. Wood's friendship with the Nicholsons continued after his return to France and as the pace of his work increased. In the spring of 1927 he wrote to Ben Nicholson:

> my life is in a whirlwind, so many ideas crush my brain, that I seem never to be able to concentrate on one that a thousand others disturb it. I begin so many things and finish so few at present; I won't worry and just go on in my own way, sometimes working all day long, and not producing anything at the end of it. You must know that I have never worked so hard before, and I am really having a life and death struggle with it, never as I knew before. Perhaps it means I am trying new and difficult things, and perhaps making progress. I don't think somehow that good or great things are ever done easily.[10]

'Good or great things' were being done, however, and these were shown

in 1927, when Christopher Wood had his first exhibition in London, at the Beaux Arts Gallery, shared with Ben and Winifred Nicholson and the potter W. Staite Murray. In the introduction to the catalogue of that exhibition Jean Cocteau took a simple view of Wood's precocious talent. 'In Christopher Wood there is no malice', he wrote. 'There is something straight-forward and naïve — the freshness of a puppy who has not yet had distemper.'[11] Wood's clear and obvious talent was beginning to be appreciated, but his life continued to be complex and confused. A brief elopement to Paris with Meraud Guinness was brought to an end by legal action on the part of her parents. He was becoming increasingly affected by his addiction to opium and by the recognition of his homosexuality. His dedication to painting was undiminished, and he returned to the villages of Brittany and Cornwall. His friends were increasingly the Nicholsons, on whom he became more reliant. He spent the early months of 1928 with them at their home in Bankshead in Cumberland, and the summer with them in Cornwall.

After their stay in Pill Creek both Wood and Nicholson moved on to St Ives. Nicholson stayed for three weeks and later produced a number of paintings of Pill Creek, and St Ives from Porthmeor beach. There is an unstoppable freedom and invention about these paintings, sketched in with lightly rubbed paint on a scraped surface that resembles sun-bleached woodwork.

Christopher Wood stayed in St Ives for three months, from September to November 1928, living in Meadow Cottage, behind Mr Baugham's shop and close to Wallis' cottage in Back Road West. In November he wrote to Winifred Nicholson:

> Admiral Wallis I often see. I took him some baccy and a few papers last evening. He showed me the lovely boats Ben sent him. I think he appreciated them as he had noticed the same constructions in his own pictures. He said when he came to my house 'they looked as well as anything draw 'em off' . . . I do two a day cheap and nasty, at least I can't tell what they are till you and B. have seen them. More and more influence de Wallis, not a bad master though.[12]

After St Ives Christopher Wood went on to Mousehole where he stayed in lodgings near the harbour. The paintings of this tiny port, a small sandy bay almost closed by the encircling harbour wall, are among his best. There is a certainty in the way he fits together the grey, textured surfaces of the granite cottages and breakwaters, interrupted by the black shapes of the jerseyed fishermen and the broken water of the sea. He found in Cornwall a freedom from other voices and manners which continued throughout 1928 and 1929, when he spent most of the summer in Brittany. Like other artists since the days of Stanhope Forbes and the Newlyn painters, he found direct similarities between the life and character of the two coastal areas. His letters to Winifred Nicholson make these comparisons. He wrote:

19.
Christopher Wood
Anemones in a Cornish Window, 1930
Oil on canvas,
40.5 x 51cm

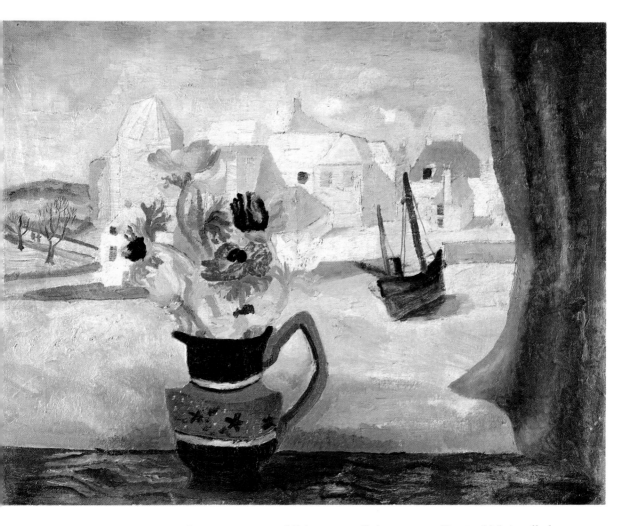

I may be motoring round Brittany to a little port near Brest which is called Douarnenez, rather St Ivesish I should think, but with real sailing boats. St Malo is very interesting but too big for me to understand quickly. I want to see the French crab boats we saw at Falmouth and St Ives so much three years ago. I looked everywhere for them and found none and was very disappointed for I came here for that reason.[13]

These years brought artistic success for Wood. A large exhibition — thirty-three paintings, including many of Cornwall — was held at Arthur Tooth's Gallery in London in April 1929, and its reception was highly favourable. This was followed in March 1930 by an even more successful exhibition in Paris, at the Bernheim Gallery, which he shared with Ben Nicholson. This was well received and repeated in London. At a personal

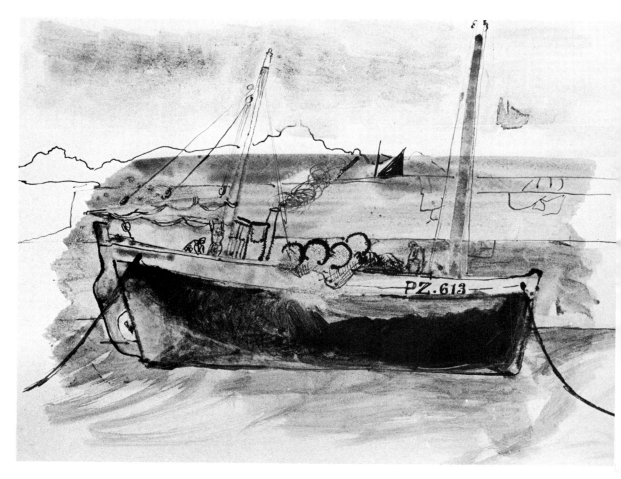

20. Christopher Wood, *PZ 613, 1930.* 27.25 x 36.75cm.

level, however, he was entering the last stages of his private tragedy. According to William Manson, 'his opium smoking had by now reached a critical point, as he had been deprived of pure opium by his increased separation from Gandarillas'.[14]

He continued to meet Ben and Winifred Nicholson, and made a final visit to Cornwall in 1930 for a few days only. In the last summer of his life he returned to Tréboul in Brittany, and the paintings he did there have a strange expression of joy, overlaid by black depression. The colours were greatly heightened, to the point of distortion, yet in their purity and intensity they contained a mark of finality. He painted little after this, and in August 1930 returned to England in a state of tormented delirium. After a brief and troubled meeting with his mother and sister on Salisbury station, he left them and either fell or threw himself under the London train. It was a tragic end to a brilliant talent.

2 Traditional and Modern: St Ives and London

After the end of the First World War, for the first time salaried workers were entitled to a paid holiday. The railways made it possible to travel to the more remote parts of England, and hiking, cycling and camping began. Express trains brought thousands of visitors from London to Penzance, which became a distribution centre for the whole of west Cornwall. Tourist traffic by private car began a year or two after the Armistice and grew gradually in the 1920s and 1930s. But despite the increasing numbers of summer visitors, change was slow and St Ives remained a fishing port with visitors in the summer months only, one souvenir shop, a few hotels and boarding houses. The town was now widely recognized as an artists' colony and was the home of a number of respected traditional painters and a large number of semi-professional and amateur artists who enjoyed its relaxed, protective environment.

St Ives Arts Club changed from being a meeting place for professional painters and welcomed a more broadly based group, including such notable talents as Hugh Walpole, Compton Mackenzie, his sister Fay Compton, Havelock Ellis, Leslie Stephens the poet and his daughters Vanessa Bell and Virginia Woolf, all of whom made St Ives their home for a time. In this literary climate readings and theatrical performances began to replace exhibitions and discussions on art. As the club attempted to consolidate, it was decided that artist members should not have work on sale in any other gallery in St Ives. However, instead of reinforcing the club's position this restrictive rule further alienated many of the exhibiting members. At a meeting in Lanham's Gallery on 19 January 1927, a group of the more liberal-minded formed a new organization, the 'St Ives Society of Artists'. The first president was Moffat Lindner, who had been president of the Arts Club during the difficult war years. Julius Olsson's old studio overlooking Porthmeor beach became their gallery and the first exhibition was opened by Olsson in 1928 with a membership of more than one hundred. The older, more established members included Arnesby Brown, Stanhope Forbes, Julius Olsson and Lamorna Birch; active among the younger ones were Borlase Smart, Leonard Fuller, John Park and Shearer Armstrong.

Borlase Smart had been brought up in Kingsbridge, Devon, and was trained at Plymouth Art College and the Royal College of Art. In 1913 he was in St Ives as a student of Julius Olsson who introduced him to marine painting. He saw active service as a subaltern in France during the First World War and recorded his experiences in a series of powerful sketches done at the Front. His paintings and drawings of the battlefields were shown

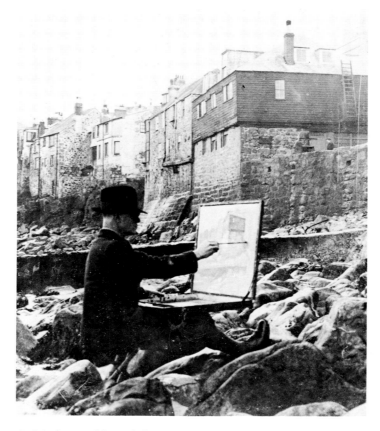

21.
Borlase Smart painting
on the rocks below
The Warren, St Ives.

in his first public exhibition, 'From Vimy Ridge to the Somme', in Plymouth in 1917 and later at the Fine Art Society in London.

The young painters Borlase Smart and Leonard Fuller were in the army when they met during the war at Grantham, while being regrouped after action on the battlefields in France. Deeply affected by the experiences of war, they decided that on demobilization they would join the art colony of St Ives. Borlase Smart became a central figure in the community of artists, working in one of the studios converted from old fish lofts overlooking Porthmeor beach. His painting was direct and traditional, based on observation, interpreted by sound draughtmanship and a vigorous, bold use of paint, often on a large scale. He was fascinated by the structure of landscape and had a feeling for the weight and mass of rock and the change of weather. The sea became his principal subject, the effects of light, the movement of water, the structure and formation of waves, and the parade of boats and shipping.

Leonard Fuller was to establish the best known art school in St Ives. He and his wife Marjorie Mostyn were both competent portrait artists and exhibited regularly in London and Cornwall. Leonard Fuller is remembered

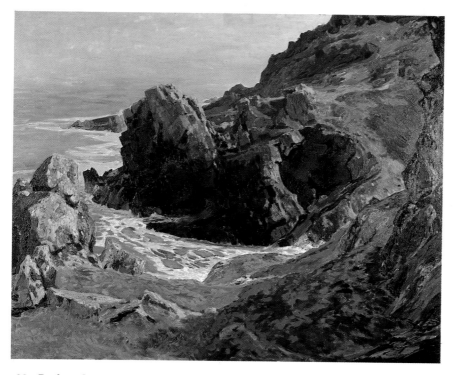

22. Borlase Smart, *Cornish Cliffs, Zennor*, 1925. Oil on canvas, 103.5 x 129.5cm.

more as a teacher, however. His classes at the 'St Ives School of Painting' attracted many of the younger painters in the 1920s and 1930s, who drew and painted from the model and from landscape, on the basis of daily payment as in the French ateliers.

St Ives played a central part in John Park's early struggle to become a painter. He arrived in 1899 as a youth of nineteen, one of a large working-class family from Lancashire. At eight he had worked in the cotton mills; later he joined his father as a decorator. He may have seen paintings by Cornish artists exhibited in the north of England, but he received no early training except that which he gave himself, mostly drawing and painting family likenesses. He was fortunate to meet Julius Olsson who found him an apt and willing pupil and gave him free tuition. Park soon made progress in portraiture and painted the harbour scene in St Ives with a spontaneous enjoyment. He first exhibited at the Royal Academy at the age of twenty-five and, still under the guidance of Olsson, decided to continue his training in Paris. From 1905 he studied at the Atelier Colorossi under Delacluse, at the same time as Modigliani, and saw the success of Impressionism in the art capital of the Western world.

23.
Leonard Fuller,
On the Verandah, 1940.
Oil on canvas.

He returned to St Ives in 1923, to paint the coastal scenery and the old houses and cottages of Downalong with a Mediterranean sparkle of clear colour freshly and freely applied. He found an abundance of subjects in the old fishing port, where the white sands and multi-coloured hulls of working boats gave endless movement and reflections. Equally evocative is his description of a pearly morning, as the fishing fleet prepares to leave — the water radiant in the early light, the hulls and sails now dark, scattered shapes. His subjects were those of his Impressionist masters; he had learnt well how to handle the effects of strong sunlight and reflections from water. Park painted St Ives as it welcomed the summer visitor, and it is the limitation of his art that this exhuberant colourist remained within the range of such gentle pleasures. But his work brought him considerable success in London and Paris. He was elected to the Royal Society of Oil Painters in 1923 and became a member of the Royal Society of British Artists in 1932. The regular exhibition of his work at the Paris Salon earned him its Gold Medal in 1934. Park was a friendly, popular figure and one of that small group of thoroughly professional artists who carried on the painting tradition of St Ives in the quiet years between the wars.

The sense of community among the St Ives artists is evident from the popularity of the show days, which continued a tradition started by the Newlyn painters. Artists who had prepared work for the Royal Academy's spring exhibition first showed it in their studios to friends and visitors. In St Ives this developed into a series of group exhibitions to which the public was invited. Around 1910 as many as eighty studios were open in Downalong, the Porthmeor studios and the old Piazza studios along the Wharf, and visitors came in large numbers on special excursion trains arranged by the Great Western Railway.

Art in St Ives took some time to recover after the First World War. In 1920 only fifteen studios were opened and they received about five hundred visitors, but numbers slowly grew. By 1929 forty-one studios were open to visitors, notably those of Borlase Smart, at Ocean Wave, St Andrews Street, Moffat Lindner at Porthmeor studios, Fred Milner and John Park at Piazza studios, and a large number of others at the recently opened Porthmeor Gallery. A section of each spring exhibition at the Royal Academy came from St Ives, and during the show days an annual arts ball took place, with decorations and fancy dress. Work for the Academy was taken to London in a specially hired railway carriage at a charge of fifteen shillings per picture.

A notable addition to the artists' group in 1920 was the potter Bernard Leach, then recently returned from Japan. With the help of his Japanese friend Hamada, Leach built his 'climbing kiln' in the Stennack Potteries, the first of its kind in Britain. He began to show his first pieces and etchings and drawings of Japan.

In addition to the residents, visiting artists came to St Ives in these years, finding a charged emotional message in the Cornish landscape. The short time that Matthew Smith spent in Cornwall was crucial to his development.

24. John Park, *Morning, West Pier, St Ives*, 1920s. Oil on board.

After an unsatisfactory period at the Slade, in 1908 he went to France, painting at Pont-Aven, as so many British artists had done, and at Étaples in the Pas-de-Calais before attending Matisse's short-lived school in Paris. His meetings with Matisse were brief, but the master's teaching left a lasting impression. In 1914 he returned to London. He found a studio in Fitzroy Street and his work began to develop rapidly. In 1916 he did the first of the great figure paintings called *The Fitzroy Street Nudes* — powerful designs, boldly conceived in the strong contrasting colours of Fauvism: acid greens and yellows, flame red and blue. This blaze of creative energy was interrupted in 1916 by the call to army service. On demobilization he returned to London, his health collapsed, anxious and depressed.

In 1920 Matthew Smith came to stay by the sea in Cornwall to try to recover the thread of his art. At first he produced little, but as his health improved he worked more easily. He moved to St Columb Major near

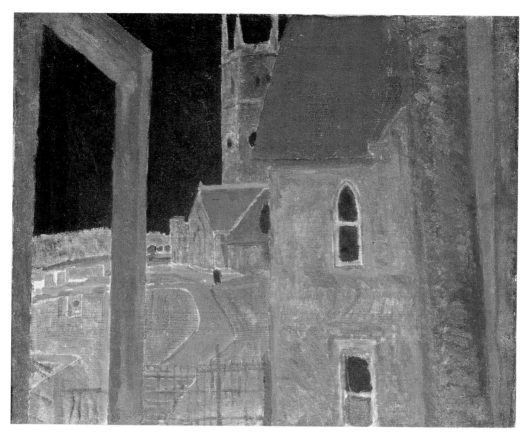

25. Matthew Smith, *Cornish Church*, 1920. Oil on canvas, 53.25 x 64.75cm.

Newquay, and from June to December that year painted a number of glowing canvasses. Passion is combined with innovation in these disturbing pictures — views of the church, landscapes and flower pieces. Strong horizontal bands of colour flatten the forms of the landscape, and there is a sombre and passionate intensity in the reverberating colour: dark greens, blues, violets and magenta. These paintings reveal his sense of despair and desperation, yet in their creation he found a way through his personal distress. When Matthew Smith's first one-man exhibition was held at the Mayor Gallery, London, in 1926, Augustus John wrote in lavish praise of the work in which the Cornish experience played such an important part: 'With a cataract of emotional sensibility, he casts upon the canvas a pageant of grandiose and voluptuous form and sumptuous colour which are none the less controlled by an ordered design and a thoroughly learned command of technique.'[1]

Another painter for whom St Ives meant much was Frances Hodgkins, whose full talent came late in life. Born in 1870, she was the daughter of an amateur painter in Dunedin, New Zealand, and was thirty years old before she came to Europe. After sketching classes in Brittany she was based in Paris for much of the period before the First World War, and taught watercolour painting at the Colorossi Academy. From 1914 to 1920 she lived in Cornwall, mostly in St Ives. Here she met Lett-Haines and Cedric Morris and was encouraged by them to begin painting in oils. She then moved to Manchester and it was not until 1927, after a visit to Tréboul, that she began to exhibit her work in London. She was nearly sixty when her work developed a vigour and quality similar in spirit to that of the younger painters — Ben Nicholson, Ivon Hitchens and others who were leading the Seven and Five society, with whom she began to exhibit regularly. She was in Cornwall again in 1931, at Bodinnick near Fowey, at a time when her work was about to enter its final and greatest period. In a series of freely orchestrated paintings that lie close to Surrealism, she described the landscape of Cornwall in vivid colour — sea and hills, farm and country, with their implements and domestic objects.

In June 1937 Stanley Spencer came to St Ives on a six-week painting visit. He had recently married Patricia Preece who was now staying with a woman friend in a rented cottage in St Ives. Stanley followed soon afterwards. This was one of the more bizarre episodes in Spencer's remarkable life, for the marriage to Patricia had been arranged by his first wife Hilda, who agreed to a divorce so that he might satisfy his infatuation for Patricia, and as an alternative to the *ménage à trois* that Spencer had proposed to set up in Cookham. The marriage to Patricia was a mockery and even on the honeymoon in Cornwall Spencer did not share the cottage with the two women. He did, however, paint six views of St Ives, seen from a high point above the Malakoff, studies of fishing boats, the harbour and cottages, which have an originality and precision based upon close observation that is unusual in the many paintings of the town.

Painting in St Ives in the inter-war years was quiet, conservative and wholly unconcerned with those innovative discoveries that were so changing the art capitals of Europe. The attitude of this sheltered community in St Ives is in sharp contrast to that of the small group of embattled avant-garde artists in London, among which Ben Nicholson was to take a position of leadership.

By 1930 Ben Nicholson, then thirty-six, had lived and worked in many parts of the world. He had absorbed a wealth of new ideas and was testing them in his own work with increasing confidence. In the shared exhibition with Christopher Wood at the Bernheim Gallery in Paris in 1930 Nicholson was recognized not as a foreign visitor, but as a new and significant talent, ready to enter the ranks of the avant-garde. In the following year he had his first major exhibition in London, at the Bloomsbury Gallery. Barbara

26. Ben Nicholson, *c.* 1936.
27. Barbara Hepworth with
Kneeling Figure, 1932.

Hepworth saw this exhibition and the powerful impression it made on her led to the first meeting with the man she later married.

Barbara Hepworth was then a young sculptor beginning to find a mature style. She had been born in 1903 in Wakefield and was brought up there, the eldest of the four children of Herbert R. Hepworth, CBE, and Gertrude Allison (née Johnson), both of whom came from the West Riding of Yorkshire. Her father, county surveyor to the West Riding, often took her motoring with him across the Yorkshire Dales. Her early experience of the rough landscape of the Dales and its ungracious industrial background in which man and nature share a particularly close relationship, were always to be of importance to her, and she drew on these memories in her sculpture. 'I would imagine stone images rising out of the ground,' she recalled, 'which would pinpoint the spiritual triumph of man, and at the same time give the sensuous, evocative and biologically necessary fetish for survival.'[2]

At sixteen she went from Wakefield Girls' High School to Leeds School of Art, where Henry Moore was also a student. Within a year she and Henry Moore were each awarded county major scholarships and entered the Royal College of Art in London. Outside the teaching hours of the College she began to carve 'direct', which was not part of the teaching programme. After the three-year course she received a West Riding scholarship for a year's travel abroad, and in September 1924 went to Italy. Florence became her base and she explored the early sculpture and painting of the Renaissance in Tuscany and Umbria. This was a time for looking, for testing new experiences. Italy revealed the properties of strong sunlight to describe the

subtleties of contour and colour in stone. She spent the winter in Rome and Sienna, continuing to find a treasure-house of impressive Romanesque and early Renaissance sculpture. In May 1925 she married John Skeaping who was then the Rome scholar in sculpture at the British School. Here they were taught the technique of carving in marble by the Italian master-carver Ardini. It was a chance remark by Ardini that 'marble changes colour under different people's hands'[3] that made Hepworth appreciate the need to understand the nature of the material in order to persuade it into forms natural to it. Returning to England the following year, she and John Skeaping set up a studio in St John's Wood and soon arranged a joint studio exhibition. The few carvings of the period, single standing figures and small carvings of birds, are the start of an extending experiment to simplify form and to find personal harmony within the material.

The birth of their son Paul in August 1929 was a great joy, but Barbara Hepworth remained totally occupied with her work, and her child and home became an extension of this. John Skeaping went in other directions. 'Quite suddenly we were out of orbit'.[4] She found new strength in her carving. She had gained considerable control of her medium and was ready to break down and rebuild her work in new forms. The paintings that she had seen by Ben Nicholson and her subsequent meeting with him helped her to make this break. In the summer of 1931 they and Henry and Irena Moore were part of a summer party at Happisburgh on the Norfolk coast. It was a pleasant combination of work and discovery, collecting ironstones on the beach, carving, drawing and painting and preparing for a joint exhibition to take place at Tooth's. 'We were free and totally and individually dedicated. They were hard times but so happy,'[5] Barbara Hepworth recalled.

By 1932 Ben Nicholson and Barbara Hepworth had formed a close friendship. At Easter they travelled together to France where they met Picasso, Arp and Brancusi. This last visit was particularly memorable for Hepworth as she saw in Brancusi's studio primitive forms expressed in abstraction, 'all in a state of perfection and purpose and loving execution'.[6] She showed Brancusi photographs of a sculpture she had recently made, a highly innovative piece called *Abstraction* in which, for the first time, she had pierced the stone with a hole to reveal its formal properties. In the summer Hepworth and Nicholson visited Braque and the following year met Brancusi again and visited Mondrian for the first time. This meeting with Mondrian was to be of the greatest significance to both artists.

The austerity and purity of Mondrian's work was to play an important part in their development towards total abstraction, but it was Mondrian's personality that first impressed Nicholson: 'The feeling in his studio must have been not unlike one of those hermit's caves where lions used to go to have thorns taken out of their claws,'[7] he wrote. At this time Ben Nicholson and Barbara Hepworth identified completely with the European avant-garde. Their work was shown in a number of important international exhibitions alongside such artists as Calder, Miró, Gabo, Giacometti and

28. Barbara Hepworth, *Large and Small Forms*, 1934. White alabaster, 25 x 45 x 24cm.

Mondrian, and some of these European artists began to be shown in London.

In 1934 Nicholson and Hepworth were married. For Hepworth the experience of the European avant-garde and the example of her husband encouraged her to engage upon a series of free experiments in the formal qualities of sculpture, in a search for a new vocabulary. The work of these three important years, 1931 to 1934, was abstract, yet still based on the human figure, particularly the theme of mother and child. She took the greatest liberties in refining the female form which became a polished block reminiscent of flint or naturally shaped pebbles, the features lightly engraved upon the stone. These references to maternity were undoubtedly in anticipation of the birth she was expecting. In October 1934 triplets were born: Simon, Rachel and Sarah Hepworth-Nicholson. She and Ben Nicholson were then living in a small basement flat near their studios in Parkhill Road, and found considerable difficulty in providing for their new family from their uncertain incomes. Yet despite financial hardship the experience of the children seemed to intensify their individual sense of direction; their work

was strengthened and they had greater unity of purpose. After the birth yet another change took place in Hepworth's work. When she resumed carving all traces of naturalism had disappeared. Shapes became more clearly geometric and she used the simplest primary forms — spheres, cones and cylinders, precise in their relationships, weight and balance. The materials of her sculpture — usually white marble — took on a new clarity of surface, polished to its own glowing colour.

Ben Nicholson's work also changed considerably in the early 1930s. Close acquaintance with the School of Paris had given new forms and a new confidence to his painting. He reduced his use of colour, now black and brown played a majestic part and the likeness of the human figure appears as a line scratched through the gritty, painted surface to the gessoed ground beneath. These references to the female nude or to a head seen in profile were a reflection of Nicholson's new relationship, but they appear casually, like graffiti on an old wall. Nicholson's work was moving towards what he described as 'freedom': freedom from appearances, or even references to the traditional paraphernalia of the artistic world.[8]

In 1933 Nicholson began to explore the space in paintings in an entirely new manner. Instead of inscribing the surface, he began to carve into it and produced a series of carved reliefs that were geometric and totally without colour. In their uncomprising purity they rival the most extreme non-figurative work of Mondrian. These white reliefs usually took the form of an opposition between one or two circles and a series of overlapping rectangles. The positioning of overlaid surfaces, each with its light edge above and dark shadow below, gives spatial separation to the carved planes, an abstract harmony of parts. The reliefs were carved from large boards, usually mahogany leaves of old dining tables bought in the Portobello Road. In the carving the marks of the gouge were allowed to show and the slightly wavering edges softened the geometry. These imperfections serve to convince us all the more of the precision of the artist's intentions.

This radical change in Nicholson's work, from the free investigation of painterly space to the formal interplay of relief carving, owes in large measure to those ideas of abstraction to which he had been introduced in Europe, particularly in his contacts with Mondrian. However, more immediate influences were also at hand. The first was the example of Barbara Hepworth, whose carvings had become totally non-figurative and purist. The second was Nicholson's strong interest in architectural form and theory. His brother Christopher Nicholson was a distinguished architect, and with Leslie Martin, also an architect and a life-long friend of Ben's, he had many contacts with progressive architects in Europe, and helped a number of them to come to England.

By 1935 both Nicholson and Hepworth had reached a point of adamant abstraction that remained in their work, Nicholson with his carved reliefs, white on white, Hepworth with white marble carvings of geometric solids. They had become leaders among that small group of artists, architects and

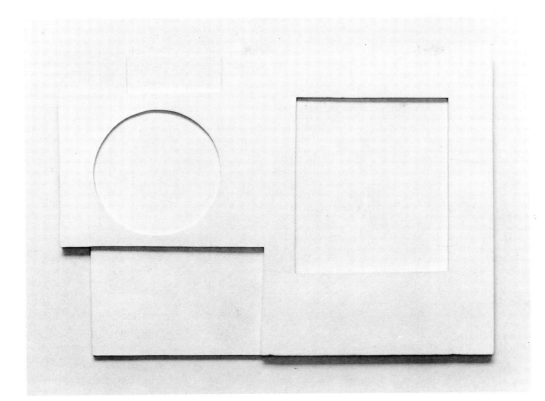

designers who reacted positively towards the progressive movements emanating from continental centres. The force of their own ascetic personalities illuminated their absolute dedication. They worked to create in London an equivalent of the Modern European Movement, and assisted in the formation of groups and societies to further these important principles.

The Seven and Five society had been formed in 1920 and in the earliest stages its members had no avowed policy. (At no time did it show the work of seven painters and five sculptors as its name suggests.) The original group of eighteen exhibiting artists contained names that are now forgotten — with the single exception of Ivon Hitchens — and seven of the original members left after the first exhibition. Over the years the society showed paintings, sculpture, pottery and drawings that were among the finest work produced in England by a group of young artists of high talent and originality. The Seven and Five 'manner', if it can be so described, had a gentle freedom hallmarked by the strong use of pattern, paint generously applied, flattened and open forms and no sense of 'finish' in the work. Simplicity, even naïvety was cultivated. Colours were less strong than in the French equivalent, Fauvism. Hot reds and greens were rarely used, more frequent were the ochres and earth colours, soft warm greens and broken

whites characteristic of English light. Subjects were also evidently English: gardens and flowers in the work of Winifred Nicholson, interiors with still life in that of David Jones; lush southern woodlands pictured by Ivon Hitchens and Frances Hodgkins.

Nicholson joined the Seven and Five society in 1924, soon becoming the most prominent member, and in 1926 its chairman. He pursued policies broadly in line with the changes of his own work and led a successful effort to purge the society of watercolourists and portrait painters. He also introduced a number of new members, mostly friends who shared his views about the central importance of abstraction. The most radical change came in 1934 when Nicholson proposed that the name be changed to the 'Seven and Five Abstract Group'. This was not agreed, but he was successful with his suggestion that 'the exhibitors are to be non-representational. The hanging committee are only empowered to select and hang non-representa-tional work.'[9] This ruling polarized the membership, many of whom resigned or were voted off, and brought about the demise of the society. The last exhibition in 1935 at Zwemmer's Gallery in London showed the work of only eight members, including Winifred Dacre (previously Winifred Nicholson), Barbara Hepworth, Ivon Hitchens, Henry Moore, Ben Nicholson and John Piper. All of the work was abstract; Nicholson exhibited a *White Relief*, Hepworth *Discs in Echelon*.

After many years spent mostly away from London, in 1931 Ben Nicholson moved to one of a block of studios, the Mall studios, built in the gardens of large houses in Parkhill Road off Haverstock Hill, between Hampstead and Camden Town. For a time he and Barbara Hepworth shared number 7, later they had adjacent studios. Henry Moore had been living in Parkhill Road since his marriage in 1929, and Cecil Stevenson, another artist from Leeds, had number 6 Mall studios. Paul Nash was nearby in Eldon Grove. This group, which broadened to include many other notable English and European artists, was centred here until the Second World War. Herbert Read, also from Leeds, took number 3 Mall studios, and it was he who with his unique understanding of his friends' work codified the philosophical attitude of the group and attracted much public attention to it. He coined the phrase 'a nest of gentle artists'[10] to describe them and later recalled:

> For five years I lived in friendly and intimate association with this group of artists, visiting their studios almost daily watching the progress of their work. At the back of the studios were small gardens, and in mine I built a wooden hut, about six by four feet, and there, during the first summer, I wrote *The Green Child*. It was the happiest period of my life. I remember how when we had just moved into the studio and freshly decorated it, woodwork pale blue, walls white, Ben Nicholson came in to see the result. 'Wait a minute', he said, and retired, coming back a few minutes later with a round cork tablemat which he had painted scarlet. He seized a ladder and nailed the scarlet disc high on the white wall. The whole place was transformed by this accent of colour, perfectly placed.[11]

At the time that Herbert Read came to Parkhill Road, both his life and his work had reached turning points. He was forty and had already achieved much in literature, criticism and philosophy. The two previous years as Professor of Fine Art at the University of Edinburgh had not been happy — the intellectual climate in the Scottish capital was not sympathetic to one who so strongly supported the heretical cause of modern art, and his first marriage had broken up, causing him considerable personal distress. In his early life Read had seen hardship. His father, a tenant farmer in Yorkshire, had died when he was ten years old, and part of his education had been in an orphanage, part at Crossleys School, Halifax. He left school early and worked for a time in a savings bank; then, intent on continuing his education, he sought admission to Leeds University. Leeds contained great cultural wealth at that time, and Read was fortunate to meet two men who were to shape his life through their deep understanding of modern art movements. They were Jacob Kramer, painter and teacher of great repute, and Sir Michael Sadler, later Vice-Chancellor of Leeds University, who was then forming one of the most extensive collections of modern art in this country.

Read started to write seriously for publication, his first short books of artistic criticism on Gaugin and Kandinsky were published in 1913 and 1914; he also began to write poetry. As a commissioned officer in the Yorkshire Regiment during the First World War he showed great bravery in France and was twice decorated, MC and DSO. At the end of the war, without a training that would earn him a living, he joined the Civil Service, first in the newly formed Ministry of Labour, then in the more congenial Victoria and Albert Museum, in the Department of Ceramics. He studied and wrote on decorative and stained glass and pottery, and became increasingly interested in contemporary philosophy and psychology, particularly in relation to the creative intelligence of the artist. From 1929 he contributed regular articles on art to *The Listener*.

In his extensive writings on art Read did not put forward an ideology, rather he sought to illustrate by historical example and by sympathetic attention to the art of the present, how the artist's inner life is directed by his sensibilities. He showed the artist as part of nature, not as a copyist, stressing that today's artists are as much affected as those of the remote past by the voices of spirits or the inspired oracle. Read's approach was comprehensive, based on wide historical knowledge and an informed scientific and psycho-analytical understanding of those systems of thought that direct the work of art. For the artists whom he supported he acted as a magnet for ideas; his deep convictions were given added authority by his position as a distinguished poet. For the public he had a unique ability to communicate complex thoughts and ideas about abstraction in art, and he helped immeasurably to spread the ideas of the group of artists and writers loosely associated around Parkhill Road. He became the foremost defender of modern art in Britain and acted as champion and chief protagonist for the

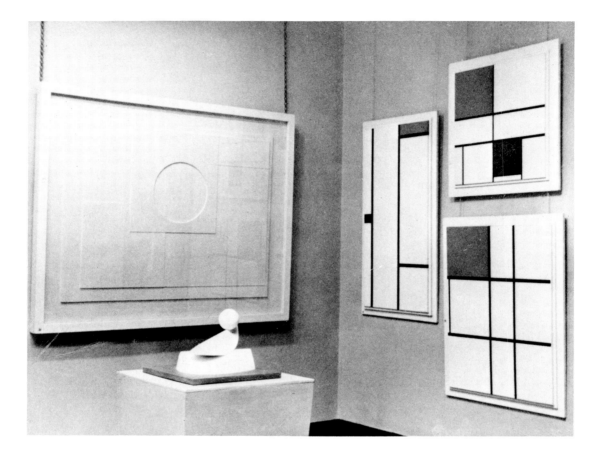

work of Ben Nicholson, Barbara Hepworth, Henry Moore and others in an important series of articles and such definitive publications as *Art Now* (1933), *Art and Industry* (1934), and *Art and Society* (1936).

The strenuous efforts of this small band were for the most part either overlooked or derided, and they depended mainly upon their own cohesive activism and the support of a small number of understanding friends. H.S. Ede and Margaret Gardiner, both close friends and early patrons of Nicholson and Hepworth, were in nearby Hampstead. Geoffrey Grigson, whose writings were also sympathetic, lived in Keats Grove and nearby was Roland Penrose, soon to be centrally involved in the message of Surrealism. The critic Adrian Stokes added the dimensions of psychoanalysis, C.S. Redihough, another early collector, and the architect Leslie Martin were all in the area, as was John Summerson, architectural writer, who married Barbara Hepworth's sister. This was not a movement or a group with an agreed programme, but an association of friends drawn together in a common direction by their understanding of experimental art forms.

.
'ork by Ben Nicholson,
irbara Hepworth and
et Mondrian in the
:hibition 'Abstract and
oncrete', 1936.

All aspects of modern art were under continuous attack in the 1930s and to counteract criticism a group of artists and architects, under the joint leadership of Paul Nash and Ben Nicholson, formed the group 'Unit One'. In his letter to *The Times*, announcing its formation on 2 June 1933, Paul Nash stated that: 'The common bond of its members is that each one stands for the expression of a truly contemporary spirit, for that thing recognised as peculiarly of today.'[12] The name was intended to convey the idea of unity — Unit — with that of individuality — One — and to replace the rejection and isolation of its members by group endeavour. A book, also entitled *Unit One*, edited by Herbert Read and a touring exhibition helped to put forward this idealistic combination of design and art as 'a hard defence, a compact wall against the tide behind which development can proceed and experiment continue'.[13] Ben Nicholson made a brief, but remarkable contribution, asserting the authority of the artist to make decisions based on his personal pleasure at the result. After confronting materialistic science, he went on to make a decisive claim for art, and for abstract art in particular. 'As I see it,' he wrote, 'painting and religious experience are the same thing, and what we are all searching for is the understanding and realisation of infinity — an idea which is complete, with no beginning, no end, and therefore giving to all things for all time.'[14]

In Germany, the aggressive militarism generated by Hitler's growing political power had made life intolerable for many artists of the international movement. London became a reception centre for the politically oppressed and culturally dissident. The Bauhaus design school in Germany, which had based its whole approach on the unity of the arts with design and architecture, was finally closed by the Nazi government in 1933. Walter Gropius, the founder of the school and its director since 1919, came to London in 1934 and lived in Lawn Road, Hampstead near Parkhill Road, in one of the flats recently built by Wells Coates. He remained in London until 1937 when he moved to the United States. In 1935 Naum Gabo, already known to Nicholson and Hepworth, also come to Lawn Road, as did the architect and designer Marcel Breuer, the photographer and experimental film maker Laszlo Moholy-Nagy, and the architects Erich Mendelsohn and Lubetkin. Despite considerable professional difficulties, many of these expatriates found opportunities to continue their work in Britain. They produced a small number of notable architectural masterpieces, often in collaboration with young designers and architects, that were to provide a further focus for the functional aesthetic.

Piet Mondrian came to London in 1938, to a studio found for him by Ben Nicholson at 60 Parkhill Road, facing the Mall studios. He repeated the simplicity of living that Nicholson had seen in Paris and new canvasses with the same fierce impact began to appear. He was a living example to the English artists. As Hepworth put it, 'Mondrian showed us how completely possible it was to find a personal equation, through courage and exceptional

faith in life itself, and for the artist's intrinsic right to assume entire responsibility for the development of his art. No artists in our time have had such a powerful and *silent* influence as Mondrian and Brancusi.'[15]

In 1936 Nicholson had attended the famous opening of the international exhibition 'Surrealism' at the New Burlington Galleries in London. After the opening he, Hepworth and Gabo discussed ways of putting forward the alternative view of constructive art. This resulted in the publication of *Circle: An International Survey on Constructive Art* (Faber, 1937) which brought together the views of English and European avant-garde artists and architects. Nicholson, Gabo and Leslie Martin were joint editors. The book took two years to produce and included eighty-two contributions by painters, sculptors, architects and writers, each of whom defined his or her position in a written statement or visual presentation. The list of contributors was truly international: Arp, Braque, Duchamp, Kandinsky, Lissitzky, Mondrian, Picasso, Piper, Brancusi, Calder, Moore, Tatlin, Aalto, Corbusier, Gropius, Mendelsohn and many others. The book was a comprehensive attempt to define the nature and common spirit of abstract art, 'that inspiring wave of imaginative and creative energy'. It was not intended as a manifesto — it had no agreed social, political or even artistic platform, save that it excluded Realism and Surrealism, proposing constructive art as an internationally significant development which affected all of the plastic arts. For those who participated in *Circle* this was a time of high idealism and they believed that the expressions of their art could have a place in shaping a new future. As Hepworth recalled:

> suddenly England seemed alive and rich — the centre of an international movement in architecture and art. We all seemed to be carried on the crest of this robust and inspiring wave of imaginative and creative energy. We were not at that time prepared to admit that it was a movement in flight. But because of the dangers of totalitarianism and impending war, all of us worked the harder to lay strong foundations for the future through an understanding of the true relationship between architecture, painting and sculpture.[16]

For a brief moment the efforts of Nicholson and Hepworth and their friends to bring together a truly international circle of artists, architects and designers seemed to be successful, but this short-lived period of optimism was soon ended by the threat of war and the dispersal of the artists away from London. Herbert Read wrote a pessimistic introduction to the exhibition 'Living Art in England', an exhibition dominated by Surrealist work, which was arranged at the London Gallery by E.L.T. Mesens in 1939:

> The triumph of fascism has everywhere carried along with it the exultant forces of philistinism, so that over more than half of Europe, art, in any vital sense, can no longer be said to exist . . . even in those countries which are still professedly democratic, a wave of indifference has swept the art world.[17]

3 Wartime in St Ives

It was in August 1939, only a week before war was declared, that Nicholson, Hepworth and their five-year old triplets came to St Ives to shelter from the threat of bombardment in London. The last person they saw before leaving was Mondrian. They begged him to come with them to Cornwall, but essentially a town dweller, he would not leave London, even under the threat of war. (He left for New York in 1940, after his Hampstead studio had been damaged by bombs.) The Nicholsons came to Carbis Bay, St Ives, at the invitation of Adrian Stokes, a friend from Hampstead days, who with his wife Margaret Mellis was a recent arrival. Stokes had supported the work of Nicholson and Hepworth since he first came to terms with abstract art, and had written enthusiastically about them in the early 1930s.

Born in Bayswater in 1902, Adrian Stokes was the third son of a wealthy family with intellectual interests. As a boy at Rugby School he showed a precocious talent and the ability to sustain investigation of complex and intellectually demanding material, which led him to an early interest in philosophy and Freudian psychoanalysis. He read Modern Greats at Magdalen College, Oxford (he graduated with a second class degree: having excelled in philosophy, he refused to turn in papers in mathematics and German) and persuaded his father to finance a world tour. He sailed for Bombay, and during the several months of his stay began to write seriously on Indian culture and mysticism. He returned to journalism in London and published his travel diary embellished with somewhat undisciplined views of Western culture as *The Thread of Ariadne* (1925).

A friendship with Osbert Sitwell led his father to finance further travels, and he began to look at the art of Italy, particularly the sculpture and buildings of the Renaissance, that was to engage the greater part of his attention from that time. A heady mixture of Italy past and present was presented in a group of writings, first the exploratory *Sunrise in the West*, published in 1925, then the more mature confidence of *The Quattro Cento* and *The Stones of Rimini* (1932 and 1934). During this period of intense creative energy, Stokes became increasingly self absorbed, and began a more extensive reading of Freud. In 1930 he started analysis under Melanie Klein. This seven-year period of examination by an analyst who placed considerable importance upon the earliest development of sensations and responses in the infant, became for Stokes an analogy of the artistic process. He returned from Italy to London in order to continue psychoanalysis and during this period started to write on contemporary art. In 1934, drawn by his friendship with the artists in Parkhill Road, he moved to one of the nearby Lawn Road flats.

Stokes' extensive written work displays his wide interest in the plastic arts, dance, painting and poetry. Fantasy was close to the surface in his

thought, and in his writings places were interpreted with a sensitivity and an exact response which conjured up their many associations. There was a strain of anarchism in him, a distrust of theory, a preference for disorder. His personality displayed a strong internal struggle characterized by his self-analysis and psychoanalysis. In the spring of 1936, with a painter friend Adrian Kent, Stokes came to Cornwall for a short visit to receive lessons in painting. His activity as a painter, which started at the age of thirty-three and continued until his death in 1972, originated in his need to better understand the principles of art activity for the purposes of criticism, but it became an increasingly important part of his life. If his written comments on painting were complex, searching and questioning, his own early paintings had none of these characteristics. He produced unpretentious landscapes of Cornwall (a further visit was made in 1937) and Italy, and still-life groups of bottles in which the glass was a vehicle for semi-transparent colour. To many, the paintings appeared amateurish, blurred and unemphatic. Stokes was modest about them: 'my fuzzy paintings of bottles, olive trees and nudes, dim as blotting paper,'[1] he wrote. Later and slowly, he established a firmer control and these subjects were invested with an irridescent quality expressing subtle relationships between objects and the spaces separating them. His theoretical approach to painting was presented in the books that he worked on in St Ives. *Colour and Form* (Faber, 1937) was his most important publication and his last for eight years.

In 1937 Adrian Stokes moved from Hampstead to Fitzroy Street, two doors away from the Euston Road School, a teaching studio recently established by William Coldstream, Graham Bell and Claude Rogers. Here he worked with others including Victor Pasmore and Lawrence Gowing. The Euston Road School was a considered attempt by a number of painters to rediscover a social function for art, based on the close observation of everyday reality. It introduced Stokes to the complex problems of painting from the figure, and helped him to introduce into his still-life paintings a certainty of placing, and to describe the radiant light that appears to emanate from within them by the use of thin colour.

In 1936, while painting in Paris, Stokes had met the painter Margaret Mellis, and they were married in July 1938. Unlike her husband's work, which was topographical, even impressionistic, hers was abstract with formal, stylized design and colour of a clear, light tone. On a visit to St Ives in 1939 Stokes was attracted by a house in Carbis Bay, and, acting on impulse, bought Little Parc Owles, a friendly, rambling house with large gardens and about six acres of land. The Stokes' son Telfer was born there in 1940. During wartime Adrian Stokes ran part of the large garden as an agricultural smallholding for food production.

Because of the close friendship that already existed between the Nicholsons and the Stokes, the Nicholsons stayed for about four months at Little Parc Owles. The house became a resting place for others too. William Coldstream

31. Naum Gabo, 1936.

spent the first months of the war there, and at Barbara Hepworth's suggestion this oddly dissimilar group worked together on a scheme of camouflage for the chimneys of the nearby Hayle Power Station as their personal contribution to the war effort. Soon after the Nicholsons arrived, Naum Gabo and his wife Miriam came down, also as guests of the Stokes.

Naum Gabo was that rare combination of engineer and artist, a mathematician with the eye of a poet. His presence in London from 1935 and in St Ives for the war years was a spiritual example for those artists who felt themselves to be part of the modern movement. He had experienced at first hand the terrors and hardships of the Russian Revolution and shared the exalted hopes of those who supported massive social change. Despite the frustrations that followed he retained confidence in his own direction and a belief in a social purpose for the artist. He made an art form of space itself, non static and without mass or volume, building his constructions of materials that were new — transparent plastics, stainless steel, wire, glass and chromium — to serve a new society.

Naum Gabo was born in Briansk in 1890, of a family named Pevsner that included four brothers and a sister. His father was an executive in the copper refineries. Since two of the boys were engineers and one an artist (his brother Antoine who was four years older), it was decided that Naum

should become a doctor and he was enrolled in the medical faculty of the University of Munich. But it was the physical sciences and the arts that drew him, and after a year he transferred from medicine to study physics, chemistry and mathematics, and later civil engineering. At that time Munich was the centre for much brilliant work in both the sciences and the arts. The University's Faculty of Science included such members as Roentgen, who discovered Xrays, and Beyer the industrialist. In the arts the activities of Wassily Kandinsky and the group known as the 'Blue Rider' were central. Gabo met Kandinsky in 1910 and read his *Concerning the Spiritual in Art*, when it was first published in 1912.

At the outbreak of war in 1914, Gabo went to Norway where his younger brother Alexei was studying at the University of Oslo. During this period of seclusion Gabo made his first constructions, combining the principles of engineering and art in structures of the head and body as a series of open and closed forms in sheet metal and plywood. In April 1917, with Russia in the turmoil of revolution, the brothers returned to Moscow. At a time of famine, civil war and great social and economic privation, Naum shared in the exultation of this brief experimental period. The most extreme investigation of abstract art was then in progress, led by the Suprematist group and its creator, Kasimir Malevich. The new Communist government for a time encouraged socially motivated artists to take over the schools of art and the museums of the new state. The People's Commissariat of Education established *vkhutemas* (higher art and technical workshops) to replace the old Imperial Academy of Art, and Kandinsky, Malevich and Tatlin became professors. Antoine Pevsner was instructor of painting. Naum Gabo (he had changed his name to avoid confusion with his brother) refused to become a teacher, although he had been invited to lead the department of ceramics and sculpture, but edited a weekly paper called *120* which was devoted to enquiries into the function of art. He was drawn into the many artistic, social and political activities of this free academy, and from 1917 to 1920 Gabo and Antoine were at the centre of this whirlwind of discussions, open forums and seminars involving a shifting population of students who debated the ideological and future place of art. In the workshops their theories were given tangible form in painting, sculpture, designs for architecture, clothes and furniture and goods of many kinds.

Naum Gabo and Antoine Pevsner put forward their views in an exhibition in Moscow for which they printed a broadsheet, *The Realist Manifesto*, which declared the personal and spiritual nature of their art and their need to find forms of expression not limited to utilitarian ends, views which implied a dangerous freedom of action. The state's limited sympathy to new directions in art was withdrawn, and opportunities for teaching or holding exhibitions no longer existed. Gabo was allowed to leave Russia in 1922, to supervise the arrangement of the Constructivist section of a large exhibition of Russian art in Berlin, where he remained and was soon joined by Antoine. Gabo spent most of the next ten years in Berlin, but increasing-

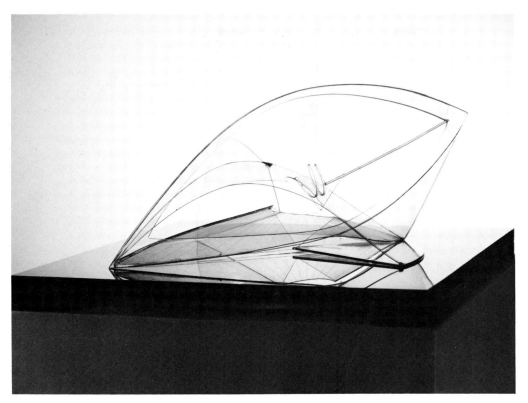

32. Naum Gabo, *Spiral Theme*, 1941. Plastic sculpture, 244mm deep, 140mm high, 244mm wide.

ly began to exhibit his work in Europe and the United States. Gathering tensions in Germany caused him to leave in 1932 and to spend the next three years in Paris, isolated and lonely. Then, attracted by the developing interest in abstraction in England, and following the example of many of his European friends, Naum Gabo came to London. In 1935 he visited to discuss the possibility of a new ballet for the Ballets Russes. In 1936 he returned as one of the fifteen artists exhibiting in the exhibition 'Abstract and Concrete', arranged by Nicolette Gray and shown at the Lefevre Gallery after its provincial tour. It was here that he first remembered meeting Nicholson, Hepworth and Leslie Martin: 'It was such a contrast with Paris which was so violent, gossipy and full of intrigue and jealousies which I hated, and London to me was like coming to a place of peace from a place of war, although I knew afterwards it was not so peaceful!'[2]

In England Gabo found a spirit of optimism and sympathy for his position as an abstract artist. In 1936 he met and married Miriam Israels in London (with Ben Nicholson and Barbara Hepworth as witnesses at their wedding). On the outbreak of war and with the dispersion of friends and associates from London, the Gabos made plans to go to America, but not being able immediately to find a place on a boat, they agreed to join Hepworth and

Nicholson in St Ives, where they stayed for the first weeks with the Stokes. With their daughter Nina-Serafina (born in 1941), the Gabos lived simply in Carbis Bay, in a small bungalow called Fairystones near Little Parc Owles. Gabo used the studio behind the Red House, the Lanyon family's St Ives home, during Peter Lanyon's time in the army. It was a craftsman's studio, tools sharpened and laid out in an orderly manner. The equipment he used for his constructions was very basic — the complex shapes of moulded plastic were heated to the temperature for bending in an ordinary domestic oven. His method of work relied not on measurement but on the assembly of freely formed shapes defined first by drawing. Perspex was bent to shape, correctly engineered to give the construction its strength, and joined using chloroform as a solvent. Each joint was precisely made with the quality of good craftsmanship, but it was made by a man of intense romanticism, directed by feeling and instinct rather than calculation.

The constructions Gabo produced in Cornwall were a continuation of the work he had started in London, although on a less ambitious scale. *Spiral Theme* (1941) is a free-standing sculpture in clear plexiglass: its form refers to the spiralling of shells. The action of turning and rotating is described by its evolving shapes and by radiating lines inscribed into the transparent surfaces which move towards the fragile central spiral. *Linear Construction*

33.
Naum Gabo,
Linear Construction, no.1.
Perspex, 21 x 21 x 7cm.

(1942–3), of which several versions were made, is basically an open box of clear plastic, its curved sides marked into regular divisions from each of which a nylon thread is taken to the opposite point, crossing and recrossing. This simple winding of the thread on a transparent frame creates a dynamism of shape, tension and symmetry. Gabo also explored symmetry and movement in a series of paintings made in St Ives. Many were kinetic, intended to be viewed in motion. Here the illusion of deep space is created in a series of overlapping and enveloping circular forms. During the war years Gabo broadcast for the BBC and continued to write articles on constructive art. He also worked with Herbert Read in the Design Research Unit, a group of artists and designers brought together to co-operate with industry. As a member of that team he produced designs for a new body form for the Jowett car, a project that was not realized.

For Gabo art was the most immediate and most effective means of communication between human beings. The artist perceives the world through his senses and by intuition, and acts in a spontaneous, irrational and factual manner. Gabo's emphasis upon the importance of feeling and instinct may appear at odds with the work of one who used the most exact and abstracted forms of geometry; but when he answered the question, 'Where do I get my forms from?', his reply was from the imaginative observation of nature:

> I find them everywhere around me, where and when I want to see them. I see them, if I put my mind to it, in a torn piece of cloud carried away by the wind, I see them in the green thicket of leaves and trees. I can find them in the steamy trail of smoke from a passing train or on the surface of a shabby wall. I can see them often even on the blank paper of my working table. I look and find them in the bends of waves on the sea between the open work of foaming crests. Their apparition may be sudden, it may come and vanish in a second, but when they are over they leave me with the image of eternity's direction. I can tell you more (poetic though it may sound, it is nevertheless plain reality): sometimes a falling star, clearing the dark, traces the breath of night on my window glass, and in that instantaneous flash I might see the very line for which I searched in vain for months and months.[3]

Wartime St Ives became even more isolated from the rest of Britain. News was local, except for the distant confusion of war portrayed by the BBC. Local travel was restricted by petrol rationing; the bicycle took the place of the car, and communities like Newlyn and Mousehole became extra-ordinarily remote. The fishing industry was further reduced; most of the young men were called up and some of the boats went to Dunkirk. If they returned, it was often to more productive ports. The natural caution of the Cornish and their distrust of their neighbours was increased by the attitude 'careless talk costs lives', which sometimes seemed to become an excuse for unwarranted dislike. Bernard Leach was looked upon with considerable suspicion by many of the townspeople because of his known friendship

with Japanese potters. Artists who happened to be sketching out of doors were thought to be surveying coastal defences for the enemy, although cliffs and sea were their only interests.

A Home Guard unit was formed in St Ives in which the artists played a part. Leonard Fuller, a captain in the First World War, was made commanding officer, Borlase Smart became intelligence officer, and Denis Mitchell corporal. One of the men in his squad was private Bernard Leach. In the early days of the war the unit sought to protect land defences with the aid of pitchforks and shotguns, and looked down on the less adventurous role of ARP. Denis Mitchell remembers one manoeuvre in which a machinegun had been issued. Struggling to set up the gun in the constricted space of the blockhouse overlooking Porthmeor beach, he accidentally pressed the trigger, and a burst of shots passed close to the head of Leonard Fuller, supervising the operation. Shearer Armstrong, a painter and founder-member of the St Ives Society of Artists, was put in charge of ARP, with Ben Nicholson and Naum Gabo as part of her unit. St Ives suffered little attention from the enemy during the war, but on two occasions, including an attack on the Leach Pottery, bombs were dropped by German aircraft returning from a mission, and the railway was strafed by machinegun fire.

The resident artist community continued to work in St Ives and show days were held, with scenes of the war replacing many of the more traditional subjects. The few artistic events arranged were, because of their rarity, very well supported. CEMA, the Council for the Encouragement of Music and the Arts, brought occasional touring groups, concerts and poetry readings to St Ives and Penzance, and these were invariably packed out. For the newcomers in Carbis Bay the older community of artists held little interest and there was little contact. The important exception was the artist Bernard Leach who had chosen St Ives as his base, where he struggled to make a living from pottery from 1920 onwards. By personal courage and example and the innovatory qualities of his own work and writings he launched a national movement that raised the products of the potter artisan-craftsman to an accepted art form.

Bernard Leach was born in 1887 in Hong Kong, where his father was a judge. His mother died at his birth and he spent his first four years with his grandparents in Japan. When his father remarried he returned to China until the age of ten. He was educated in England and trained as an art student at the Slade. In contrast to Nicholson who was there a few years later, Leach found the discipline wholly to his taste and spoke with affection of 'Beloved Tonks', the Slade professor. He later studied etching at the London School of Art under Frank Brangwyn and began to establish a reputation as an etcher and engraver; but fascinated by his memories of Eastern culture and philosophy, and by the writings of Lafcadio Hern, he returned to Tokyo at the age of twenty-one to teach etching and study Oriental art. He was greatly affected by the living tradition of pottery in the country areas of Japan, and by the fine Chinese and Japanese pottery in the museums. In 1911 he began

to make pottery, studying under the great master Ogata Kenzan. His residence in Japan, which with visits to China and Korea lasted eleven years, gave him a profound understanding of Oriental forms of expression in pottery, while allowing his own vision of Western art to blossom.

In 1909 Leach married a cousin, Edith Hoyle. Their sons David and Michael were born in 1911 and 1913, and their daughter Eleanor in 1915. He wished to return to England in order to educate his children and in 1920 Leach returned to England. With his friend and colleague Shoji Hamada, he came to St Ives to establish a pottery, at the invitation of and with financial backing from Mrs Horne, who was then developing the St Ives Handicraft Guild. The decision to come to Cornwall brought many difficulties. With the exception of Lake's Pottery in Truro there was no local tradition of pottery; there was a lack of local clay for stoneware and little wood to fire the kiln.

The pottery built by Leach and Hamada owed much to Japanese models in its construction and working methods. It was the first Oriental climbing kiln in Europe. Heat travelled up a series of steps, producing different heats and permitted different ceramic effects at each level. Every piece bore the mark of its passage through the potter's hands. Glazes were made from simple, traditional recipes. From the first the pottery produced articles that were functional as well as of formal beauty, rediscovering materials and forms traditional in English pottery, and bringing them up to Oriental standards of excellence. In the early days sales of handmade pots were poor, with the exception of *raku* pots which had popular appeal. In 1923 Leach was in serious financial trouble; catastrophe was avoided only by the sale of work in Japan, which continued to bring high prices.

As the work of the pottery slowly developed and became known in England and abroad, Leach took on many students who contributed to its work. One of the first and best was a young student of classics from Oxford, Michael Cardew, who came to St Ives in 1923 as Shoji Hamada left. Another Japanese potter, Matsubayashi, arrived and Cardew helped him to rebuild the kiln, burnt out while Leach was preparing for a successful Bond Street exhibition. Other students who worked at the pottery in the 1920s included Katharine Pleydell-Bouverie and her friend Norah Braden.

In 1928 Leach began to define his own aesthetic in the pamphlet *A Potter's Outlook*. Meanwhile he was endeavouring to find a wider audience and more stable sales. He was considerably helped when his son David became first an apprentice at the pottery and then an assistant. This gave Bernard Leach more time to write and experiment in pottery design, and in 1933 at the invitation of Leonard and Dorothy Elmhirst, he set up a teaching pottery at Dartington Hall in Devon to develop rural crafts within the community. The following year the Elmhirsts financed a trip to Japan, and for a year Leach travelled, lectured and worked in several potteries including those of Hamada and Tomimoto. On his return to Dartington with his second wife, Laurie Cooks, he did the preparatory work for his most important publication, *A Potter's Book*. David Leach had managed the St Ives pottery

during his father's absence, developing a range of standard stoneware that began to find a regular market. He also introduced a number of important technical innovations including oil firing, and helped to train a team of apprentices. In 1941 when David Leach was called to war service, Bernard and Laurie returned to St Ives to run the pottery. *A Potter's Book* had been published in the previous year.

34.
Bernard Leach, 1946.

There was much of the teacher, preacher and prophet in Leach; he was highly articulate, emotional and persuasive. In many ways innocent and unwordly, particularly in financial matters, he was deeply convinced of the strength of his own feelings and an inspiration to others. He described his approach to pottery as 'artist turned craftsman'. He came to pottery with the attitude of an artist, trained in the Western skills of drawing, yet infatuated with the message of the Orient and schooled in that tradition. He saw with a missionary zeal the need to bridge East and West. His own work has an Oriental purity of form and beauty of decoration, particularly in stoneware and porcelain. To this he added a strongly-rooted English tradition of earthenware pottery with trailed slip decoration. He used his skills as a draughtsman in brushed decoration of great simplicity and economy, and as a master craftsman he demonstrated a balanced understanding of shape and form in relation to clay, glaze and heat. It was only with the greatest difficulty that the Leach Pottery continued during the war. Materials were in short supply and labour was not available except for a few students too young for call-up. In January 1941 an enemy landmine devastated the house and the pottery and the family moved to Carbis Bay until repairs could be effected. Later a more stable policy emerged when contracts for utility tableware brought regular sales.

The early years of the war saw the decline of Alfred Wallis, who was eighty-four in 1939. As he grew older, his stubborn character became isolated; he turned away from people, imagining grievances and suspecting the motives of others. He began to hear voices, believing that he was receiving direct 'wireless' transmission from devils trying to draw him away from his belief in the Bible. Neighbours who offered him food were roughly turned away, suspected of wishing to poison him, and he became a butt for children, convinced that they were sent from Penzance to pester and throw stones at him. Yet he continued to paint. His work had found its way into many important private collections, mostly on the recommendation of Ben Nicholson, and had been shown with the Seven and Five group and at the Museum of Modern Art in New York.

By 1941 Wallis was failing and having contracted bronchitis became unable to look after himself. He was taken to the workhouse in Madron, near Penzance, where he became something of a celebrity. He was treated with kindness by the authorities and respect by the other inmates. His claim to be an artist was supported by occasional visits from distinguished well-wishers. During the fourteen months he was at Madron he did a good deal of painting and crayon drawings in four sketchbooks given to him by

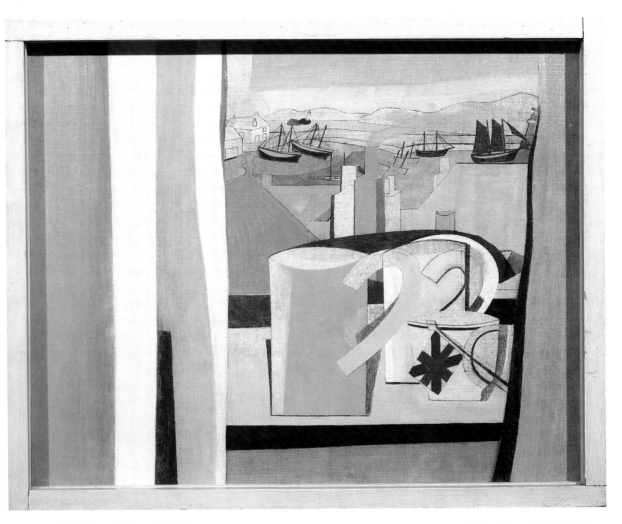

35. Ben Nicholson, *St Ives*, 1943–5. Oil on board, 40.5 x 50cm.

Nicholson. He created a series of pictures that may be seen as an allegory of
his impending death, painted mostly in black and white on chocolate-
coloured paper. They take the form of a voyage to Labrador, remembered
from his youth. An iron boat with its crew sails through stormy waters,
meeting great peril from the sea and mountainous icebergs. The boat
becomes an ark, its cargo dead seamen in their coffins. Wallis died on 29
August 1942 and was given a Salvation Army funeral arranged by Adrian
Stokes. A wreath from Naum Gabo read: 'In Homage to the artist on whom
nature has bestowed the rarest of gifts, not to know he is one.' His grave is in
Barnoon cemetery overlooking Porthmeor beach, a raised slab decorated
with tiles by Bernard Leach depicting a lighthouse in a heavy sea to which a

little man climbs up with the aid of a stick. It is inscribed with the words: 'Alfred Wallis, Artist and Mariner'.

Something of Wallis' innocent vision is recalled in the paintings done by Ben Nicholson at this time. After their stay at Little Parc Owles the Nicholsons had found a small house 'Dunluce' nearby. But for Ben Nicholson the early war years were neither highly productive nor obviously adventurous. However, his work started to develop in new and unexpected directions and he showed remarkable tenacity of purpose. The poetry of the Cornish landscape became an essential ingredient in his painting: its light and colour, the variations of coast and sea, tin mine, tor, cottage and harbour — all enriched the sparseness of abstraction. Drawing had not played a central part during the years of abstraction, but now expeditions to Halsetown, Lelant, Carbis Bay and as far afield as Mousehole reawakened the experience of the visible world last seen in drawings and paintings of Cumberland ten years before. His record of the toy-like town, set in a valley landscape, with ships on an ultramarine sea speaks of his first encounter with Wallis.

36. Ben Nicholson, *Zennor*, 1941.

37.
Ben Nicholson, *Still Life*, 1945. Oil on canvas, 84 x 66cm.

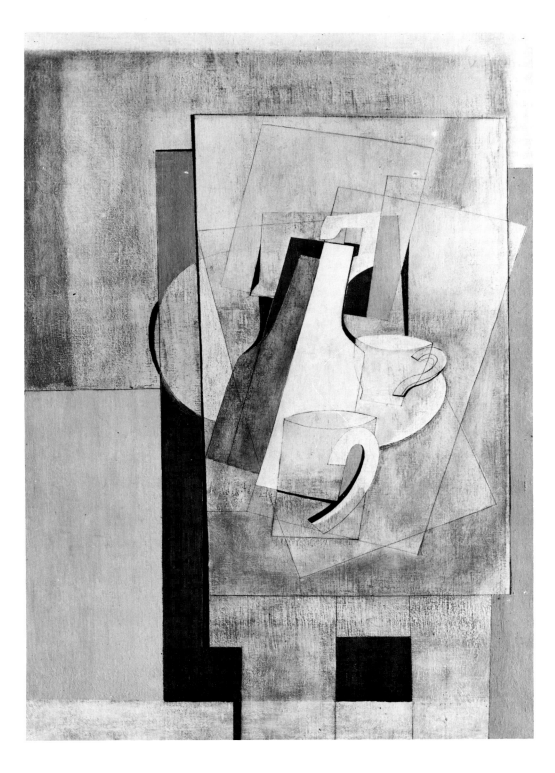

Explorations of the countryside around St Ives were ever rewarding: a few miles by bicycle from Carbis Bay to Zennor Head or the Hayle Estuary, or to Trencrom Hill, a favourite walk and the site for many drawings. From this ancient hill fort the whole crescent of St Ives Bay may be seen, and across the peninsula, St Michael's Mount, Mount's Bay and the Lizard.

In the work of these years there is a clear sense of Nicholson remaking his visual world. The ruler-straight line of church tower and telegraph pole cuts the soft curve of winding road or hilltop. Perspective is sacrificed to planal geometry; distance is reduced to a tightly-compressed space for the imagination to explore. Taut divisions of space flatten boats, hills and houses — a landscape as if seen for the first time. The highly simplified pattern of roofs sets a limited pictorial space for the many descriptions of the busy harbour. He frequently referred to the immediate surroundings of the studio — the jugs, bottles and still-life objects near to hand, including some collected by his father. Many of the most successful drawings and paintings combine the landscape around St Ives with a foreground of studio bric-à-brac. These are experimental first directions with a clumsiness both in landscape and table-top objects, in which Nicholson discovered new tensions by focussing the distant scene through these familiar forms.

Realism or abstraction, each approach satisfied aspects of Nicholson's quizzical personality: the search for order, refinement of form and precision, or the puzzling relationships of the seen world. He kept the two attitudes separate at this time, unresolved and incomplete. Painted reliefs were reduced versions of the majestic work of the 1930s and retain their classic formality. Quiet, elegant, often small in scale, they are purist exercises in cool or warm greys, rectangles of ochre, deep blues or earth green, with one, or at most two inscribed circles and often a small square of red — the 'eye' of the painting. Nicholson frequently made editions of paintings. In a series of unique works he could refine and clarify a formal arrangement, and they also served the practical purpose of producing a number of versions of the same work, some very small, that could be sold easily, for the war years saw considerable financial hardship.

Although wholly removed from the group activity of the pre-war years, Nicholson was anxious to clarify and define the position of an abstract artist who could contribute to the country's culture. He put his thoughts into an important statement ('Notes on Abstract Art', *Horizon*, 1941) in which he proposed that abstract art should be seen as one of our war aims:

> I think that so far from being a limited expression, understood by a few, abstract art is a powerful, unlimited and universal language. Within the means of abstract expression there are immense possibilities and it is a language with a power peculiar to itself. But the kind of painting which I find exciting is not necessarily representational, but it is both musical and architectural, where the architectural construction is used to express a 'musical' relationship between form, tone and colour and whether this visual, 'musical', relationship is slightly more or slightly less abstract is for me beside the point.[4]

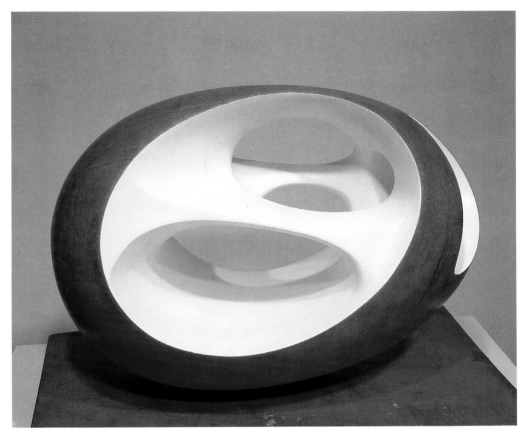

38. Barbara Hepworth, *Oval Sculpture (no. 1)*, 1943. Plane wood.

For the first three years of the war Barbara Hepworth was unable to continue her carving. She ran a small nursery school and worked in her garden to produce a little extra food for the children, 'salads in the hedgerows, and mushrooms in the fields, while the children's appetites grew bigger and bigger'.[5] In the late evenings she made a large number of drawings in gouache and pencil — all of them abstract, faceted blocks, crystals with edges linked by converging lines. She explored the same forms in plaster maquettes, such as the small *Sculpture with Colour* in which strings set across the edges of the deeply hollowed form define the tensions within, setting up new relationships of solid, void and colour, for colour now played an important part.

She did not find the experience of cooking and looking after the children a deprivation. She was nourished by this rich life, provided that each day she did some work, even a single half hour, 'so that the images grow in one's mind'.[6] She read extensively, preoccupied with the position of the artist in society, to find expression for her 'will of life' against the background of war.

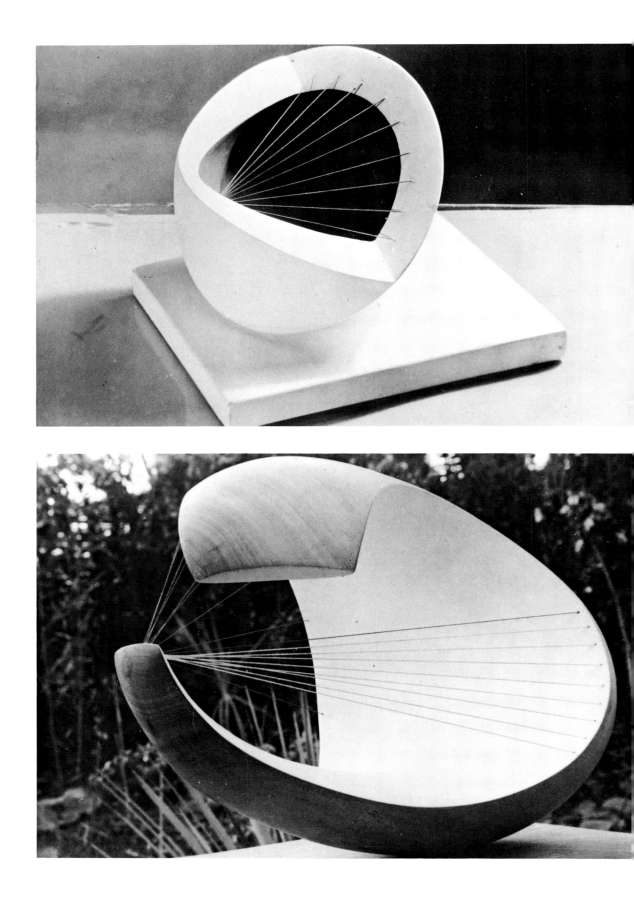

39.
Barbara Hepworth,
*Sculpture with Colour,
Deep Blue and Red,* 1940.

She was also engaged upon a journey of the imagination based on her new experience of Cornwall. The forms of rock and headland seen from her garden held for her the human likeness of hand, arm or face, and the pale sand conjured the fantasy of the rich mineral deposits of quartz, topaz and amethyst in the deep mine shafts. Of the years 1940–3 she was to write:

> It was during this time that I discovered the remarkable pagan landscape which lies between St Ives, Penzance and Land's End; a landscape which still has a very deep effect on me, developing all my ideas about the relationship of the human figure in landscape-sculpture and landscape, and the essential quality of light in relation to sculpture, which induced a new way of piercing the forms to contain colour.[7]

In September 1942 the Nicholsons moved to a large, shabby house, Chyan-Keris, in Headlands Road, Carbis Bay, high on the cliff overlooking the grand sweep of St Ives Bay from The Island to Godrevy Lighthouse. It gave Ben a reasonable studio and Barbara one near the kitchen, filled with light. There was a small yard with a roofed area which could be used for sculpture all the year round. The triplets were now ten and increasingly independent. Their education was provided for by the generosity of Leonard and Dorothy Elmhirst, who offered scholarships to Dartington School. Carving again became a possibility. In April 1943 Barbara Hepworth had her first retrospective exhibition, at Temple Newsam House, Leeds. The work she

40.
Barbara Hepworth,
Wave, 1943–4.
Plane wood with colour and strings, interior pale blue. Length 47 cm.

showed was noticeably more open, organic and fluid than that of the pre-war period; the materials solid, carved plaster and wood, the most characteristic shape being the oval pebble, deeply carved and hollowed into a void crossed by regular stringing.

For Nicholson, Hepworth and Gabo this period in war-time St Ives was one of reflection and consolidation. With the support of their neighbours Adrian Stokes and Bernard Leach they were conscious of an imperative need to keep alive their faith in their work, as a flame to be safeguarded until it could again blaze in bright illumination. They lived apart from the art community of St Ives, in correspondence with friends in London and New York, and occasionally visited by some who sought a brief period of rest in St Ives. In this comparative isolation, their work found a new spirit of optimism, a belief in the future in which the artist would have a socially understood message. The principles upon which this was based remained those of abstraction found in the distant pre-war world, humanized and tempered by the clear light and landscape of Cornwall.

4 Artists gather in St Ives

The first summer after the war was one of brilliant sunshine. There were crowds in St Ives celebrating the return of peace and festivities in the evenings. Rations were still short but people had money to spend and time to relax. The ban on outdoor sketching had been lifted and artists were again to be seen painting on the foreshore. Ex-servicemen began to re-explore their peace-time directions, and there was an upsurge of interest in the arts: painting and sculpture again began to represent values for which the struggle of war had been a search.

Many of the artists who had been to west Cornwall before began to return; others came for the first time, attracted by its reputation as an artists' colony, or more practically by the knowledge that cottages and studios were available for a few shillings a week. The age-old associations of Cornwall, the grandeur of its coast and high places offered privacy to recover broken directions and represented a return to stability, secure and untroubled after the confusion of war. St Ives had an air of permanent holiday: it was changing rapidly from a fishing port to a tourist town. It had more than a trace of bohemianism, a riotous and exhibitionist character which offered a Mediterranean gaiety to those still denied travel abroad.

One who was now able to pursue his ambition to paint was John Wells. Since his student days and his first meeting with Nicholson and Wood in 1928 he had wanted to become an artist, but for financial reasons he had become a doctor. During the emergency of the war years he had had a medical practice on St Mary's in the Scillies. As the only doctor in an area of more than one hundred square miles of islands and sea, he attended his patients in all weathers, sailing his own boat or by launch. He developed a close relationship with the scattered community and started a small but complete hospital on St Mary's, treating all who came as best he could. At the outbreak of war he became medical officer to the Royal Navy. After the fall of France many refugees came in small boats from Brittany and the Scillies became the first centre for relief to the injured. In 1945 Wells left his practice and returned to Newlyn where he found the Anchor Studio built by Stanhope Forbes in the Meadow, and later an adjacent studio which Forbes had used as his school, to convert to living accommodation.

During the arduous war years Wells had come frequently to Cornwall, from time to time visiting Nicholson and Hepworth, through whom he met Gabo. He felt an instinctive sympathy for the romantic engineering of Gabo's constructions, and in return Naum Gabo formed a high opinion of John Wells' work, describing him as the 'Paul Klee of the Constructivist movement'. Despite such heavy responsibilities in the Scillies, Wells had

41.
John Wells,
Relief Construction, 1941.
Mixed media,
3.5cm deep, 32cm high,
42cm wide.

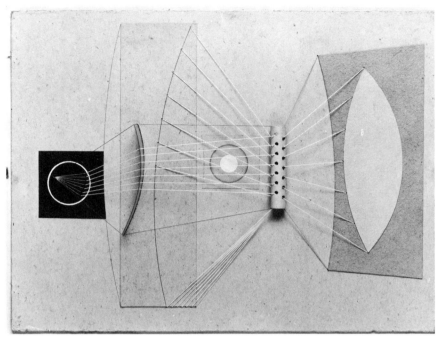

managed to produce a considerable body of work that he drew on in later years.

There is an incisiveness and intensity about John Wells' work that shares naturally the organized geometry of Gabo. He combined his scientific training and background with speculative imagination which embraces the real and the invented, the mystical and the precise. He reaches towards those phenomena for which no visual description exists, the flight of birds, the sensation of sunlight on rock, special feelings of dawn or dusk. The sensations of this private and symbolic landscape are transcribed in the simplest geometric terms, circles, ovals, rectangles, radiating lines, triangles and rubbed, scrubbed and diluted colour. Abstraction and observation aid each other within his richly textured surfaces. Intersecting straight lines of triangles and rhomboids give structure and carry those crescent shapes which hint at the forms of boats, the circle of a sun seen through mist, a feeling for water. John Wells' work was most purely abstract during the immediately post-war years. Soon it began to soften and to refer more specifically to the coves, beaches and headlands of West Penwith, to the birds and insects living on them or flying above them.

Wells was affected little by the radical changes that influenced so many artists in the mid-1950s. His work developed with a gentle loosening of form and a freer interpretation of landscape, but he always retained the possibility of working either from observation or from complete abstraction, a duality

42. John Wells, *Painting (1957)*, 1957. Oil on board, 30 x 28cm.

he shared with Nicholson. For Wells, abstraction has always been related to experience, and has allowed him to paint those feelings and emotions that cannot be seen. There is neither strain nor struggle in his natural, intuitive acceptance of abstraction, but a process of investigation and self-discovery. One of his finest works, *Aspiring Forms* (1950) (Tate Gallery), is based on landscape but has a clear geometry of proportions constructed on sevenths and the use of the golden section. It has a most evident feeling of spirituality.

In 1952 Wells had a one-man exhibition at the Durlacher Gallery, New York, arranged with help from Ben Nicholson. Later in the decade his work was shown in Scandinavia, in touring exhibitions in Canada and in the United States. In 1958 he was awarded the Arts Critics' Prize, British section, by the International Association of Art Critics (judged by J.P. Hodin, Sir Herbert Read and G.S. Whittet) for the painting *Vista* (1955). This is an abstracted landscape in which strongly-shaped hill and field patterns in deep blues and dove greys against lighter greens build towards an horizon. He also had his second show at the Durlacher Gallery. In 1960 his first exhibition with the Waddington Galleries, London, with fifty works, mostly oil paintings, was a considerable success. His next exhibition, in 1964, was

43.
John Wells,
Aspiring Forms, 1950.
Oil on board,
106.75 x 72.25cm.

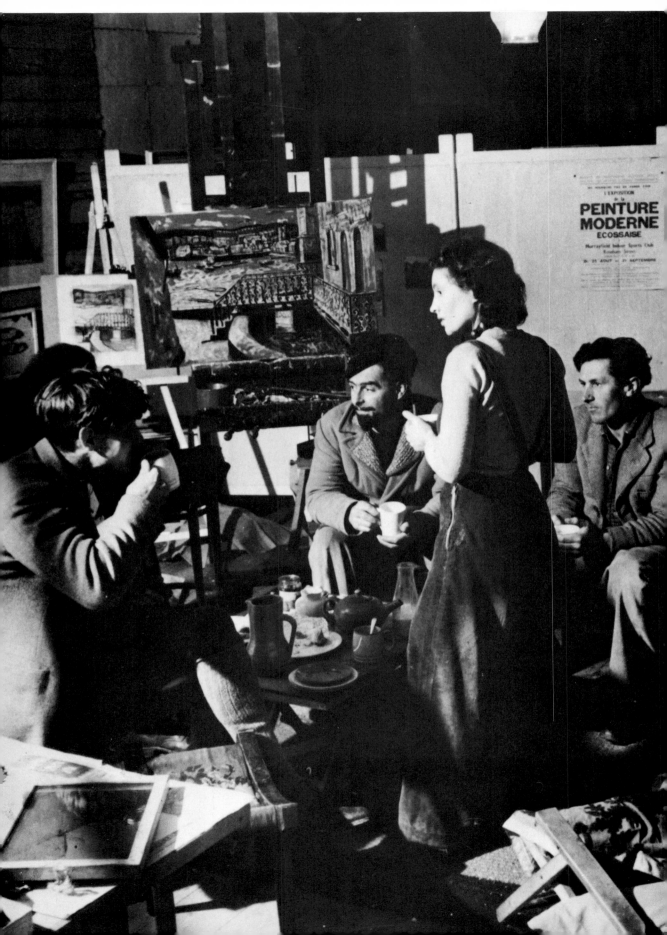

44 and back cover.
L. to r.: (seated)
Peter Lanyon,
Guido Morris, Sven
Berlin, John Wells and
(standing) Wilhemina
Barns-Graham in
St Ives, 1940s.

45.
W. Barns-Graham,
St Ives II, 1949.
Ink on paper,
43.2 x 66cm.

more austere and abstracted, consisting mostly of larger constructions and rectilinear paintings, less easily understood by the critics. Since then John Wells has continued to show in mixed exhibitions in London, but his work has not been prominently displayed on a major scale.

A young painter who entered fully into the post-war artistic activities of St Ives was the Scottish artist Wilhemina Barns-Graham. She had arrived in 1940, and came to know well both the older group of St Ives artists and the 'moderns' in Carbis Bay. Born at St Andrews, Fife, she started her training at Edinburgh College of Art in 1932. By 1936 when she was twenty-four, she had her own studio in Edinburgh, but met family opposition to her idea of becoming a professional artist. A post-graduate travelling scholarship allowed her to leave Scotland, and since this was the first year of the war she was advised by Hubert Wellington, Principal of the Edinburgh College, to visit St Ives which he knew to be the recent retreat of Ben Nicholson and Barbara Hepworth, to whose work he thought she might respond. In addition, her Edinburgh friend Margaret Mellis, recently married to Adrian Stokes, was living in St Ives.

In St Ives Willie Barns-Graham was introduced to Borlase Smart who helped her to find a studio (number 3 Porthmeor) and remained a great friend and supporter. Through Margaret Mellis she found herself part of the little coterie of recent arrivals — Nicholson, Hepworth and Gabo — already

engaged in work. Although wartime restrictions prevented lavish entertainment, there were social meetings, tea parties, croquet and tennis, and a feeling of group activity. Because of her friendship with Borlase Smart she was drawn into the activities of the St Ives Society of Artists, and although its atmosphere was far from progressive, she exhibited her early landscapes and portraits in its wartime exhibitions. She was something of a lone wolf, and although pleased to meet these groups of artists wished essentially to work on her own.

Willie Barns-Graham's studio in St Ives was a few doors away from Alfred Wallis' cottage. She remembers that 'the greys and greens of his paintings spoke to her because she found them true'. Her early landscape paintings are softly coloured, the sea and the freely-placed cottages and boats sharing something of Wallis' colour. She also worked in the abstract, but this was far from popular with the St Ives Society of Artists and she exhibited few of these pictures. In drawings of the cliffs and rocks and of St Ives harbour she defines the elements of landscape with considerable invention. There is a disciplined elegance in these concise drawings and a wiry quality of line which shows a progressive sophistication. Her fresh vision is combined with an alert awareness of formal qualities and an eye to the poetry of her descriptions, as in her dream-like painting of St Ives seen from the water, *Sleeping Town* (1948), which has a spectral quality of shifting, transparent

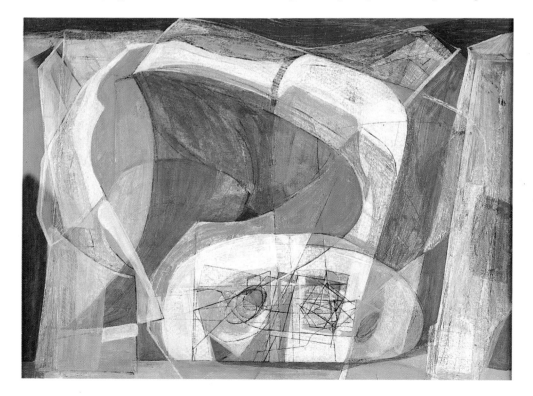

forms. In 1948 she visited Switzerland and produced a large number of drawings of glaciers in the high mountains. In the many drawings and paintings she made after this visit, the pressure and movements of the ice-mass become a series of vertical free-standing forms on the picture surface, a re-creation of nature in motion.

By the mid-1950s, Willie Barns-Graham was showing her work regularly in London, Paris and the United States. She had been on extended visits to Italy, making drawings of the mountains and hills, the inspiration for the more abstracted work she produced on her return. She taught for a year at Leeds School of Art, when Terry Frost was Gregory Fellow. In 1961 she took a studio in London, and was mostly there for a period of two years. She returned to St Ives to the new studio block on the site of the old Barnaloft studios, overlooking Porthmeor beach, and continued to exhibit in London, St Ives and elsewhere. Since 1971 she has divided her time between Scotland and St Ives.

In post-war St Ives Sven Berlin was a larger than life Bohemian. He characterized the rebel, outspoken and outlandish. Strong and bearded, with the frame of a professional athlete, he was to be seen carving huge blocks of stone out of doors in his yard on The Island. He had been born in south London in 1911. His mother was English, his father Swedish, a paper merchant who had come to London to trade but found little financial success. Mounting debts required Sven to leave school early to become apprenticed as a mechanical engineer. But he was drawn to the arts. Naturally athletic and graceful in movement, he trained as an adagio dancer, an acrobatic form of dancing that flourished for a short time in the 1920s and '30s. Dance offered an opportunity to break away from the cities, and with his first wife and partner Helga, Sven Berlin toured as a professional dancer, slowly working his way up the provincial music hall circuit, reaching a peak as a supporting act to the Crazy Gang.

Adagio required fitness and dedication, but as an art form was wholly tied to public entertainment, relying on novelty rather than artistic ability. Sven Berlin called it 'a bastard dance'. After nearly ten years of professional touring, he decided to leave the stage. In 1938 he and Helga returned to Cornwall (a first visit had been made in 1934), to a cottage on the Zennor moors where Sven found occasional work as a farm labourer. But this was poorly paid and there were times when starvation was near; for one period of six days Sven and Helga were totally without food. At about the time their first child, a son, was born they were evicted from their cottage. Yet despite these difficulties he stayed in Cornwall and continued his delayed education, attending art classes at Redruth School of Art. He began to paint landscapes and portraits and to make his first experiments in sculpture. On the outbreak of war, Sven Berlin registered as a conscientious objector and found employment with Adrian Stokes in his market garden at Little Parc Owles. It was here that he first came into contact with Ben Nicholson and Barbara Hepworth. He was impressed by the vision of Gabo, but was never drawn

46.
W. Barns-Graham,
*Glacier Crystal,
Grindelwald,* 1950.
Oil on canvas,
51.5 x 60.25cm.

towards the abstract message of Constructivism. For a time Berlin worked in the Leach Pottery, making himself generally useful in the manufacture of clay driers and other work about the pottery. He became a friend of Bernard Leach, for although so different in age and in background, they shared a love of Eastern art and mysticism. For a time they lived next door to each other after the Leach Pottery was bombed.

Sven Berlin identified strongly with the troubled life of Alfred Wallis. In the last months of Wallis' life in Madron Workhouse, Berlin was living in extreme poverty near Zennor, and although they never met, Berlin had seen the collection of Wallis' work formed by Ben Nicholson and Adrian Stokes, and had talked to local people who had known him. The qualities of truth and innocence in Wallis' work had a strong emotional message for Berlin, which led him to write an article on Wallis, published in *Horizon*.[1] Encouraged by the success of this article, he began to write a book, *Alfred Wallis — Primitive*, which was completed in army barrack huts during the war. This long-researched book was published in 1949 (by Nicholson & Watson). Berlin had changed his attitude to the war in 1943 when he witnessed a German air attack on a Channel convoy. This distressing incident led him to join the army, and as an observer in the Royal Artillery he took part in the Normandy landings. He later recorded his views of the war years in a book entitled *I am Lazarus* (1961), illustrated with his drawings. He was discharged from the army in 1945, suffering from jaundice and nervous shock, and for a time convalesced in a military hospital. By this time his marriage had broken up.

While in hospital he received an invitation from John Wells to visit him on the Scillies for a painting holiday. This he willingly accepted, and on his return to St Ives became a central figure among the group of artists embarking on the new adventure of peace. He rented an unoccupied building on The Island called The Tower, which he turned into a sculptor's workshop, a bench and vice in the only window, pieces of stone stacked around the walls, with a turntable made from an old-fashioned mangle found on a rubbish dump. Larger work was done in the open outside The Tower. He had no electricity or mechanical tools, but without lifting aids could handle weights of up to a ton on his own.

Sven Berlin also produced many paintings, with drawing as a central discipline. For him, the nature of drawing was allied to dance; both were an exploration of the human form in space, sharing rhythm, motion and tension. He was not attracted to abstraction which he saw as an activity of the mind, alien to his search for direct expression of feeling and emotion. He believed that:

> A sculptor explores the heart of the stone to discover the image that lies buried — buried also within himself. An image that is there but not yet created always lives within the potentiality of the stone or wood in the same way as the thunder dreams in the heart of each drop of dew.[2]

Stylization rather than abstraction characterizes most of his work. Thickened limbs, rounded and simplified heads or hands retain their figurative form. The human figure is seen as a hierarchical god, or embraced as lover. Animal and bird sculptures have an arabesque simplification. Just as he discovered his own directions without the shaping of an art school, so his vision was clear and personal. His craftsmanship was in the direct expression of his ideas submitted to the stone. He looked for the realization of a state in which intellect and conscious will are subordinate to the artist's experience of the drama of human life.

In the immediate post-war years his work began to attract attention. With help from Ben Nicholson he had a successful one-man exhibition at the Lefevre Gallery in London in 1946, centred upon the sculpture *Composite Man*. He also won a reputation for his opinions, aided by his writing and radio broadcasts and in a series of 'Important Contemporaries' exhibitions at Tooth's Gallery. In St Ives for a time he worked closely with the other artists in setting up the Crypt Group and the Penwith Society of Artists, but by temperament he had little inclination for group activities and soon excluded himself from them.

47.
Sven Berlin,
Mother and Child, 1950.
Cornish granite

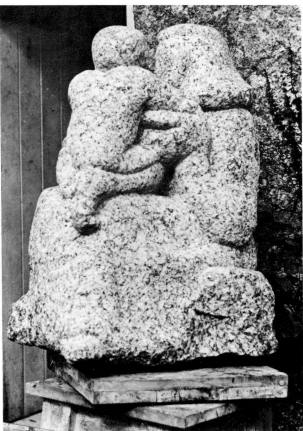

Close to The Tower on The Island in St Ives, in a net loft overlooking Porthgwidden beach, the Latin Press was set up by Guido Morris. His 'iron soul', as Sven Berlin termed his printing press, came down from London by lorry in April 1946 with tons of type and books. A few large tables and an elaborate system of bookshelves and pigeon holes for papers improvised from margarine boxes hoarded from before the war, gave the impression of a printer's workshop. As he awaited the arrival of the handmade papers on which he loved to print, he produced a display notice which read:

> The Latin Press, the Private Press of Guido Morris, Here Fine Printing of every Description, including hand-made notepaper is undertaken to the glory of God and the Arts of Peace.[3]

Guido Morris had set up his first press near Bristol eleven years before, and learnt by experience how to print. Army service interrupted this, and after struggling for a year in London he came by chance to St Ives. Immediately he felt that the town was active artistically and commercially, a place where he could work. Guido Morris was an artist in type, a printer whose work was strictly modern in conception, yet referred back to early Italian examples. He made an uncertain income from the design and printing of trade cards and advertisements for shops and hotels, but was fascinated by typography as an art form. His greatest pleasure was in the perfection of hand-set, hand-printed invitations, catalogues and posters for St Ives' many art exhibitions. His printing became better known when he worked for important galleries in London, in which he also exhibited: fine sheets of printing set in the Bembo type which he used exclusively, printed on handmade paper. One of his first commissions was for the twenty-sixth anniversary exhibition of the Leach Pottery, at the Berkley Galleries in London, to be followed by a Chinese dinner, which he printed as a tall oblong, the words in small capitals running down the sheet — intentionally Oriental in appearance. Forty-five copies were printed, each on a different paper which used most of his collection of Japanese papers.

One of the few St Ives artists to have been born there was Peter Lanyon who identified closely with the area of West Penwith where he grew up. The landscape, the exposed coast, the weather and high places, and the areas 'where solids and fluids met', were of central and lasting importance throughout his life. He felt the rocks to be his own bones. All the time he was away from St Ives during the war he was helped by this feeling:

> I couldn't see my country as if from outside. I had seen it from other places that I had been to during the war from outside, but always when one is looking for something, from a dugout, you got shot at or you got bombed or something. But I had an intensity from the war from street fighting and being under fire, which made me find a strength in myself. The strength was I think, the granite strength of my own country.[4]

Peter Lanyon was born in St Ives on 8 February 1918. The family background was cultivated and prosperous; his father, W.H. Lanyon, was a concert pianist and composer and a distinguished photographer. There were two children, Peter and Mary. St Ives was full of painters, and from time to time Peter visited studios with his father; on Sunday evenings open house was held in the Lanyons' large home overlooking the town. Friends gathered for music and to discuss painting and poetry. Peter Lanyon was educated in St Ives and Penzance, and at thirteen was sent to Clifton College in Bristol where there was a broadness in the education and interest in the arts. On leaving school he took lessons in drawing from Borlase Smart and went with him on expeditions to draw the rocks and cliffs. Lanyon remembered Smart's enthusiasm and directness with great affection, and later said that without this example he would not have become a painter.

After a visit to South Africa, where the family had connections, and a youthful exhibition of his work in Johannesburg, Lanyon returned to St Ives intent on following an art training, but uncertain of his directions. He had met Adrian Stokes in 1937 and had shown him some drawings. Stokes was impressed with their elegance combined with intensity of feeling. On his advice Lanyon enrolled at the newly-formed Euston Road School in London, where Stokes was also studying. Lanyon attended the school for four months in 1938, working from the model. The structure of Coldstream's precisely observed painting and the enthusiasm of Victor Pasmore had a lasting effect upon Lanyon. He spent the next summer in France, in Aix-en-Provence, the home of Cézanne, whose influence seemed to offer a means of welding together observation, which he had been taught at the Euston Road School, and his more poetic feelings for landscape. But on his return to St Ives he became increasingly dissatisfied with his efforts to apply this form of realism to his own deeply felt experience of the Cornish coast.

He attempted a radical revision of his painting, in an early, if unformed attempt at abstraction, reducing the elements of landscape to the fewest possible elements, a line on a white board, a few simple geometric divisions. 'I was left with nothing but the white board. The outside world now appeared no use at all,'[5] he recalled. He had also become increasingly politically aware, strongly affected by the views of the Left, and for a time seriously considered joining the revolutionary army in the Spanish Civil War. He read deeply and attended public meetings in Penzance, but his health failed and he had a nervous breakdown. He later described this crisis in his life as an escape, 'I was always good at finding escapes', he remarked.[6]

Lanyon was helped again in this difficult period by Adrian Stokes, whose book *Colour and Form* was of central importance to him. He referred to it as his 'Bible'. It was Stokes who introduced Lanyon to Ben Nicholson, newly arrived in St Ives. The sight of a white relief in Nicholson's studio was a powerful confirmation of Lanyon's own early efforts in abstraction. Stokes suggested that Nicholson should take Lanyon as a pupil and they met twice a week in Lanyon's studio. Nicholson's introduction to a simplified form of

drawing based on plastic values was reinforced by Gabo whom Lanyon met a few weeks later. Lanyon was greatly influenced by the poetry of Gabo's constructions. Lanyon's early drawings show a familiarity with the abstract world, and most important to his development were the five constructions he made at this time which are simplified diagrams of movement through landscape. (Three of them are shown in a photograph of his studio taken in 1939.)[7]

This early period of experiment, which took Lanyon to the limits of abstraction and gave his naturally reflective nature the opportunity to centre his paintings upon his own feelings and responses, was cut short by the war. He was called up in 1940 and served in the Royal Air Force in the Western Desert, in Palestine and in Italy until his demobilization in December 1945. His intention, on joining the RAF, had been to fly, but migraine made him unfit for this and he became an aero-engine fitter and equipment specialist. Apart from some drawings and paintings of buildings in Italy and North Africa he was unable to continue with his art. He had a hard war and saw action on a number of occasions, but his experience of working in difficult and often hostile surroundings toughened his character and reinforced his decision to continue painting as a career. On demobilization Peter Lanyon returned to St Ives, to the attic studio in his father's house that Gabo had used throughout the war. In 1945 he was able to move with his growing family to Little Parc Owles in Carbis Bay, which Adrian Stokes had earlier vacated. In April 1946 he married Sheila St John Browne. Six children were to be born to them between 1947 and 1954.

The experience of war had changed Lanyon's attitude to painting. In the struggle to find a new form for his work his concern now was for the physical reality of landscape realized in time and space, and for human beings in an ever changing world. He was deeply dedicated to his subjects in Cornwall, but in order to capture their mood he looked for new pictorial forms which fitted his own physical and emotional experiences. In a significant group of work called *Generator* (1946–7) there is a conscious effort to explore the themes of birth and procreation. The most important painting of this group is *Yellow Runner* (1946) in which the hill at Gunwalloe on the Lizard peninsula is seen against a clouded sky and sea-washed coast. On a distant hillside a yellow horse is inscribed in the manner of prehistoric figures, in the foreground another horse is enclosed by the womb-like hollow of the hill. The work is charged with a multitude of symbolic references to fertility and the power of creation, but painted in soft and muted colours, scraped and re-painted. He is closest here to Nicholson and to the humanistic abstractions of Hepworth, but soon his work took a radical change as he found a more personal direction.

The reality of landscape and the moods of the weather were also of central importance to Bryan Wynter, who had come to Cornwall at the first possible moment after the war, immediately the restraint of imposed labour was lifted. He knew Cornwall from childhood holidays and returned to re-

48
Peter Lanyon
The Yellow Runner
1946. 44.5 x 58.5cm

49.
Bryan Wynter,
Carn Cottage,
1946. Gouache.

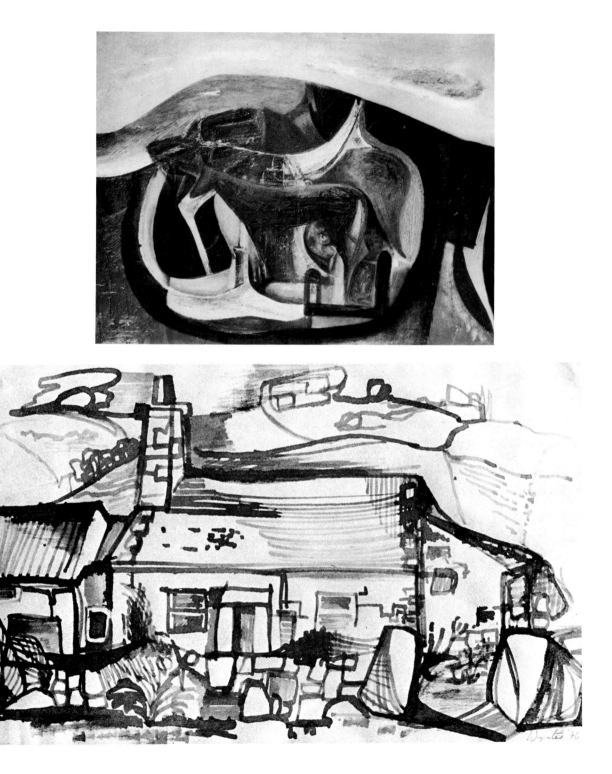

explore his memories. After camping with a friend he found a cottage in Zennor and six months later took Carn Cottage, 700 feet above sea level, looking due east to the steep drop to the sea. It was as remote and exposed as any part of the Cornish moorland and nearly derelict, without water or electricity and accessible only by footpath from the road a mile away.

Bryan Wynter was born in London in 1915, his father was in the laundry business and it was intended that Bryan should join the family enterprise. He was educated at Haileybury and after working for his father went to Zurich to train in laundry management and practice. However, he had developed his own interests in drawing, particularly animals, and already knew that he was not intended for commerce. His family eventually gave way to pressure and in 1938 he was allowed to go to the Slade where he stayed for two years; but he found little in the teaching that directly stimulated his own enthusiasms. By the time the war came, Wynter had became attracted by pacifist attitudes, particularly those of Huxley's *Ends and Means*.[8] He also sought ways of becoming more independent of society and became a conscientious objector on humanitarian grounds. Throughout the war he worked on schemes of land drainage near Oxford, and for a short time in laboratories using monkeys, under the direction of Solly Zuckerman. Wynter drew throughout the war years, a double investigation of the observed forms of landscape and the more obscure regions of his own mind. The internal struggle was often dominant in drawings of surrealist fragmented figures charged with emotive sexuality, and birds with sharpened claws and overlong beaks.

Bryan Wynter took directly, continuously and vividly from the forms of nature. The cottage and its position had a pronounced effect upon his work, and the area became a deeply-felt source. By choosing to live in a remote, exposed place he submerged himself in an environment in immediate contact with weather and sea. He restored and extended his cottage, devised ingenious ways of collecting rainwater and made a road useable by a Land Rover for most of the year. In 1962 he wrote:

> The landscape I live among is bare of houses, trees, people; is dominated by winds, by swift changes of weather, by the moods of the sea; sometimes it is devastated and blackened by fire. These emotional forces enter the paintings and lend their qualities without becoming motifs.[9]

The paintings of the first ten years of Wynter's time in Cornwall are mostly small gouaches. His subjects were the more remote farms or coastal villages nearby, to which he brought a sense of place heightened by the drama of unexpected events, a surreal and barren landscape invested with a special power by the bird and animal life that peopled it. *Birds Disturbing a Town at Night* and *Foreshore with Gulls* have a dark melodrama. The birds are predatory, animated yet abstracted as they terrify the settled cottages they attack. *Raven* of 1946 is a celebration of the bird that lived in the chimney of Wynter's own cottage. The late 1940s saw a new elegance of drawing with a

vivid patterning of the surface, fragments of buildings dissected and re-assembled with authority and conviction. They held an inventive association of ideas as English as the landscape he depicted, yet there was about his work the crisp assertiveness of his French counterparts, Picasso and Braque. In the words of his close friend Patrick Heron, 'The Wynter of this period fused an intense feeling for landscape, with a cubist vocabulary that was totally literate by Paris standards.'[10]

The struggle for a new beginning in Cornwall after the war was also experienced by Terry Frost. Born in 1915 in Leamington, he left school at fourteen and had a number of factory jobs before becoming a salesman for a wholesale electrical components firm in Birmingham. At eighteen he joined a cavalry regiment in the Territorial Army and on the outbreak of war was immediately accepted into the army. He served in France and Palestine in the Army Reserve, and in 1941 transferred to the Commandos, serving in the Sudan, Abyssinia and Egypt. He was captured that year and spent the rest of the war in prisoner-of-war camps. It was in a Bavarian camp (Stalag 383 in Hohenfals) that he was first introduced to painting, in the restricted conditions of a small art school run by five prisoners, one of whom was Adrian Heath, a former Slade student. Amid the drab routine of camp life and with a minimum of materials, Frost developed a reflective, inward-looking attitude in an otherwise outgoing personality. The little school was important to him; he began to paint portraits (exhibited in the *Daily Telegraph* exhibition of 'Arts and Crafts by POWs') and when his camp was liberated made drawings of the arrival of American soldiers. In the last months of the war he decided to become a painter.

In August 1945 Frost married Kathleen Clarke. An application to Camberwell School of Art had been turned down and he returned to his pre-war job in Birmingham, but he continued to paint and draw, attending evening classes at Birmingham School of Art. He came to Cornwall in May 1946 on the advice of Adrian Heath who was now painting in London and had earlier been a student of Stanhope Forbes in Newlyn. For Frost, Cornwall was an escape from the Midlands, a cheap place to live, and a chance to find new directions. It was not the abstract artists who attracted him to St Ives — in 1945 Nicholson and Hepworth were unknown to him — but rather the older painters, Leonard Fuller, John Park, Borlase Smart and others. He went first to a small, private art school newly started in the School House in Mousehole by George Lambourne and Edwin John, son of Augustus. He soon met such artists as Harry Rowntree, 'a snappy bloke' who designed posters for Cherry Blossom boot polish and was opposed to his interest in abstraction, and Leonard Richmond who painted many posters for Southern Railways and wrote several books on painters.

It was the example and craftsmanship of these older artists that was important to Frost as he tried to come to terms with painting and to make a living from it. His first professional exhibition, 'Paintings with knife and brush', was held at G.R. Downing's bookshop in St Ives, and with prices of

between £8 and £10 he sold £80 worth of paintings — a successful start to a professional career. The income supplemented their small savings and money that he and Kathleen earned as domestic workers at a local guesthouse. Their first child, Adrian, was born in July 1947, and by this time they had moved to a rented house in Back Road West, St Ives. Five other children, four boys and a girl, were to be born to them.

In 1947, still anxious to receive instruction and training, Terry Frost was accepted at Camberwell School of Art. William Johnston, its vigorous and independent Principal had brought together a remarkable staff of some of the most talented younger artists and designers in London, and the painting school had become a new home for that group that had created the Euston Road School before the war: Victor Pasmore, Claude Rogers, Lawrence Gowing, and, as acknowledged leader, William Coldstream. A rapid expansion of the school took place as returning ex-servicemen and younger students flocked to it, crowding into the studios, practically out of the door, painting at long distances from the model. Frost accepted the discipline of measured drawing from the model, but was questioning of his teachers. His later rejection of that earlier experience is implied in his phrase, 'falling asleep on the end of the pencil'. The one teacher to whose work he was attracted was Victor Pasmore, whose art was on the point of change from lyrical atmospheric painting to structural abstraction, a change that was eagerly watched by the art world. Pasmore advised Frost against the influence of art schools:

> He said instead that I should continue as I had been, working on my own and just going round the Galleries. He was right of course. The Art Schools at that time were all caught up in bloody miserable realism. Unimaginative Euston Road stuff. Plumb line 'dot and carry one' life drawings. Trying to relate one shape to another, intellectual, and morally right of course, but nothing to do with art — it nearly killed me.[11]

With his protracted training at an end, Frost returned to St Ives and took number 4 Porthmeor studios, next to Ben Nicholson's. This brought him into regular contact with the older painter who reinforced his convictions about modern painting and helped him greatly with advice and comment on his work. For his part Nicholson was much impressed by this enthusiastic young man, whose energy and absolute dedication were beginning to attract attention.

As younger artists came to St Ives, so some left. In 1946 Naum Gabo left for the United States, his long friendship with Nicholson and Hepworth marred by a disagreement over the timing of an exhibition of his work planned in London. It was in America, where he lived until his death in 1977, that he was to find the opportunities to create a public art to which he had for so long aspired. But his presence in St Ives during the war was of the greatest importance; his close association with Nicholson and Hepworth had

supported them at a time of public rejection. For young artists he was a particular encouragement. Peter Lanyon retained the greatest gratitude for his early advice and example; John Wells found a spiritual quality in Gabo that convinced him in his own leanings towards abstraction.

Adrian Stokes also left Cornwall at about this time, with the breakup of his marriage in 1947. He returned to London for a brief session of further psychoanalysis, and then went to Ticino, Switzerland, to marry Ann Mellis, his first wife's sister. Writing again engaged his attention and he produced important works on Cézanne (1947), Michelangelo (1955) and Raphael (1956), as well as extending his work on the relationship of artistic activity to science and psychology. Towards the end of his life (in 1972) he became a prolific poet.

50.
Terry Frost, *St Ives, Back Road West*, 1949. Pencil on paper, 44.5 x 31.75cm.

5 The Crypt Group and the Penwith Society; the Festival of Britain in London and St Ives

In the 1940s the chief exhibiting society in St Ives remained the St Ives Society of Artists. Borlase Smart had become its secretary in 1930 and with Leonard Fuller as chairman the society prospered. There was concern among the older members when Borlase Smart, himself a traditionalist, was drawn towards the work of the 'moderns'. Willie Barns-Graham helped Smart to draw Ben Nicholson and Barbara Hepworth into the society. She arranged a meeting between Smart, Nicholson and Hepworth after which Borlase Smart bubbled with excitement, saying, 'Magnificent, they are going to join the Society'. Nicholson and Hepworth exhibited in its galleries in the Porthmeor studios during the war years, as did Peter Lanyon and Sven Berlin. It was Borlase Smart who obtained a promise from the Methodist Church authorities that when their Mariners' Chapel was no longer required for church purposes it would be offered to the society. In the summer of 1945 the society had its first exhibition in the newly-decorated chapel, a high, light space which allowed more work to be shown than in the Porthmeor Gallery, and gained greater attendance and higher sales. He later negotiated the purchase of the chapel for the society for the sum of £2,500, lent by two members.

In the immediate post-war years, St Ives Society of Artists' exhibitions were mounted in a number of municipal galleries in the British Isles, including Gateshead, Sunderland, Middlesbrough, Carlisle, Darlington, Newquay and the National Museum of Wales, Cardiff and toured to Maskew Millar Art Gallery in Cape Town, South Africa. The presence of work by the 'modern group' as they became known was a constant irritant to those conservative members of the society who inclined to the views of Alfred Munnings, President of the Royal Academy, who became President of the St Ives Society in 1948. His outspoken criticisms of 'modernism' in all forms were frequently heard. In 1949, he chose the occasion of the Royal Academy's annual dinner to launch an intemperate attack on modernity in art. In the presence of Sir Winston Churchill, newly elected extraordinary member of the Academy, and well aware that his words would be spread by the BBC and the world's press, he fervently rejected the art of the present day:

> I find myself the president of a body of men who are what I call shilly-shallying. They feel that there is something in this so-called modern art. You will say, I am getting right away into the subject. Well, I myself would rather

have a damned bad failure, a bad muddy old picture where somebody has tried to do something, to set down what they have seen, than all this affected juggling, this following of what shall we call it — of the School of Paris.[1]

His criticisms also included art education and critics, 'the highbrows here tonight, experts who think they know more about Art than the men who paint the pictures'.[2] He made swipes at Picasso and Matisse, and then focussed on Henry Moore's *Madonna and Child* which he had hunted out in its Northampton Church and found 'disgusting'. In this catalogue of rejections he opened the widest breach for many years between those responsive to the art of the day and the established art societies, of which the Royal Academy was the summit.

In the St Ives Society of Artists' exhibitions there were increasing disagreements about the selection of work. That of the more 'advanced' artists was usually placed somewhat apart in a poorly lit corner of the gallery near the font. The 'advanced' group included Nicholson, Hepworth, Berlin, Barns-Graham, Gabo, Wells, Lanyon and Denis Mitchell, who became known as the 'exhibitors around the font'. The younger artists felt strongly that they were not receiving a fair deal. The disputes and bitterness over the inclusion of abstract work were partially resolved when a number of members impelled by Peter Lanyon attempted to clarify their own position and to revitalize the society by showing their work in a separate exhibition in the crypt of the Mariners' Chapel.

The first exhibition of the 'Crypt Group' took place in July 1946, consisting of one hundred and five drawings, paintings and sculptures by Sven Berlin, John Wells, Peter Lanyon, Bryan Wynter and Guido Morris. The catalogue of the first exhibition was itself a work of art, printed by Guido Morris in black on handmade paper with red sparingly used. The word 'catalogue' was too wide to fit the measure of the narrow page, so he set 'CATALO' in large capitals, and on the next line, 'GUE OF AN EXHIBITION', echoing a device that had precedent in the sixteenth century. For some time the word 'CATALO' was spoken with some relish in St Ives. In this large exhibition each artist was able to show a group of work spanning several years. John Wells showed early paintings dating back to 1930, with a large number of abstract constructions from the war years. Guido Morris had fifty 'printings' on show, including the first sheet printed by him in St Ives in April 1945, a Roman alphabet, while he was trying out ink and rollers. The Crypt Group exhibitions soon attracted attention outside St Ives and the first successful one was followed by another in August 1947, which showed the same artists plus Willie Barns-Graham. The third and final exhibition of the short-lived group was in August 1948. By this time Kit Barker, David Haughton, Adrian Ryan and Patrick Heron had joined the earlier exhibitors. The work had a more contemporary flavour, each artist showed no more than ten works, mostly from 1948. Guido Morris' catalogue was now set in Gill sans serif type, the most modern available.

David Haughton had come to live in west Cornwall in 1948 and had already found a magical quality in the remote granite town of St Just, six miles from Land's End. He painted it in all weathers, floating in a radiant light on the bleak moorland, its long lines of miners' cottages contouring the hills, and in thick mist, when nothing is sharp or clear. He described the discovery of St Just as 'the turning point in my life'. 'What happened to me on that Spring day was inexplicable, but . . . once one has experienced anything of that nature it is impossible to forget it. And unless one is quite unworthy of one's human dignity one must live by it for the rest of one's life. I have no idea what caused it, whether it really was the divine and transcendant visitation that it so clearly seemed to be or merely a freak of one's chemistry. But I do know that it was all important and unutterably beautiful, a trance that went beyond logic but never against it, and that I was at home and everything was mine, loving and tender, the landscape and houses a living thing.'[3] Haughton left Cornwall in 1951 to teach in London, but returned each year to refresh his memory, and his paintings were wholly concerned with this area for thirty years.

Adrian Ryan had trained as an architect before going to the Slade during its wartime evacuation in Oxford. From 1943 to 1948 he lived in Mousehole. His use of strong colour in free, expressionist paintings of Mousehole and its people have the urgency and vitality of Soutine, whom he came to know later in Paris. He left for France in 1948.

Patrick Heron had spent much of his boyhood in Cornwall and had returned to St Ives during the war. He was now living in London, but making the first of those long visits that kept him closely in touch with St Ives and eventually drew him permanently to Zennor.

Pressure from the younger artists to have their work exhibited in St Ives continued, and other opportunities were created. At Downing's bookshop in Fore Street, prints and pottery by Bernard Leach and furniture by Robin Nance were on sale. From time to time small, one-man exhibitions of paintings and drawings by Lanyon, Wells, Heron, Barns-Graham and Frost were arranged, with one show of work by Hepworth, Lanyon, Nicholson and Wells which included a Nicholson *White Relief* of 1936, all with catalogues and posters beautifully printed by Guido Morris. Lanham's Art Gallery, which had sold artists' materials since the early twentieth century, supplied frames and arranged exhibitions in its High Street premises. At the Castle Inn in Fore Street, Denis Mitchell's brother Endell had resumed the licence when he returned from the army. He arranged exhibitions in the lounge bar in the summer of 1945 which became a regular feature of the St Ives scene for several years.

The strong flame of primitivism that burned so clearly in Alfred Wallis is also seen in the work of Tom Early who exhibited in the first of the Castle Inn exhibitions. Sven Berlin described him as 'a unique painter' who 'leads us through landscapes of fierce intensity, and terrifying loneliness without ever seeming to be aware of our dismay and our wonder at walking within a

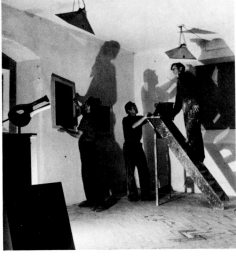

51. Hanging the first Crypt Group exhibition.
L. to r.: Sven Berlin, John Wells, Peter Lanyon.
52. Guido Morris, *CATALO*, 1946,
first edition.

dream he has made.'[4] The exaggerated flickering form of his painting *Tuckingmill Chapel* has a feeling of the 'great wind' which surged through the souls of early Methodist preachers while they held their audiences in terror of hell fire, or trembling in adoration before the heavenly host.

With commercial expansion in the town, studio space was at a premium. In April 1948 it was announced that the Porthmeor studios were to be sold, and that the vendor would accept a special price, provided that they were preserved as artists' studios. The St Ives Society of Artists opened a purchase fund in memory of Borlase Smart who had died the year before, and whose studio had been in the block. Public subscriptions raised one third of the purchase price of £6,000; the remainder was provided by the Arts Council who arranged for the administration of the studios to be placed in the hands of a trust. The continuing use of this large block of studios in the middle of the town has been of the greatest value to successive generations of artists.

The removal of Borlase Smart's gentle support for the younger artists opened the division between the two groups in the society, and there was open hostility. On 5 February 1949 ten members, concerned at a proposal to establish selection committees for exhibitions, called an extraordinary general meeting at which there was an explosive exchange of views, with

criticism of the 'modernist' members being strongly expressed and as vigorously rejected. Barbara Hepworth and her assistants were prominent, Ben Nicholson looked on. On a vote of no confidence the meeting was split and seventeen members resigned from the society, including the chairman, Leonard Fuller. Heated discussions took place later in the Castle Inn and in artists' studios and it was decided to form a new group to unite the various interests of abstract and traditional artists, and the craftsmen, grouped around Bernard Leach.

A meeting of nineteen artists and craftsmen took place on 8 February 1949 in the Castle Inn to discuss the possibilities of forming a new society. It was agreed to proceed on the basis of a proposal by Bernard Leach, who offered as a name 'The Penwith Society of Arts in Cornwall', to include craftsmen as well as artists among its membership. Herbert Read was to be asked to act as president, and Leonard Fuller became the first chairman. A committee was elected and Barbara Hepworth offered to approach the Arts Council for financial assistance. In the next weeks members of the committee gave a great deal of time to hammer out their policy. It was decided that membership would be limited to forty, elected on the basis of one craftsman to four artists. All members were to be subject to re-election every two years.[5]

From the first this radical new group attracted considerable attention. Two days after the first meeting Peter Lanyon was asked to liaise with the press because of the numbers of enquiries that had been received. He soon replaced Barbara Hepworth on the committee as her health was not good, and for the first year was a very active member. After a search in the town for exhibition premises the St Ives Public Hall in Fore Street was rented from the Labour Party for thirty-five shillings a week.

The society first met on its own premises on 27 April 1949 and began to make exhibition plans for the summer. Everyone worked hard, in the first year the committee met fifteen times and there were five general meetings of members. Volunteers helped with the work of preparing the gallery and acted as curators to the exhibitions. Peter Lanyon co-ordinated exhibition design, using screens to provide intimacy and scale for presenting crafts. Barbara Hepworth appealed for the use of white to provide light and space in the gallery. Guido Morris designed the printing, and building work was commissioned. The empty room was turned into a modern art gallery with white walls and screens, display tables and gallery lighting. Members were still divided over the question of selection of work, but for the first exhibition Barbara Hepworth's suggestion of two selectors for sculpture, two for crafts, two for traditional work and two for modern was accepted. Members were to choose to which group they wished to belong.

There was spirited enthusiasm among the members who shared a sense of building an organization with a purpose, to promote the art in which they so keenly believed. The gallery became a community venture; members participated fully in the preparation of events and were to be seen on their

knees in the street painting the door, designing, printing and distributing the posters or licking the stamps. Meetings were held at six at night in the pub or at twelve noon in the gallery and discussions took place in the narrow streets of St Ives. Lay membership grew rapidly and social activities, musical evenings, discussions and travelling exhibitions became an important part of the St Ives scene.

At the first meeting in the Castle Inn it had been agreed that the Penwith Society be founded as a tribute to Borlase Smart. The catalogue to the first exhibition, in June 1949, acknowledged the special debt — and even the existence of the new society — to Borlase Smart, 'because he was broad in outlook, and (at a time when it was unpopular to do so) made room for the modern, and encouraged young artists with fresh ideas. It is on his ideas of progress that the new Society has broken away from the old.'[6] Paintings by Borlase Smart and by Alfred Wallis were included in the hundred exhibits. To many the work was strange and unfamiliar, the classical abstracts of Ben Nicholson and John Wells, the freely interpreted landscapes of Peter Lanyon and other experimental drawings, paintings and sculpture were shown alongside more traditional views of harbour and cliffs normally associated with St Ives. The solid craftmanship of Bernard Leach, the clean lines of Robin Nance's furniture and the inventive printing of Guido Morris added stature to the exhibition.

The early months of the Penwith Society's existence combined great energy with continued dissent between abstract and representational artists. A proposal to resolve the problem of selection was drawn up by Ben Nicholson (although characteristically his name was not attached to it). Categories of artists were to be Group A (traditional), Group B (modern) and Group C (craftsmen). The selection panels for each exhibition would contain members representative of each interest. In selection, Group A would have two votes if a traditional work was being chosen, against one vote from each of the others; the same system would apply to the choice of modern and craft work. After a vote by the whole society this method of sorting was adopted.[7]

The strength of feeling on this issue revealed the strong differences of opinion held by powerful personalities. It also demonstrated the defensive attitudes generated by abstraction. It was at this time that the Penwith Society was most clearly seen to be under the leadership of Nicholson and Hepworth, both of whom preferred to act through others. The proposal to divide the membership into traditional (with implications of 'old fashioned' or 'static') and modern ('progressive', 'forward-looking') had many of the characteristics of Nicholson's earlier attempt to turn the Seven and Five society into an 'abstract' group. It was to be a divisive issue in St Ives for years to come and resulted in the resignations and public estrangement of a number of important founder members. Many wished to see a broad policy maintaining a balance of traditional and contemporary art — these included Guido Morris, Isobel Heath and Henry Segal, who declared themselves

against the scheme and refused to be placed in any of the groups. Henry Segal was particularly outspoken and foresaw the seeds of dissension which would eventually break up the society. Early in 1950 Segal, Isobel Heath and Sven Berlin resigned, and in May, with considerable publicity, Peter Lanyon and Guido Morris followed suit.

Peter Lanyon felt strongly that figuration and abstraction were not incompatible, and although his work would have put him with the more 'advanced' abstract artists, by training and background he identified with the older artists of St Ives. The matter brought Lanyon to a permanent break with Nicholson and Hepworth and was to affect his attitude to St Ives. Others who resigned over the same issue were Bryan Wynter and David Cox. The work of this important group of dissenters was noticeably absent from the society's second exhibition in 1950.

However, the Festival of Britain was now to provide a new focus for the energies of the St Ives artists, many of whom played a prominent part in both the national exhibitions held in London and the local celebrations in St Ives. Post-war Britain was a land of shortages. Currency restrictions had made certain building materials unobtainable, food rationing was still in force, and celebrations of any scale had not been envisaged since the war's end. The Festival of Britain, centred on London but planned on a national scale, captured the imagination of the nation and was enormously popular. It brought to the South Bank as many as a hundred thousand visitors in a single day, eight and a half million in all. The site was the south bank of the Thames, divided by Hungerford Bridge and containing a circuit of pavilions that lay roughly in a semi-circle. Upstream, displays were arranged in each pavilion to tell the story of the 'Land of Britain', downstream the theme was the 'People of Britain' shown in their domestic life and leisure activities. The central area held the two great buildings, the Festival Hall and the Dome of Discovery, 365 feet across, the largest dome built, and dedicated to the achievements of British men and women in 'mapping and charting the globe, in exploring the heavens and in investigating the structure and nature of the universe'.[8]

For six months the twenty-seven acres of London became a bustle of enjoyment, instruction, pageantry and plain fun. By night there were exciting spectacles illuminated with fireworks, and floating above all the flood-lit pencil of the 'Skylon'. The design team saw their role as bringing together painters and sculptors with modern architects and exhibition designers to produce new unity. For the artists this represented an earlier ideal to which many responded with enthusiasm. In spite of the turmoil of preparation and pressures of working to close deadlines, some notable works of art were created. The Festival brought artistic patronage to a huge and responsive audience and provided the means for artists to work on a scale not hitherto possible. It also brought into prominence the newly-formed national bodies of the Arts Council and the Council for Industrial Design.

54. South Bank Exhibition, Festival of Britain, 1951. The Dome of Discovery and Skylon.

53.
Barbara Hepworth, *Contrapuntal Forms*, 1950. Blue limestone, height 3.2m.

The two pieces that Barbara Hepworth was commissioned to make for the Festival stem from different sources in her work. *Turning Forms*, a mobile sculpture of reinforced concrete, refers to the many abstract drawings developed from crystals, shells and other organic forms during the early 1940s. In its open, spiralling motion it is clearly a constructivist work. Curving planes reveal the interior as a series of open volumes rather than solid mass. Her material — reinforced concrete — is wholly unlike the transparent plastic surfaces used by Gabo, but the monumental scale is in the spirit of Gabo's wish to fuse the sculptural with the architectural. Her piece was sited in a small courtyard in front of the Riverside Festival Restaurant under Waterloo Bridge, at some distance from the large mural designed by Ben Nicholson for the entrance hall. Mounted on a circular base, its white curving surfaces gleamed in the sunlight and its maritime associations were increased by being placed in a setting with suggestions of spars, decks and awnings. In the bustle of the Festival the spiralling rhythm of this slowly rotating piece had a tranquil calm.

Hepworth's second Festival commission was *Contrapuntal Forms*, a massive double sculpture, the tallest block ten feet high, carved in blue limestone. It represented two stylized figures, male and female, caught at the moment their watchful attention is directed at some distant object, an expression of human spirituality as well as of physical presence. At the Festival it stood on a stepped base close to the great curved roof of the Dome of Discovery, the Festival's principal treasure house, and near to the Skylon, its central feature. It was later set up in Harlow New Town.

Ben Nicholson produced for the Festival the largest abstract painting he had yet attempted, a curved panel for the Regatta Restaurant. It was divided into three rectangles floating on a light, textured ground; sixteen feet of light, luminous colour, given weight by coloured edging areas. A precise rectilinear geometric construction cuts across the panels, as if a design for some future austere architectural project. The curve of the panel emphasizes the unexpected tensions and overlays of the linear structure drawn upon it.

Victor Pasmore was invited to design a ceramic mural for the south wall of the Regatta Restaurant, close to the entrance from Hungerford Bridge. He saw it as 'a true challenge' and took as his starting point a series of drawings of the sea revealing the spiral forms of waves that he had made the year before from Porthmeor beach.

The Arts Council's contribution to the Festival was the exhibition '60 Paintings for '51', for which commissions had been offered to sixty selected artists. The works were to be large — at least 60 x 45 inches was stipulated, with no maximum size. Artists were provided with canvasses, which were still in short supply. The painters invited were drawn widely, from the Academy, and from the more advanced groups. The Cornish group was well represented. Patrick Heron showed one of the largest canvasses, *Christmas Eve* (1951), Ben Nicholson a monumental *Still Life* (1950), Peter Lanyon exhibited the important painting *Porthleven* (1951) (which marked a turning point in his work) and Bryan Wynter *Blue Landscape* (1951). The exhibition was shown first in Manchester, then at the newly restored and redecorated Tate Gallery in London before its long provincial tour. Public reaction was quick to come, and was mostly critical of the more abstract paintings. The press made much of the fact that one of the paintings (by William Gear) was reproduced upside down in the catalogue. Letters to the editors railed at the loss of traditional values, a question was asked in the House of Commons and the exhibition was discussed on the BBC's radio programme 'Any Questions?'. Ben Nicholson went so far as to write a lengthy defence of modern art in which he took to task the sceptical viewer of abstraction:

> People to whom this freedom in painting and sculpture is new ask, 'But what is it supposed to represent?' The answer to that is very much the same one might give if asked what a flower is supposed to represent. Each flower exists *in its own right* — it does not represent anything but itself.[9]

In St Ives the members of the Penwith Society discussed plans for their own Festival celebrations, ranging from designs for garden seats and public shelters, to painting shop fronts and street improvements, on all of which members of the society would advise. It was eventually decided to hold an exhibition with substantial prizes. In the spring of 1951 a light-hearted and spirited exhibition took place with the Penwith Gallery decorated in red and white and an awning to the street. The exhibits were unusually varied, work by the better known members who were now gaining national recognition

55.
Patrick Heron
Christmas Eve: 1951
1951. Oil on canvas
183 x 305cm

56.
Ben Nicholson in his
St Ives studio, 1951, with
the carved panel for
the Festival of Britain
mural

57.
John Tunnard
Woman on the Sea, 1946
Pen and ink wash
25 x 35.5cm

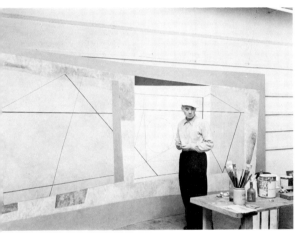

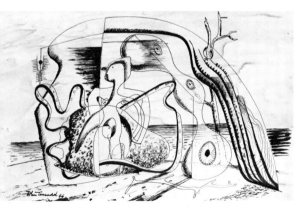

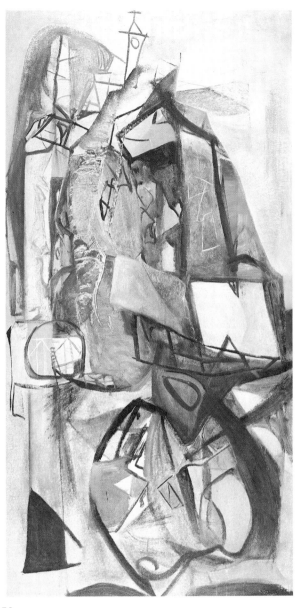

58.
Peter Lanyon,
Porthleven, 1951.
Oil on board,
244.5 x 122cm.

was shown with that of local artists and craftsmen. The Arts Council had given a grant that allowed the society to employ a full-time curator (Denis Allen in 1950, replaced by David Lewis in 1951) and sales and attendance were exceptionally good. The winning works in the exhibition were Willie Barns-Graham's painting *Porthleven*, Barbara Hepworth's *Rock Form Penwith* and a lidded pot by Bernard Leach, which were all duly presented to the town.

After the euphoria of its first two years the society settled into a more regular programme of activities, with three exhibitions of members' work each year. The exhibitions were well supported by members and consistently attracted important work from outside Cornwall.

Another artist working in west Cornwall who contributed to the Festival of Britain, but who worked quite independently of the St Ives artists, was John Tunnard. He had been drawn to the county by its wild, natural beauty, not by the artists' colony in St Ives. He first visited the Lizard peninsula in about 1930, and in 1933 moved from London, where he had designed textiles for Tootals and John Lewis, to Cadgwith with his wife Mary (Bob) Roberts, who had been a fellow student at the Royal College of Art (where Tunnard studied design). In Cornwall they started a business printing hand-blocked silks which brought a small income and gave John Tunnard time to paint, as well as opportunities to pursue his life-long interest in natural history.

Tunnard's feeling for minutae and a particular closeness of vision informed even his early paintings of the 1930s which were representational, but emphasized the dramatic swing of the rocky landscape, the turn of the path, bay and headland. Towards the end of that decade he allied his naturalist's eye to the surrealist world of Klee and Miró; his pictures of this period are inventive fantasies set upon a bare stage in which insects and machines share a strange drama. Although he never joined the Surrealist movement — he was never a 'joiner' and always guarded in his dealings with groups — he began to exhibit in London, and his work was associated with the Surrealists at a time when they offered the only radical alternative to abstraction. He brought a nautical air to these coastal landscapes, the debris of an infinite beach with its architecture of propellors, rudders, rocks, seaweed and gorse, which act as settings for confrontations between free-standing sculptured forms that watch, wait and balance. By 1937 he had met Peggy Guggenheim, who had been so close to many of the Surrealist artists in New York and Paris, and who showed Tunnard's work in her London gallery 'Guggenheim Jeune'. His work was also prominent in a number of group exhibitions that year, including 'Living Art in England' at the London Gallery and 'Abstract Paintings by Nine British Artists' at Alex Reid and Lefevre. The particular wit and invention of the man and the fantasy of his painting was captured by Julian Trevelyan, writing in the *London Bulletin* in 1939:

Tunnard's a hot-jazz king, Tunnard's a good cook. Tunnard's a man who talks outside the performing fleas, Tunnard's a husband, Tunnard's a scream. When you confront him with one of the objects in his glass boxes, he goes all queer and jumps about saying 'Oh, it's just a little idea I had when the roof fell in'.[10]

During the war Tunnard served as a coastguard in Cadgwith, and his work of these years shows something of the long introspective nights of scanning the darkened sea, the close observation of stars and space. The few exhibitions arranged during the war years kept his work before the public, and in 1944 the Museum of Modern Art in New York bought his painting *Fugue* (1938).

In the unsettled post-war period, after a short time teaching at Wellington School, the Tunnards took a rented house on the moors of West Penwith, on Morvah hill. Tunnard's work was included in British Council exhibitions abroad, in London at the Lefevre Gallery, and in an exhibition in New York in 1947. He was well represented at the Festival of Britain, with a mural for one of the Festival restaurants and a haunting picture *The Return*, commissioned for '60 Paintings for '51'. This is a coastal view, the forms of cliffs and rocky coast interrupted by a montage of doorways, tunnels and secret pathways by which stands a watching figure encircled with thorns. Although his work was sometimes shown in London with the St Ives artists, Tunnard did not mix with them. His leisure pursuits were those of the country, salmon fishing or otter hunting. However, he certainly had a social side to his nature, and a love of jazz had led him to form a jazz band on the Lizard in which he played the drums.

In 1952 a legacy enabled the Tunnards to move to Trethinick, Laura Knight's old house in Lamorna. John Tunnard painted less and for some years did not exhibit. In 1959 he started to show again at the Royal Academy, and in the last ten years of his life he held regular exhibitions at the McRoberts and Tunnard Gallery in London (in which one of the partners was a cousin). John Tunnard died in Cornwall in December 1971.

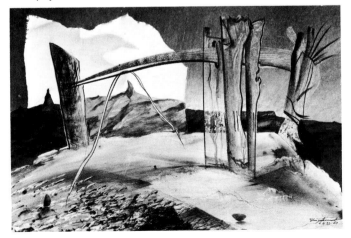

59.
John Tunnard,
Wasteland, 1960.
Gouache,
37 x 54cm.

6 Post-war Britain; Nicholson's growing reputation

A new romanticism had emerged during the war years, as painting in Britain drew away from those extremes of purist abstraction and surrealism characteristic of the late 1930s. There appeared a group of young artists who pictured more traditional aspects of the English scene as it was affected by war, in ways which gave purpose to the visual arts in a time of struggle and continuity within the Romantic tradition of painting and poetry.

A natural leader of this group was Graham Sutherland whose arrival as an important painter had been marked by a successful exhibition in 1938, at the Rosenberg Gallery in London. The paintings were of Welsh subjects, from drawings done in Pembrokeshire during the previous three years. His popular and artistic success continued as a war artist. Championed by Kenneth Clark he recorded the devastation of Cardiff and Swansea and the bombing of the East End of London. In July 1942 Sutherland came to Cornwall to commence a series of drawings of the tin mines which had been reopened to provide essential mineral for the war effort. In a six-month period working partly in Cornwall and partly in his Kent studio, he produced a large number of drawings of the mines and miners. At Geevor mine on the north coast between St Just and Pendeen he made small sketches that were later worked up as larger studies, exploring the strong contrasts of light and darkness in the claustrophobic tunnels that suddenly gave way to large caverns where the shafts met. Figures are seen at work in the womb-like declivities and the narrow passages from which the soft ore was extracted, 'precipitous perspectives of extraordinary and mysterious beauty in which the men, brilliantly lit, would be seen from above.'[1] While working on the sketches Sutherland stayed with his friend Bouverie Hoyton who had become principal of Penzance School of Art the year before, and used the studio of his wife Inez Hoyton. Through them he met Ben Nicholson, whom in a letter to Kenneth Clark he described as 'very agreeable and pleasant'.[2]

Returning to his studio, Sutherland began to work on a series of drawings expressing human vulnerability in relation to the pressing surfaces of rock. They were large drawings, in chalk, wax, watercolour and ink, and formed the bulk of the ten fully-worked studies that he handed over to the War Artists' Committee in December 1942. These drawings and paintings were widely exhibited and reproduced as evidence of the battle being carried on by the people of Britain.

A growing reputation was being made by John Piper who had been associated with Ben Nicholson for a period before the war, first as secretary to the Seven and Five group as it moved towards abstraction, then more

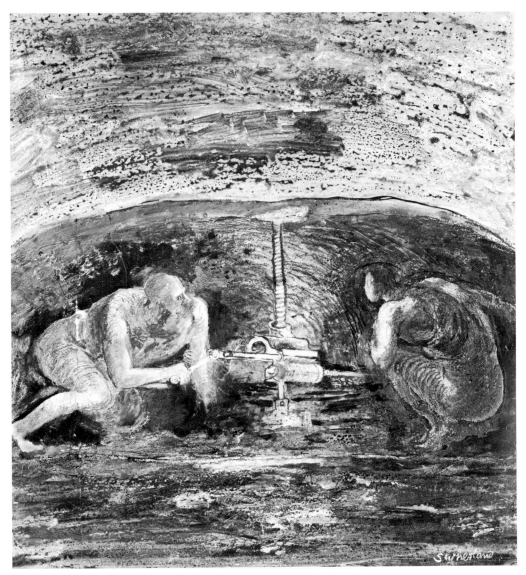

60. Graham Sutherland, *Two Miners Drilling*.

tangentially as co-editor with Myfanwy Evans of the quarterly *Axis* which
examined the changing directions of advanced art in the mid-1930s. He
expressed his own sympathies for the English landscape, in a series of direct
drawings from well known places and buildings, and as a war artist recorded
the bomb damage in Coventry, London, Bristol and Bath. In drawings
balanced between abstraction and topographical description he gave vivid
expression to the strange beauty associated with the violence of war, the
destructive energy of the blitz as it created a theatrical façade of Regency

terraces or made romantic ruins of Georgian buildings. He also made a notable series of portraits of fine buildings and landscapes entitled *Recording Britain*. Piper's work was warmly received in the war years, and helped to link the artist's vision with the suffering of the people.

Among the most powerful records of wartime Britain must be included Henry Moore's shelter drawings, made during the early days of the bombardment of London. With great tenderness and clarity, he portrayed the scenes of sleeping, huddled figures sheltering in the underground. Paul Nash, who had produced so many memorable paintings of the First World War, completed his work as war artist in the Second World War, and died in 1946. His visionary landscapes became charged with menace under the assault of enemy aircraft. These same aircraft later become wrecks collected together in a dump, a Sargasso sea of torn and twisted fragments. The prominence given to Sutherland, Piper, Nash and Moore as war artists kept them before the public, and their work demonstrated a remarkable flexibility to deal with the extreme situation of war in terms that were readily understood.

This return to a form of realism had a powerful effect upon a group of younger artists. John Minton, Robert MacBryde and Robert Colquhoun, Michael Ayrton, Keith Vaughan and John Craxton were all, in different ways, drawn to this romantic vision. Their response was a flamboyant, expressionist art form in an unmistakably English setting. It was created for and by the blitz, a surreal landscape of shattered, blazing buildings, writhing hosepipes and rescue squads. It was equally of the English countryside: deeply wooded lanes and overgrown coppices with long associations of a settled existence, now blacked out and prepared to deal with invasion. The artists who formed the 'neo-romantic' group were in their late teens or twenties when war was declared, friends who came together intermittently but frequently during the dark days of wartime London. Their art was descriptive and accessible. It appeared reassuringly stable, looking back to a previous dreamland of idyllic existence, and lay close to the literary tradition that had buttressed so much of English art. It was also agreeably 'English' and did not demonstrate those disturbing Fascist or Bolshevik tendencies which were a feature of the avant-garde of the 1930s.

At the end of the war, Graham Sutherland's work moved forward by his use of two major themes, death and change. As photographs of atrocities at the Belsen camps were released, his preoccupation with death found form in a remarkable painting, *The Crucifixion* (1946), which joined Henry Moore's tranquil *Madonna and Child* in St Matthew's Church, Northampton. The torn figure of Christ has a symbolic majesty in the agony of release from war. His studies of thorn heads, done in association with the painting, give added dimension to anguish and suffering. Sutherland also developed a number of extreme comparisons which make revealing analogies, in the paintings of *Standing Forms*. These gashed and mutilated vegetable-like creatures have a haunting presence as they stand in human confrontation. Are they man or

plant? They fix the observer with an unblinking eye, and ask disturbing questions about the nature of personality, the existence or loss of identity. Such ideas of change or metamorphosis affected other artists, many of them French, who had been drawn to the ideas of Existentialism. They were shared by a number of artists in Cornwall.

By 1947 Sutherland had moved his base to France; his work had become wholly absorbed in the Mediterranean and seemed much less relevant to post-war London. As wartime restrictions were lifted, travel again became possible. There was considerable contact between the younger neo-romantic group and those establishing themselves in Cornwall. John Craxton visited the Scillies in 1945, accompanied by his friend Lucien Freud, and stayed with John Wells. On their return to the mainland, Craxton and Freud visited Ben Nicholson in St Ives. Keith Vaughan's talent for creating mood and atmosphere by the use of figure in landscape took him to France, to Brittany and Paris, and in 1950 he was painting fishermen at Mevagissey in a manner close to that of William Scott's paintings of Mousehole. John Minton, Robert Colquhoun and Robert MacBryde spent the summer of 1949[3] together in St Ives as an alternative to travelling in Europe. Thereafter Minton also became enamoured of the Mediterranean scene. Bryan Wynter was one St Ives artist who shared the interests and attitudes of neo-realism. He was a friend of many members of the group and their drinking companion on his frequent visits to London.

In post-war Britain there was considerable popular interest in the visual arts. New institutions played an important part in the promotion of British art at home and abroad. Towards the end of the war the British Council, which had acquired persuasive skills of promotion with its wartime information services, began to mount a series of exhibitions at home and to take the work of British artists abroad. This new form of patronage emphasized contemporary artists, particularly those who demonstrated a quality of 'Englishness' in their work. The first touring exhibitions were selected from the national collections, still without permanent homes in London, and taken to new audiences in Canada and Latin America; and as Europe became safe a regular programme of exhibitions was held in its ravaged capitals. The Council had the additional role of hosting invited exhibitions in London — a role it soon handed over to the Arts Council and the Tate Gallery. Its first major venture was an exhibition of important work by Picasso and Matisse, held at the Victoria and Albert Museum in December 1945, and later toured to Glasgow and Manchester. This included a series of glowing Mediterranean canvasses by Matisse and the sombre still-life paintings done by Picasso in occupied Paris, as well as the more joyful *Night Fishing at Antibes*. This was a hugely successful exhibition, seen by nearly 400,000 people, and immediately re-established the international authority of French painting. The success was repeated a few months later when the Tate, in collaboration with the British Council, arranged major exhibitions of work by Braque and Rouault.

The British Council took over arrangements for the British section of the Venice Biennale which resumed its exhibitions in 1948. England's greatest painter of the past, Turner, was shown on the world stage together with her most authoritative living sculptor, Henry Moore. Moore was awarded the Biennale prize for the best foreign sculptor. In 1950 Barbara Hepworth was the sculptor shown in the next Biennale, alongside paintings by Constable and Matthew Smith, but seen in the shadow of Moore the international reception for her work was less enthusiastic.

To avoid total extinction of the arts during the war, the Council for the Encouragement of Music and the Arts (CEMA) had been formed. An improvised and emergency body, it brought the arts in all forms to new audiences in the provinces and in London. Musicians, including Kathleen Ferrier and Yehudi Menuhin, performed in hospitals, churches, factories and air raid shelters. The Old Vic was taken on tour and ballet and opera were performed in town halls, miners' institutions and hostels. Large numbers of travelling exhibitions were arranged, and special exhibitions drawn from War Artist commissions, such as the popular 'Henry Moore, Graham Sutherland and John Piper' were widely shown. By 1945 interest in the arts had extended in a totally unexpected manner, and there was wide feelng that the wartime experiment should continue.

In June 1945 the Arts Council of Great Britain was set up and there began a substantial increase in activity in all areas of the arts, from national opera and ballet companies to orchestras, theatre festivals, arts societies and art centres — the last a post-war development in need of careful nursing. The visual arts were now provided with greater expertise than previously and exhibitions of high standard were toured from London to the provinces. Both the British Council and the Arts Council were backed by committees of independent and well informed individuals who collectively shaped policy. A number of those who had supported the exhibiting groups of the 1930s played a prominent part in this new patronage. Herbert Read, Roland Penrose, William Coldstream and Adrian Stokes are names that come immediately to mind. The scale of the new provision appeared wildly generous in comparison with that envisaged by the small, independent groups of the 1930s, and the Arts Council was able to describe itself as a 'power house for the living arts in England.'[4]

In this cultural grid St Ives was one of the brightest lights, although one of the most distant from the centre, a model of participation between artists and people. The enterprise of the Penwith Society was unrivalled for such a small and remote community. It was singled out as a group making a notable contribution not only to the town, but to the neighbourhood and the Arts Council hoped 'that what St Ives has achieved, largely through the drive and personality of a few dynamic members may be repeated elsewhere.'[5] Its annual grant — still £150 — was the second largest for a provincial group. Selections of work by members were toured by the Arts Council in the south-west region in 1954, 1957, 1958 and 1960 (when the grant was

61.
Ben Nicholson,
Three Pears,
1948.

62.
Ben Nicholson,
*Mousehole, November 11,
1947*,
1947. Oil on canvas,
mounted on wood,
46.5 x 58.5cm.

101

increased to £200). A special exhibition to mark the tenth anniversary of its formation was also toured.

In the search for new directions, the work of the Cornish-based artists had a special place. Nicholson and Hepworth were no longer regarded as ivory-tower abstractionists. Their work had been humanized during their years in Cornwall and now included many direct references to landscape. More than any other artists in England they had kept faith with the ideals of the 1930s, in their endeavour to establish a unity of the arts and architecture and a clear social message for the artist. Now and for the first time their work was seen to offer a message of optimism, and a belief in the future that was in accordance with the national spirit of rebuilding and reconstruction. Their continued presence in St Ives provided an example and encouragement for the group of younger artists now beginning to establish their own, independent reputations. At the end of the war Nicholson and Hepworth stood in a unique position, and they began to receive full recognition for their work from a large audience.

There was an evident release of energy in Ben Nicholson's work at this time, a new sureness and certainty appeared, and an awareness of serving a wider public than the few friends and collectors who had supported his wartime isolation. His feeling for the Cornish landscape was as acute as ever, but played a less prominent part. Now it was seen as background or through a window, behind a still-life group, or reserved for the drawings which continued unabated. There is an exuberance in the paintings of flattened table tops with elephantine legs which carry the plan and elevation of jugs, decanters, plates and goblets, in a counterpoint of curved and straight templates, true and clear in colour. The paintings have a developed sense of architectural presence, a balance between freedom and order, with a visual poetry that drew upon his immediate surroundings. More abstracted than the paintings of the war years, still-life objects are recognizable in the hook of jug handle, circle of plate or profile of beaker, with occasional references to the high horizon and hills of Cornwall.

Nicholson seized every opportunity to show his work in the mixed exhibitions now being arranged. He continued his pre-war association with the Lefevre Gallery, and had one-man shows there annually from 1945. From 1949 he had exhibitions in New York at the Durlacher Gallery. His work was also shown in a series of international exhibitions. In 1946 (with Hepworth) he took part in the UNESCO exhibition of modern art in Paris; in 1947 in the British Council exhibition of English painters shown in Athens, Rome, Paris and Prague, and in 1948–9 in 'Twelve Contemporary British Painters' shown in Brussels, Dusseldorf, Hamburg, Amsterdam and Luxemburg. Appreciative articles in the international art press appeared, and St Ives began to attract visiting critics and writers on art. A modest but influential booklet in the series 'Penguin Modern Painters'[6] helped to promote Nicholson's reputation in this country.

Larger and important works came regularly from the studio. *Poisonous*

63.
Ben Nicholson,
*December 1951 (St Ives –
Oval and Steeple)*,
1951. Oil and pencil on
board, mounted on
board, 50 x 66cm.

Yellow of late 1949 (later awarded first prize at the thirty-ninth Carnegie International in Pittsburgh) is a large cubist still life, the familiar jugs and decanters flattened to the table top, strongly shadowed and held by a scaffolding of divisions of the picture area. It possesses a transparent majesty of form and surface with great intensity of colour. Another monumental still life is the large panel *West Penwith* (October 1949), reminiscent of the studio interiors produced by Braque during his wartime seclusion, but with a poetry of Nicholson's own. The still-life groups of this period, in which experiment gave way to mastery, are undoubtedly among the finest achievements of Nicholson's career. He had the skill to invent continuously, with the confidence to make an unequivocal statement. There is a tension in the contradictions he set before us, at once highly sophisticated, elegant, controlled and pure, yet curiously naïve, as if each dish or landscape was seen for the first, fresh time. The line is never mechanical, but trembles with the controlled movement of the human hand, a clearly related order of straight and curved, tautness and softness. The purist constructions of an inscribed circle on a white ground remain a summit for his achievement, yet the tumble of everyday life provided continuous variety of form from which he constantly refined.

A fastidious man, reserved and centred upon his painting, Nicholson had few social contacts with the younger artists, but he was always supportive of any work of an abstract nature. Terry Frost remembers the help he received and Nicholson's encouragement of a number of young painters and architects working with abstract reliefs. Both Nicholson and Hepworth were dedicated to their art, and to some extent led separate lives. Visitors to the studio were not encouraged and the rhythm of work was always of first importance. Nicholson was meticulous over arrangements for exhibitions and fully professional in his dealings. His view of life was surgically incisive, which to many represented a lack of generosity, but he was by no means lacking in wit or humour. Although naturally reserved (he was never interviewed for the radio, filmed or televised) he possessed a sardonic humour with an edge of irony and a sharp repartee. He had a real dislike of aesthetic conversation and soon turned the subject with some sarcastic remark or pun. Perhaps he is best characterized by his considerable manual dexterity, which shows in his work as that feeling for movement and action in the soft pencil line racing across the surface of painting or board, or the balanced equilibrium of an abstract relief. Any ball game fascinated him as it had done when he was a boy and he excelled in every opportunity for the co-ordination of hand and eye.

In 1950 Hepworth and Nicholson separated. Nicholson left Carbis Bay for St Ives and bought a house called Trezion in Salubrious Place, an alleyway climbing above the Zion Congregational Church in Fore Street. This symmetrical, two-storied house looked over the roof of the church to the harbour. At the rear was a secluded garden and a little workshop on whose roof there was a small wooden lookout from which the harbour, its beaches and moored boats and the headland behind might be glimpsed. This was to be Nicholson's home until 1958, and the home for the children when they returned from school, looked after by Kate Nicholson, Ben's eldest daughter. Although separated and later divorced, Nicholson and Hepworth continued to meet in the small town of St Ives and they maintained friendly relations.

When he moved to St Ives, Nicholson acquired one of the large Porthmeor studios, recently saved from destruction by the intervention of the Arts Council. It was always immaculate, a table for painting equipment and a wireless placed carefully within the rectangle of the floor as if in an abstract construction. For the fortunate visitor, one picture at a time would be brought out for inspection, and returned to the store room behind. But it was also a workshop that reflected his enjoyment of working with his hands — carpenter's tools were arranged on racks; battens on the wall carried the many paintings always in progress. The collection of bottles, jugs and decanters that constantly appear in his paintings during the whole of his working life had an important place in the studio. These were the well-known ingredients charmed into the forms of curve, hook and wedge, used and reused in his painting.

64.
Ben Nicholson,
Contrapuntal, Feb 25 '53,
1953.
Oil on board,
167.6 x 121.9cm.

In the early 1950s Nicholson's work became even more elegant and precise. Forms were linear, freely orchestrated curves with vertical structuring, the references to still life wholly absorbed into severely disciplined drawings with the occasional note of defining colour and subtle separation between the lightly textured areas. The opportunity to work on a larger scale brought a new monumentality to his work, most evidently in the mural-sized paintings such as the curved panel painted for the Festival of Britain in 1951, and the mural ten feet wide and nine feet high painted for the Time-Life building in New Bond Street, London, in 1952. On this square format, two panels float on a textured ground, each carrying incised markings of rectangle and circle — a strongly sculptural approach scraped like the hull of a boat awaiting repair.

1953 was a most prolific year, marked by the abundance of work flooding from the St Ives studio. The same tense qualities of relief are achieved either by drawing in 6B pencil on textured board or by carving into the surface. Soft contrasts appear in the ground colours, sharpened by notes of red, orange or purple, cerulean blue or cadmium yellow, as in such major masterpieces as *Contrapuntal* (February 1954) where the still-life theme is explored in sharp line and a flood of colour. The shapes of beaker, goblet and glass took on a transparency as new colours emerge through the overlapping shapes, laid out on the cool greys of the table top that was itself the plane of the canvas. These mature paintings have an inevitable wizardry of movement and grace, immediate to recognize, impossible to emulate: the virtuoso skill of a dancer.

In the 1950s Nicholson's work made a triumphant progress across Europe and America. In 1952 he received the first prize for painting in the International Exhibition (the thirty-ninth) at the Carnegie Institute. In the following year, retrospective exhibitions were held for him at the Detroit Institute of Art in Dallas, and at the Walker Art Centre in Minneapolis. In 1954 he received the Belgian Critics' Prize for his exhibition at the Galerie Apollo in Brussels and a retrospective exhibition of his work was chosen to represent Great Britain at the twenty-seventh Biennale in Venice, for which he was awarded the Ulissi prize. The next year a large exhibition of his work was held at the Stedelijk Museum in Amsterdam and toured to Brussels and Zurich. It was now that Ben Nicholson's work seemed most fitted to his time. No longer an embattled avant-garde artist, his work was accepted on a world platform and recognized for its sophisticated elegance of form, texture and colour. The root of ideas remained — the light of St Ives, the studio bric-à-brac, the themes of still life with the occasional glimpse of landscape — but presented within the discipline of abstraction with an assertive confidence.

After his separation from Barbara Hepworth, Nicholson began to travel again and to re-explore parts of Italy he had visited in the 1920s. The clear colour of St Ives was replaced by the more intense brilliance of the Mediterranean, but the themes remained those of Cornwall. The still life was firmly established and the soft, swinging line of the wholly abstracted shapes of the hills of Cornwall, Zennor Quoit, Mullion and St Ives, invaded the landscapes of Tuscany or Greece.

In his productive St Ives years, from 1943 to 1955, Nicholson's experience of the Cornish countryside, the town and harbour of St Ives and the contents of his studio, was directly stated in paintings of oil on canvas. At most other times in his life this was not so. From December 1933 the abstract carved relief became his preoccupation, and after his departure from St Ives he turned again to carved and painted relief with no explicit references to the many ancient and modern sites he visited. The visual impact of his travels in the Mediterranean, in Italy to Tuscany, Pisa, and the Veneto, in Greece to Olympia and the Islands, even back to familiar Yorkshire, are separately recorded in drawings or in etchings, but it is in the years in Cornwall that his

close contact with known places and familiar things communicated most directly through a succession of majestic paintings.

A large-scale retrospective exhibition of Ben Nicholson's work was held at the Tate Gallery in June 1955. It drew very considerable attention and praise, perhaps best summed up by his biographer John Russell: 'This is Ben Nicholson's hour.' A few months later he left St Ives. After his marriage to Felicitas Vogler in 1957, he returned to live in that area of Switzerland nearest the Italian frontier, Ticino, where he had painted in the early 1920s, in a house high up on the mountains overlooking Lake Maggiore. Living in the centre of Europe, its ancient cities and treasures were open to him by frequent travel. His international reputation was now assured and his work developed in a series of monumental still lifes and abstract reliefs, including many of monumental size. His seventeen years of close association with St Ives were severed at this point.

65.
Ben Nicholson,
Feb 28 '53 (Vertical Seconds), 1953.
Oil on canvas,
75.5 x 42cm.

7 Barbara Hepworth, Bernard Leach and Denis Mitchell

In the post-war years Barbara Hepworth emerged as the greatest woman sculptor of this or any other generation, and with Henry Moore she secured international recognition for British sculpture. A new authority came into her work. The carvings are large and substantial, deeply hollowed and pierced, so that light connects the interior caverns, conceived fully in three dimensions. Each angle of inspection creates subtle harmonies and an endless variety of curves. Each form is pregnant with associations, precise relationships to her coastal environment of beach and cliff. She drew upon the critical moments of nature: the first opening of a bud, the spiralling of a shell, the imprint of tidal current upon the sand; and on the powerful actions of the sea breaking in a wave, grinding smooth the pebbles, or gouging out a rock. She conveyed an intuitive response to the human situation and a craftsman's respect for her materials. Polished surfaces reveal the translucent grain of elm, beech or African hardwood. Stone is ground to whiteness, marble surfaced to reveal its veined colour. Interior forms are coloured in sea-washed blue or white; stringing measures the space within.

At a point of balance between geometry and organic growth is the piece *Pelagos* of 1946. A polished sphere of dark wood is deeply hollowed into the fins of a double spiral. Stringing joins the two curving arms from front to back, flowing through the whitened interior surfaces. This sculpture relates to the view from Hepworth's studio workroom in Carbis Bay, looking out to the Atlantic with arms of land to left and right. She recalled:

> I became the object. I was the figure in the landscape and every sculpture contained to a greater or lesser extent the ever changing forms and contours, embodying my own response to a given position in that landscape ... I used colour and strings in many of the carvings of this time. The colour in the concavities plunged me into the depth of water, caves or shadows deeper than the carved concavities themselves. The strings were the tensions I felt between myself and the sea, the wind or the hills.[1]

In 1947 she began to draw portraits and nude figures of dancers in the studio. Human structure and anatomy entered her work for the first time since her student days, and led to new relationships of motion, weight and balance. For a time she moved away from the forms of landscape upon which so much of her recent work had been based, to the single figure or groups of standing figures which she explored in her drawings and carvings with a new sense of scale and architectural presence.

Following surgery on one of her children she was invited to observe other

66.
Barbara Hepworth, *Pelagos*, 1946. Wood with colour and strings, height 40.75cm.

67.
Barbara Hepworth, *Concourse (2)*, 1948. Wood panel, oil and pencil, 76.25 x 122cm.

operations. This led. to a series of drawings in operating theatres, and between 1947 and 1949 she made a large number of studies, in sterilized notebooks, at the Princess Elizabeth Orthopaedic Hospital, Exeter, and the National Orthopaedic Hospital, London. Finished drawings were made soon afterwards with the memory still strongly in her mind. She became absorbed in the beauty of purpose and the co-ordination between human beings dedicated to the saving of life, and in the groups of figures bent over a patient, heads inclined, made anonymous by face masks and theatre overalls; she sought to give each motion and gesture a 'special grace of mind and body'.

The great discovery of these years, which allowed Hepworth's work to develop in scale and complexity, was a studio in St Ives with ample space for carving, preparation and the display of large sculpture. 'Finding Trewyn Studio,' she wrote, 'was a sort of magic. For ten years I had passed by . . . not knowing what lay behind the twenty-foot walls . . . Here was a studio, a yard and garden where I could work in open air and space.'[2] It was her friend Marcus Brumwell who persuaded her to go to the auction for Trewyn Studio. Another friend who was to bid for her was told, 'I will stop you when it is beyond my figure.' The first bid was made, already beyond her means, and she went pale green and fainted, but the bidding went on and the studio was bought for her. The heavy financial burden terrified her, but Marcus Brumwell encouraged her with the words, 'don't be silly — you have an ideal place, now get to work and you will be able to pay for it.'

> It seemed a miracle indeed to find in the middle of a town a studio with workshops and yard and garden, where nobody objected to the noise of hammering and where there was protection from cold winds so that I could carve out of doors nearly all the year round, and where there was proper space for all the multitudinous items of equipment needed for moving stone and carving it. The atmosphere was so ideal that I started a new carving the morning after I moved in — in spite of the difficulties of the move's involving six tons of tools and materials of all kinds.[3]

Still living in Carbis Bay, and unable to drive, for a time Barbara Hepworth came each day to the studio by taxi, and then she started to live there during the week. This put a considerable strain upon her, but the improved facilities of the studio gave a powerful impetus to her sculpture.

In the late 1940s the human figure entered fully into Hepworth's sculpture, fused with the ancient landscape of Cornwall. The prehistoric standing stones of the Penwith peninsula were the catalyst for this transformation — those watchful pillars that stand near Lamorna, the Pipers and the Merry Maidens; the protective groups of assembled boulders that form the chambered tombs of Zennor Quoit, Chûn Quoit and Lanyon Quoit; above all the enigmatic Men-an-Tol, the stone with the hole. Hepworth gave monumental expression to the sense of metamorphosis — figure into rock — in such carvings as *Two Figures* (1947–8) and *Bicentric*

68
Barbara Hepworth
Two Figures, 1947–8
Elm wood, concavities
white, height 1.22m
6
'Portrait of the Artist
(Barbara Hepworth)
Cartoon in *Punch*
1954, by Quentin Blake

110

Portrait of the Artist

MISS BARBARA HEPWORTH

THE stars have not dealt me the worst they could do:
My pleasures are plenty, my troubles are two.
I'll never be cultured or decently fed
With holes in my stomach and string in my head.

Form (1949–50) and the poised energy of *Rhythmic Form* (1949). These are
sentinel figures with watchful stare and pure outline, the soft convexities of
head, shoulder and arm understated yet precise. Large pebble-shapes such
as *Biolith* (1948–9) and *Cosdon Head* (1949) share the transition from ancient
magic to human form and become heads, with inscribed profile of nose,
mouth and watchful eye.

Barbara Hepworth's first indication of official recognition came in 1950,
when she was invited to exhibit a group of sculptures in the British Pavilion
at the twenty-fifth Venice Biennale, with paintings by John Constable and
Matthew Smith. She chose to show work that linked the landscape to its
structure: the ovoid pierced sculptures of tides and winds, and the standing
figures that portrayed the unity between man and nature. Two years earlier
Henry Moore had won great acclaim at the Biennale, and it was unlikely that
a British sculptor would again take a major prize, but *Biolith* (1948–9) was
awarded the Hoffman Wood Trust Gold Medal and from that time
Hepworth's work received considerably more attention. It began to be
bought for important collections including the Tate Gallery and museums
overseas. It was following this success that she was invited to create two
sculptures for the Festival of Britain.

Hepworth's visit to Venice to arrange her work for the Biennale gave
inspiration for the new directions already forming in her sculpture. During

the two weeks she spent there she became absorbed by the animation and movement of the city. Above all she responded to the groupings, gestures and sense of dignity of the people as they entered the great architectural space of the Piazza San Marco: somehow they seemed to become part of the spatial harmony of the buildings in the way they grouped, walked or sat in stillness. She was to explore this sense of architectural presence in her next group of work.

Immediately upon her return to St Ives she began to prepare the two large sculptures for the Festival of Britain — *Turning Forms* and *Contrapuntal Forms*. The first of these (described in Chapter 5), fabricated in concrete reinforced with a steel frame, was constructed in the small engineering yard of J. Couch in St Ives. The large, two-piece carving of blue limestone, *Contrapuntal Forms*, was carved out of doors in the garden of Hepworth's Trewyn Studio by her small team of assistants which included Denis Mitchell, John Wells and Terry Frost. The sculpture has the watchful stance of two figures with all the dignity of poise that she had recently observed in the sunlit figures in Venice.

In 1951 her marriage to Ben Nicholson was dissolved and from this time she lived permanently in Trewyn Studio. After years of intense creative effort she suddenly discovered that the attention her work demanded had received an unexpected reaction from those nearest to her. As she later recalled:

> What I did not perceive at the time; either because I was too tired or too stupid, or both, was that the house was cracking up and the family bursting at the seams.
>
> Three children of the same age want everything at the same time; but individually. This was a problem for them as well as for Ben and me. It is a good thing, perhaps, that one does not foresee tragedy ahead . . . after twenty years of family life, everything was to fall apart.[4]

As at other critical moments in her life Barbara Hepworth turned to her work, and all of her considerable energy was taken up with the larger, more complex carvings she was now able to execute. Success came to her in the early 1950s and from then on she was seldom out of the news. In July 1951 a retrospective exhibition was held in her native town of Wakefield, Yorkshire, opened by her old friend Herbert Read. Important articles appeared regularly in art magazines, and in the popular press she was viewed with tolerant humour (as in a *Punch* cartoon of 1954) as representing the avant-garde artist. Public understanding of her work was helped by a colour film *Figure in Landscape* (produced and directed by Dudley Shaw Ashton, with music by Priaulx Rainier), made in March 1953. The previous year had seen the publication of *Barbara Hepworth, Carvings and Drawings* (published by Lund Humphries), with an informed introduction by Herbert Read. Photographs of the whole range of her work and her own writings vividly

illuminated the various periods of her working life and revealed the detail of her thinking.

At about this time Barbara Hepworth suffered a great personal tragedy. Her first son, Paul Skeaping, was killed over Thailand in February 1953. He had become a pilot officer in the RAF and his plane crashed on a reconnaisance flight from Malaya. Two months later she won second prize for a memorial to 'The Unknown Political Prisoner'. This international competition, sponsored by the Institute of Contemporary Arts, drew entries from all over the western world (more than five hundred from Britain alone). Her maquette of a group of three standing figures bears the imprint of her recent loss.

Hepworth's dedication and devotion to her work never left her. In earlier years she appeared to have a detached, even naïve attitude to everyday affairs. Later, and with increased recognition and success, she became more relaxed, but still wholly absorbed in her work. Her close friends were limited in number, but to these she brought great affection. Herbert Read, who knew her well, found she was always a completely human person, 'not sacrificing her social or domestic instincts, her feminine graces, or sympathies, to some hard notion of career'.[5]

In April 1954 came the most complete opportunity for the public to see Hepworth's work, when a retrospective exhibition covering the years 1927 to 1954 was shown at the Whitechapel Gallery in London. This revealed the full development and sensuous beauty of her ideas, and helped to overcome many earlier prejudices against her. Yet even in the years of worldwide recognition she remained vulnerable and unable easily to make social communications. To many she appeared to have a terrifying intensity. Her single-mindedness and insistence on the highest standards in her work gave the impression that she was lacking in humour. Denis Mitchell, who came to know her well in the long years in which he was her assistant, was aware of this side of her personality. He remembers a puzzled enquiry made after a party at the studio, with many distinguished personalities of the art world, 'Why Denis, does everybody start laughing and talking when I go out of the room?'[6] Yet it was this very same single-mindedness that carried her through so many difficult circumstances without loss of conviction in her work.

In the 1950s Barbara Hepworth made theatre designs in which she used experimental means to find symbolic equivalents for movement, dance and action. The first of these were for Sophocles' *Electra*, produced by Michel St Denis at the Old Vic Theatre in London in 1951. Against a rectangular all-white set, the actors (with Peggy Ashcroft as Electra) moved through the symbolism of the piece in costumes of primary colour. For the production of *The Midsummer Marriage*, a new ballet by Michael Tippett first performed at the Royal Opera House, Covent Garden in January 1955, she used an austere and angular arrangement of standing wood forms which emphasized the vigorous movement of the action. The press was by no means

70.
Barbara Hepworth,
Sea Form (Porthmeor),
1958. Bronze,
length 1.17 m.

complimentary. The *Sunday Times* critic described the set as 'an intensified timber yard, on which patches of colour have an effect out of all proportion to their simplicity'.[7] *The Times* said, 'What we see is a sort of Stonehenge reconditioned for the Festival of Britain. Her dresses on the other hand are likely to win universal approval.'[8]

In 1954, while working on the Royal Opera House production, Barbara Hepworth made her first visit to Greece and to the Aegean and Cycladic Islands. Her sketch-book drawings, surrounded by written notes, are an ecstatic response to the classical legends and a prescription for more work to come. She wrote vividly of the inspiration she found there, and made many drawings for new sculptures. This visit fed directly into her stage productions and into an important group of carvings made on her return to St Ives, whose titles are the sites she visited: *Delphi, Delos, Mycenae, Epidauros*. An unexpected gift of wood from Nigeria had a pronounced effect upon the scale of this work. A friend had arranged for samples of scented guarea, an African hardwood, to be dispatched to Tilbury docks for her use. The load, when it arrived, consisted of seventeen tons of wood, in huge logs, the smallest piece of which weighed three-quarters of a ton. This was man-handled through the narrow streets of St Ives and formed the main material for her carvings for the next two years.

This powerful group of sculptures drew together the associations of Greece and Cornwall. She retained the forms of the massive logs, enhancing the warmth of the hard timber in a polished wood outline. They are deeply carved within and painted to reveal a spiralling interior in which a swinging line penetrates cave-like openings. These forms are not based on landscape or the figure, but on the rhythm of growth. They mark a period of maturity in her carving in which spiritual and emotional qualities are superbly blended.

Barbara Hepworth had also begun to work in metal. For the stage she had used bent metal rods to create drawings in space, and her early experiments in sheet copper have the linear and planal qualities of constructive work. Sheet metal, however, lacked the weight and solidity to which she responded in her carvings and she began to work in plaster for later casting in bronze, first modelling the form, then working on the surfaces as a carver before the casting process. The use of cast metal allowed her to produce more open and skeletal work, and extended the repertoire of rhythm and balance by the use of the solid and the void, piercing, turning and folding. Sometimes these large sculptures were fretted and eroded to become a web of metal, with interior and exterior forms equally described. A number of casts of the same piece could be made, and work previously carved in wood could be re-worked as an edition in the more durable bronze. Casting thus also allowed her to meet the many requests for her sculpture. One of the largest commissioned pieces of her career was *Meridian*, made for State House, London, in 1958–9. The final bronze, fifteen feet high, developed from a series of smaller maquettes, explored the use of a swinging line of textured and patinated bronze, a total expression of interior form.

71.
Barbara Hepworth,
Oval Sculpture (Delos),
1955. Scented guarea
wood, concavities
painted white,
length 1.22 m.

In the New Year's Honours List of 1958, Barbara Hepworth was created Commander of the Order of the British Empire, and in September 1959 she was awarded the Grand Prix at the International Biennale Exhibition at São Paulo, Brazil, on the basis of a group of sculptures and drawings executed over the previous twenty years. From her studio large casts and carvings were regularly dispatched to exhibitions and galleries all over the world. Yet Trewyn Studio was always full to overflowing and the carving yard, two plaster studios and large upper room were all in full use. Large carvings in stone and bronzes could be displayed in the garden against the natural textures of foliage, rock or grasses, but she looked for more space in St Ives to extend her workshop. When the Palais de Danse in Ayr Lane, opposite Trewyn Studio and a little along the street, became vacant she realized that it would make an ideal studio and workshop. For many years she had been disturbed by the thump of drums and the noisy dancers returning home. Now it presented an opportunity to house her large collection of finished work and would provide both a workshop and gallery in which her work could be seen in a safe and secure indoor setting.

In 1961 came news of the death of Hepworth's great friend, Dag Hammarskjöld who had been Secretary General to the United Nations. He had earlier commissioned a major sculpture for the United Nations building in New York, and as her testament to his memory, Barbara Hepworth made a large version — ten feet high — of an earlier sculpture, *Single Form*, which had grown out of a wooden carving of 1938. She was later invited by Hammarskjöld's successor, U Thant, to extend this to its final monumental size, twenty-one feet high, the largest single piece of her career. A plaster version of *Single Form* was made in sections in St Ives before being cast in bronze in London. A flattened wing-shape, pierced by one circular hole near the top, it was erected as Hammarskjöld had originally envisaged, at an impressive ceremony in New York in June 1964.

Barbara Hepworth remained in St Ives until her death in 1975. Throughout her long years of creative endeavour she continued to be refreshed by the experience of Cornwall, and by the limits of coast and sea. Her work faltered in the mid 1960s due to a period of illness, but then she produced a group of monumental pieces, a late and mature flowering of her work that drew directly on the powerful associations of Cornwall. The prehistoric standing stones of West Penwith had long been important to her as evidence of a mystical relationship between man and nature, a theme which ran through the work of her last years. At this time she also reworked ideas formed in the 1930s and 1940s. The elm carving *Hollow Form with White (Elegy III)* (1965) is a single standing figure, pierced with three arched caverns and close to *Elegy* of 1946.

Hepworth continued to work at Trewyn Studio in the last years of her life, although she was increasingly troubled by arthritis. With the help of a small group of assistants (George Wilkinson, Dicon Nance and Norman Stocker were three who worked with her in the late 1960s) she completed some of

72.
Barbara Hepworth, *Meridian*, 1960. Bronze, height 4.57m.

73.
Barbara Hepworth, *Single Form*, 1964. Bronze, height 6.40m. Unveiling ceremony outside the United Nations headquarters, New York, 11 June 1964.

74.
Barbara Hepworth, *Nine Figures on a Hill*, 1970. Bronze.

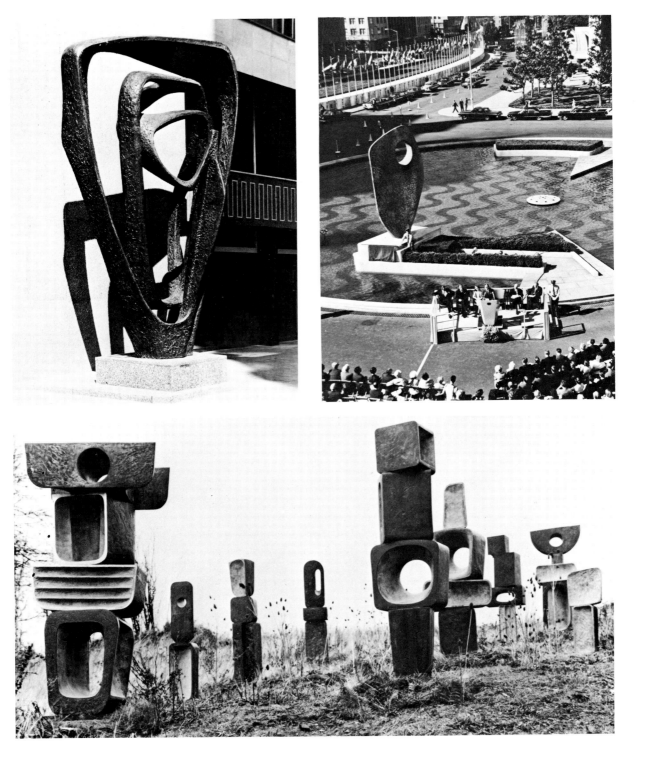

her largest and most complex pieces. In 1968 many of them were shown at the retrospective exhibition of her work at the Tate. As the monumental works were completed and large-scale exhibitions shipped to different parts of the world, so public honour and international recognition came to her. In June 1965 she was created Dame of the British Empire. Honorary degrees were awarded from the Universities of Birmingham (1960), her home town of Leeds (1961), Exeter (1966) and Oxford (1968). In 1968 she was honoured by her adopted county when she was made a Bard of the Cornish Gorsedd.

Two of the last monumental pieces gave the fullest expression to the theme of the standing form. *The Family of Man (Nine figures on a Hill)* (1970) is an assembly of huge bronze pillars, each composed of three or four piled blocks, deeply hollowed or pierced through. These totemic figures possess majesty, grouped as if in communication with divine spirits. She returned to this encounter with the great megalithic monuments of Stonehenge and Avebury, with a further group assembled in her garden in St Ives shortly before her death — *Coversation with Magic Stones* (1973). The last sculptures, some of them unfinished, were carvings in white marble, groups of pure geometric forms — the circle or sphere, the square block and egg-shape — that returned to the constructional simplicity of the pre-war years. These were grouped in complete arrangements, as in *Assembly of Sea Forms* and *Fallen Images* (both of 1974–5).

Before Barbara Hepworth came to St Ives there was no tradition there of sculpture, and to meet the needs of her workshop she used assistants. In the early days she would employ help for a few days at a time to prepare for exhibitions. Peter Lanyon and John Wells both worked in this way in the small studio in Carbis Bay. At Trewyn Studio many of the younger artists helped for a time with the heavier work, roughing out blocks of stone and wood to Hepworth's specifications, and with the multitude of physically demanding tasks that are an everyday part of the sculptor's workshop. Terry Frost spent several months in the studio in 1950 and assisted in the carving of the large, two-piece Festival sculpture *Contrapuntal Forms*. Later assistants included Roger Leigh, John Milne, Keith Leonard and Brian Wall, all of whom were to establish their own reputations as sculptors. The one who worked for Barbara Hepworth for the longest period — eleven years — and who later went on to make his own contribution to sculpture in Cornwall was Denis Mitchell.

Denis Mitchell began to work for Barbara Hepworth in 1949 and became her chief assistant. At first he worked with her on the same piece, following her design and assisting with all the stages of carving and finishing. In later years he became an extension of her hands, able to translate her intentions exactly, but under her continuous scrutiny and to her exacting requirements. He remembers the close attention she always gave to the work: 'Barbara had a fantastic eye for purity of forms,' he recalls, 'time was no object to her until she was absolutely satisfied with the final shape. It was from this I learned

that even on a very large-scale carving, less than a hair's breadth rubbed off with emery paper could alter the whole sculpture.'[9] From the experience of working with Barbara Hepworth he acquired the ability to work and concentrate on his own sculpture for eight hours a day — 'a rare achievement'.

Denis Mitchell had grown up in Swansea. His parents had parted early in his life, his father, who booked variety acts for the music hall, having left the family home at Wealdstone, Middlesex, shortly after Denis' birth in 1912. His mother took her daughter and two sons, Denis and Endell, the elder by six years, to live with her brother in Mumbles, South Wales. In his teens, Denis met Dylan Thomas, characteristically in the Mermaid pub. There is something in Denis Mitchell's expansive enjoyment of friends and conversation that was typical of the Swansea group of writers and artists. Denis and Dylan were of much the same age, both naturally sociable, and their friendship continued for a number of years.

The Mitchell boys came to Cornwall in 1930. An aunt had bought a derelict cottage about two miles from St Ives; the brothers offered to complete its repair, and stayed on to earn a living, growing vegetables and flowers and keeping a few chickens on the land. Part of the fascination of St Ives was its reputation as an artists' colony: Denis had always longed to be an artist, but it was not easy for a young man who had first to find a living. He began to paint landscapes, but as he had no art training did not regard himself as a professional artist, and did not exhibit before the war. Most of his time was taken up with the market garden, particularly after his brother left the smallholding to run the Castle Inn in Fore Street, St Ives.

In 1939, still trying to find time for his painting, Denis Mitchell married a local girl, Jane Stevens of St Ives. Instead of the army he took the option of working in the mines, for it enabled him to keep the market garden and even to employ some help. He was a face worker for two and a half years in the tin mine at Geevor near St Just, where lodes run deep under the sea. As an untrained man he was employed as a labourer, assisting more skilled men, mostly 'mucking and tramming' — clearing rubble after blasting and carrying it in 'trams' to the lifts. The comradeship of mining and the physical satisfaction of working underground brought a wealth of experience that he later translated into his sculpture. For a time he also ran a small fishing boat for mackerel in the inshore waters around St Ives.

Denis Mitchell's contacts with the progressive artists grew slowly. He came to know Bernard Leach when he was in the Home Guard in St Ives during the war; as a corporal he in fact outranked Private Leach. It was because of his general handiness that he met some of the other artists — he ploughed the land around Little Parc Owles for Adrian Stokes to make it into a workable market garden as part of the war effort, and later he helped Guido Morris set up his printing workshop on The Island.

In 1949, when he was working regularly for Barbara Hepworth, he and his wife and their three young daughters moved into St Ives. Denis Mitchell

began to work as an independent sculptor at this time, carving in wood in his little lean-to studio in the evenings. The forms he used in sculpture were abstract, although his paintings had almost all been representational. He admits the influence of Hepworth, but as his work developed from carving in wood to small bronzes he began to find his own complex engineered shapes, from the screw, the spiral, hook, ratchet and holed block, forms suggestive of the lifting gear used in the sculptor's workshop or a sailing boat's blocks and tackle. When he started to work in bronze he could not afford to have his work cast by the traditional lost wax process. He used instead a simpler, cheaper method of casting employed in engineering which requires much finishing by hand. The discipline of polishing and texturing the rough cast gave each sculpture its own unique purity.

His working repertoire may be seen in his sketchbooks and drawings — the oval standing form, flattened and pierced; abstracted flying forms of fish or bird, or those associated with man-made implements, the handle of a well-used tool or a shaped bridle piece. His chief enjoyment is in carving, where his inventive ability to work as a craftsman comes fully into play, in deeply cut shapes of wood reminiscent of the female form, or laminations of slate with incised drawing. His most characteristic work is the vertical form of polished bronze, tall and spiky with a dull, ribbed open centre.

With little regard for money, Denis Mitchell has retained a healthy disrespect for fame and reputation. He was close enough to famous artists to see the disadvantages these brought. But he has had his own share of success. He was a founder member of the Penwith Society and its chairman from 1955 to 1957, at a time when its members were beginning to earn international respect and attention for their work. He exhibited in all the Penwith Society exhibitions and in the three innovative exhibitions arranged by Adrian Heath in Fitzroy Street, London, in 1951, 1952 and 1953. This led him to exhibit at the 1952 London exhibition 'The Mirror and the Square' (which contrasted realism and abstraction). His first one-man exhibition was at the AIA (Artists International Association) Galleries in London in 1959 and his first major success came with a one-man exhibition at the Waddington Galleries in 1961, followed by exhibitions in the United States in 1962 and 1963. Since then his work has been shown regularly in London and in travelling exhibitions abroad.

The continuing presence in St Ives of Bernard Leach had given great encouragement to artists and craftsmen alike. In the post-war years the Leach Pottery was almost alone as a craft pottery in Britain and found new markets in the big London stores — Liberty's and Heal's — thus developing a new public taste for well-made craft pottery. Under David Leach, with his brother Michael and the Cornish-born ex-apprentice Bill Marshall as foreman, the pottery's work grew considerably. By the late 1950s the catalogue of domestic ware listed sixty-seven different items, and the ten or twelve potters employed were turning out up to 22,000 pieces each year. The pottery continued to be run as a co-operative venture, all subscribing

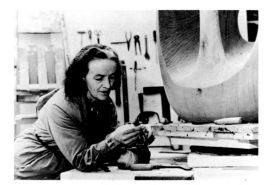

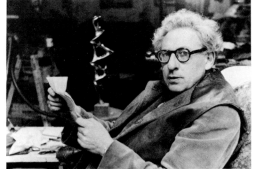

their work and ideas, and receiving a share in the profits. Bernard Leach had achieved an international reputation. *A Potter's Book*, first published in 1940, was continually reprinted and his unique combination of idealism and serious studio practice brought him world-wide acclaim, exhibitions and lecture tours.

In 1955 David and Michael Leach left St Ives to establish their own potteries in Devon (at Bovey Tracey and Fremington respectively), and in the following year Bernard Leach married a young American potter, Janet Darnell, who took over the management of the St Ives Pottery. When in 1961 the Arts Council celebrated Bernard Leach's work with the exhibition 'Bernard Leach: Fifty Years a Potter', it was able to demonstrate his great range and sensibility, built on a draughtsman's skill, and the strength of those threads of Eastern and Western culture that he wove into his work. Over the years the forms of his pottery had become increasingly purified. The earlier calligraphy of bird, fish or tree had given way to more austere scratched or brushed marks and textures that amplified the form. His pottery had become objects for contemplation, simply but fully expressed — cut, fluted or thrown, with a monumental grandeur. The brighter colours of slip decoration were replaced by dark browns and black, and a range of paler and textured ash glazes.

Bernard Leach had extended the practice of pottery into an aesthetic and a morality, at one with nature, with the spirit of man and with art. His analysis of the quality of a good pot is that of humanity and of life itself:

> The virtues of a pot are derived from the familiar virtues of life. They can be seen by the naked eye of anyone sensitive to form, colour and texture who is reasonably experienced in the language of clay . . . The pot is the man, he a focal point in his race, and it in turn is held together by traditions imbedded in a culture. In our day the threads have been loosened and a creative mind finds itself alone with the responsibility of discovering its own meaning and pattern out of the warp and weft of all traditions and all cultures. Without achieving integration or wholeness he cannot encompass the extended vision and extract from it a true synthesis. The quality which appears to me fundamental in all pots is life in one or more of its modes: inner harmony, nobility, purity, strength, breadth and generosity, or even exquisiteness and charm.[10]

77.
Denis Mitchell,
Ballet Dancer, 1949.
Holly wood,
height 48.25cm.

78.
Bernard Leach,
rectangular bottle, 1969.
Cast stoneware, seals
impressed,
48.25 x 35.5 cm.

8 Peter Lanyon

'My paintings are paintings of the weather — I was not satisfied with the tradition of painting landscapes from one position only',[1] recorded Peter Lanyon, summarising his struggle to escape from the disciplined abstraction of the post-war years, and to discover a personal direction that paralleled his strong feelings for his native Cornwall. His earliest post-war work owed much to Nicholson in its use of cubist form and muted, scraped-down colour, but it did not hold the sense of atmospheric mystery and movement that Lanyon required in a painting. Neither did it allow full play to the many layers of meaning he wished to build into his work. To achieve a more emotional relationship with his subject, Lanyon chose specific sites in Cornwall, long familiar to him and with many remembered associations. Three in particular took his attention: Portreath on the north coast above Redruth; St Just in the far west, and Porthleven on the south coast, near Helston. To assimilate these subjects he returned to traditional methods, making several visits and many broadly treated drawings. In the studio these viewpoints were fused.

The 'breakthrough from the Gabo-Hepworth-Nicholson abstraction', as Lanyon described it, 'and the basis of all my paintings since',[2] was in the painting of Portreath. His many drawings of the little port show the sea wall and the town running from the beach under the cliff into a narrow channel which feeds the two inner harbours. The deep cleft in the hills and the closely grouped houses form a background, but these freely stated drawings examine more subjective responses, the sense of enclosure given by the high harbour walls, the protection of the inner harbour, and the flow of tide and current. The painting is more complex than the drawings. The forms of harbour walls and sea are laid flat on the canvas with strongly emphasized shapes. Natural perspective is wholly altered, the cliffs, the inner harbours and their relationship to the encroaching sea have an encircling, bone-like structure.

Lanyon had so far exhibited his work little. In the exhibitions of the Crypt Group from 1946 to 1948 he had shown *Blue Horse Truant* (1945), *The Yellow Runner* (1946) and *Generator* (1946), among other works, and in an exhibition at Downing's bookshop in July 1947, Ben Nicholson and Barbara Hepworth had invited the two most promising younger artists, John Wells and Peter Lanyon, to exhibit with them. Lanyon's first one-man exhibition was held in October 1949, at the Lefevre Gallery in London. Here he showed all the best work he had done up to that time, including the painting of Portreath.

As a result of this exhibition, Lanyon was commissioned by the Arts Council for the Festival of Britain exhibition, '60 Paintings for '51'. This was encouragement at a national level to work on a larger scale than he had

previously attempted. In preparing work for this exhibition he first used drawings and constructions to 'develop an image in my mind, and to explore it in actual space before painting it'.[3] Again he took a nearby seaport — Porthleven. Again he started with a series of drawings, made from a number of locations, mostly looking down the line of the pier towards the open sea. These free and exploratory drawings examine individual details of the town — the clock tower, the harbour walls, distant houses, the pier. More schematic drawings unite these into plans of the whole harbour area, or aerial views, plotting the broad planes of movement into and across the picture surface. A design for a vertical painting began to arise, the sea as its background, the clock tower to the left, balanced by the form of the pier to the right, flattened and raised. In the lower portion of the painting are the two inner harbour basins, concentric, curving shapes.

In order to realize the subject emotionally and to further his understanding of the composition, Lanyon made use of his practical skills in a number of three-dimensional constructions. He did not see these constructions as independent works of art, but as aids to examining the illusion and content of the painting. For *Portreath* he had made six constructions, freely investigating different movements in the picture. They were built of rough timber and beach wreckage, shaped and painted, with glass and coloured perspex added. (Some still exist, as for example *Tall Country and Seashore*, which is in the Tate Gallery. Several were destroyed by the artist.)

The painting *Porthleven* was worked on over a period of about a year, but with much reworking and alteration the canvas wore through in several places. The final version was painted on masonite in about four hours, vigorous and broad in its treatment, with a freshness and directness that belies the considerable work and experiment that went into its early construction. New and untried means were found. The flat planal arrangement of *Portreath* is replaced by a more dynamic and multi-directional arrangement, with the appearance of an aerial view and the suggestion of two figures, male and female, standing to right and left of the composition. At the bottom of the picture are a number of shapes which move one inside the other like water in the inner harbour. When the painting was exhibited in the Festival exhibition it was purchased by the Contemporary Art Society and presented to the Tate Gallery in 1953.

Lanyon had been familiar from childhood with the town of St Just, where evidence of earlier mine working is seen in the stacks and derelict engine houses, out of scale with the landscape, and the long terraces of miners' cottages rising slowly up the hill, punctuated by substantial Methodist chapels.

St Just is the last town in England before you reach Land's End. It is an old ruined town with disused mineshafts all round it, which interfere with the view from the hills around the town. I don't want to paint a view from a single place but a picture about St Just, the place complete with all its associations. If

79.
Peter Lanyon,
Tall Country and Seashore,
1951. Mixed media,
20.25cm. deep,
178.75cm high,
29cm. wide.

80.
Peter Lanyon,
St Just, 1951–3.
244 x 122cm.

81.
Peter Lanyon,
Portreath, 1949.
51 x 40.75cm.

you walked about the place you might see the bits and pieces that I combine into a picture. In the painting *St Just*, the central black section is the mineshaft. There are fields all round the town, with a grass of harsh smoky quality, and the town seems to be on the top of the fields. On the left are houses, figures, rocks, maybe the church. Many people in St Just lost their lives in mine disasters, so the mineshaft becomes a cross and the barbed wire round the disused mine a crown of thorns.

For me this picture is also a crucifixion, and I painted two tall pictures to go on either side. They were landscapes, but they were also mourners on either side of the cross.[4]

From the first Lanyon's intention was to include not only the physical appearance of the place, but his strong feelings for the miners and for the tragic cycle of death and disaster they had so frequently experienced. The mine was Levant, two miles north of St Just; its workings go deep under the sea, extending for a mile from the coast. It was the scene of a tragic disaster in 1919 when thirty-one miners were killed because the man-engine broke.

The first group of work closely related to this picture consists of lino prints showing in simplified and flattened form the streets of the town. One of them, *The Cornish Miner*, has many of the characteristics of the final painting, a strongly vertical format, a central street area peopled by figures, a mine chimney dividing the composition vertically, shops and houses at the top, fields to the right. In other prints, and in pencil drawings, Lanyon included the church tower in the centre of St Just, and the network of pylons and telegraph wires converging on the town from the surrounding fields. Again he crystallized his experience in a construction — one only on this occasion — made from sheets of glass painted and cemented together.

Each part of the painting has a complex of identities. The central black column which Lanyon described as a mineshaft can also be read as a tree, branching at the top, with a suggestion of upraised arms and a crown of thorns. To the left, the white pillar is at the same time the church tower and a bound figure. There is fusion between the green areas of field and the drawn lines indicating houses. The houses in fact run around the edge of the picture, displaced horizontally and vertically from the centre, a form of perspective found in primitive art and used naturally by Alfred Wallis. This painting was intended to be the centre-piece of a Crucifixion tryptich, with two narrow vertical paintings *Corsham Towers* (1951) and *Harvest Festival* (1952) at the sides. A fourth painting, *Bojewyan Farms* (1952), was to have served as a predella for the group.

However, these paintings were never assembled into one piece, for each had a completeness and unity. They are all strongly religious and Christian, with themes of life, death and regeneration. They display Lanyon's strong feelings about the deserted tin mines of St Just and the abandoned farm at Bojewyan, and are his comments about the abuse of his county. The painting *St Just*, completed in 1951, was first shown the next year in the exhibition 'Space in Colour', arranged by Patrick Heron at the Hanover Gallery in London.

By 1952 Lanyon had established a method and manner entirely his own. He had come to terms with the early influences of Nicholson and Gabo and had broadened and extended his use of paint and bold figuration. This painterly experience was the more valuable as it was based on subjects and sympathies that were familiar and close to his home and roots. He had achieved wider recognition for his work at the Festival of Britain and in an exhibition of paintings and drawings at Gimpel Fils Gallery in London in March 1952.

In a perceptive criticism of this exhibition, John Berger wrote:

> The West Cornish landscape is like a piece of ore rather than, as others, like an orchard. Its secret is in its centre and the painter, in order to discover its true nature, must dig into it, turn it this way and that, simultaneously examine it in detail and weigh it as a whole. Lanyon does this by gathering into one painting the sensation and vision of many separate viewpoints. He tilts the landscape up and looks at it from the air, he extends it sideways as if seen from a car racing across it, he sounds its depths within its mine-shafts. His paintings are like maps, but with horizons, and with images, made volatile and sensuous by the beautifully slow application of paint.[5]

For the first three months of 1953 Peter Lanyon was in Italy, working and travelling on a bursary awarded by the Italian government. He lived for a time in Rome, briefly at the British School, and for a longer period in Anticoli Corrado, a hill village in the Abruzzi mountains frequented by British artists. He also paid visits to Saracinesco. The paintings he did on his return to England have two important new ingredients. The first is a more intense

use of colour, clearer, less dependent upon a limited tonal range, and with more chromatic contrast. The second is an investigation of myth, particularly that of identification between landscape and the female figure. This is seen most clearly in the painting *Europa* of 1954. Lanyon wrote, 'I became interested in the myth of Europa in Italy. The white bull referring to the animals of Anticoli and the girls to the shore of Cornwall. Since the painting my work has returned frequently to the shore as female, and the sea as male'.[6] He was fascinated by the legend of the Minotaur, formed from the union of the beautiful white girl, Europa, and a bull. In the picture the figures of the girl and the bull are seen as large rocky shapes, the reclining form of the girl, partly concealed by a red blanket, is united with the massive form of the bull. This was not a move away from landscape, but rather an identification between landscape and the female form, the use of legend and symbol to match the sensuous qualities of the situation.

The painting was completed several months after Lanyon's return to England, during which time he was also occupied drawing from the nude model. These drawings were done mostly at Corsham where he taught at Bath Academy of Art. In them he did not abstract very far. The eroticism remains; they are concerned with nakedness and sexuality, and the beauty of a nude woman expressed directly. In the paintings these qualities are transformed into something universal.

In 1954 Patrick Heron wrote of Peter Lanyon as 'a young painter, whom some of us believe has the capacity to revolutionise the art of landscape painting'. In a short time Lanyon had achieved the confidence and reputation of a major artist. Direct, restless and exuberant, he was yet accurate and precise about his responses and feelings. He had many friends yet remained isolated; he was concerned with people and with feelings rather than with ideas. In conversation he would take on an unusual and oblique line of argument which would often result in an unexpected and creative interpretation. He was extremely articulate and ready to discuss his intentions in relation to his paintings, as his many recordings and written comments testify. But he was intensely private about his method of work. No one was allowed into the studio while he was working, and he would shut himself away for days or weeks while a particular problem occupied him. He worked furiously and the studio was splattered with paint, but the paintings were not produced quickly, only after much re-working, alteration and radical re-positioning of elements. When he emerged at the end of a session, which left its marks of struggle and concentration, he would again be sociable and discursive about his work.

Lanyon's rejection of those artistic principles he had absorbed from Nicholson and Hepworth brought an emotional refusal to continue his earlier friendship with the older artists. Although Gabo was no longer in St Ives, Lanyon remained influenced by him and continued to hold the greatest respect for the powerful mental projections he saw in Gabo's work. Nicholson's suggestion to divide the Penwith Society into abstract and

2. Peter Lanyon, 1963.

representational artists produced a strong reaction from Peter Lanyon. His upbringing in St Ives and his early training with such artists as Milner, Park and Smart gave him a respect for tradition and he did not believe that abstraction and figuration were exclusive of each other. He felt the Penwith Society of Arts had introduced a system that was open to dangerous misuse. He expressed his views publicly in characteristically strong language:

> I believe that this over-balances the activities of the Society towards personal ambition, and can encourage younger members to search for immediate fame. Every member can be exploited and used to further some doctrine of aesthetics which is able to maintain a majority in one or another of the groups. The cost to the young artist in worry about his position in the same is considerable. The system I believe is inhuman.
>
> When these flaws on the surface of the Society have been cleared away, and the art of painting ceases to be a way to personal fame or common advertisement, I shall feel free to be an artist in my own town. At present it is my workshop. The finished product is for export only.[7]

After his resignation from the Penwith, Lanyon had little to do with the art organizations in St Ives. He became a member of the Newlyn Art Society and was at some pains to choose his friends from those who were more independent of St Ives, either by geography or by personal preference.

Although the previous three years had seen a considerable casting about for new forms of expression, Lanyon was in a better position than most to withstand the impact of the new American painting shown in the Tate exhibition 'Modern Art in the United States' in January 1956. It was not necessary for him to totally re-make a style when faced with the explosion of expressive power generated by the paintings of Pollock, de Kooning, Kline and Rothko, for his work had already developed in a broadly similar direction to that of his American counterparts: freely painted abstraction, boldly stated and of large scale. The strength of the New York artists came more as a confirmation of his own point of view, which allowed him to expand and amplify a position he had reached already in his own work.

In January 1957 Peter Lanyon made his first visit to the United States for his first one-man exhibition at the Catherine Viviano Gallery in New York. Pictures shown included *Tamarisk, Europa, High Ground* and *Tall Summer Country*. On this visit he met many of the artists with whose work he felt sympathetic. Lanyon's connections with the American artists were close, particularly with Mark Rothko, whose paintings he admired and who visited him in St Ives, and with Franz Kline, whose wife was half Cornish. Robert Motherwell also became a close friend and he met Jackson Pollock, Adolph Gottlieb and Willem de Kooning. Lanyon was received warmly in the United States — his work lay naturally in that area of expressive abstraction central to the idea of the New York School, yet retained its English character through attachment to landscape and the conditions of weather. His work was shown frequently in New York and during the latter part of his life he

visited that city frequently, probably spending as much time there as in London. He had his second one-man exhibition at the Catherine Viviano Gallery in 1959.

Lanyon's contact with American painting broadened and expanded his own work. In the paintings he produced after 1957 there is considerably more freedom, and in general the size of the paintings increased. He retained his feeling for landscape, as shown in a painting done shortly after his return from his first visit to the United States. *Silent Coast* (1957) is a very calm picture, with everything pushed right to the edges. Lanyon recalled that he 'painted it from very high up, looking down on a broad expanse of coast. Everything was still and slow moving, as on those days when after stormy weather one gets extreme silence and restfulness on the coast of West Penwith'.[8] The painting must be interpreted in landscape terms, in spite of its broad handling. Four-fifths are in blue, lighter towards the top, like clouds sweeping in towards the land. The central area of strong mid blue has the translucence of the sea viewed from above; below is the more turbulent quality of sea washing over and around projecting rocks. It may owe something to paintings by Willem de Kooning which Lanyon could have seen in January 1957 (although it should be noted that de Kooning's most atmospheric landscape-based paintings, *Bolton Landing* and the 'Parc Rosenberg' series, date from later that year and into 1958 — the influence was in both directions), but it is also a personal interpretation of the Cornish landscape at the junction of sea and land.

83.
Peter Lanyon,
Zennor Storm, 1958.
122 x 183cm.

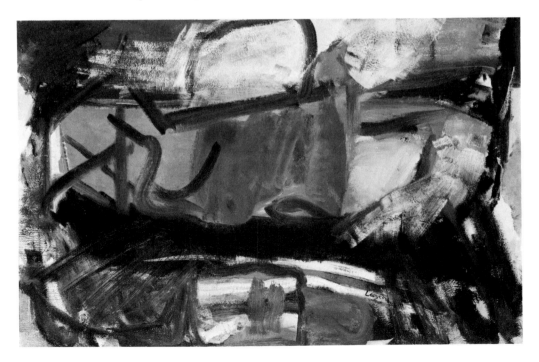

Lanyon was absorbed by the activity of putting on paint in order to find a vigour of execution that in some way short-circuited the manipulative skills and leapt the gap between feeling and execution. In all of the work from 1950 onwards there is an urge to make a single expressive statement, spontaneous, gestural and unequivocal. This was not with any thought of speeding up the painting process, for as he slowly grasped the essential components of the painting he was prepared to rearrange them repeatedly to find a satisfactory emotional balance. The activity of painting released forms buried in his subconscious mind. After long examination through drawing, Lanyon would often make radical changes and erasures; he would rework areas or whole paintings in an effort to find a balance of thought and emotion. Alongside the importance of the subject must be placed his use of analogy, particularly classical myth — the Europa legend, Orpheus, Antigone, Eurydice and others which give an enhanced form to people and events.

His earlier ambition to fly, formed during his war service in the RAF, was to be realized in 1959 when he took up gliding. In the summer of that year Peter Lanyon joined the Cornish Gliding Club, and from that time the landscape seen from the air became an important extension of his earlier experiences gained from cliff-walking and underwater swimming. The sensation of flight brought new dimensions to his view of the landscape; he became part of the elemental forces, but at the same time remained free to view it from above. In the air he found solitude and detachment from the rough, harsh country below. He became more interested in the element of time and that sensation of vertigo that was to be reflected in the structure of his paintings.

The new experiences were matched in his painting by broad and open handling and greater freedom of execution. Pictures such as *Rosewall* and *Long Moor* (both of 1960) and *Drift* (1961) are all aerial views of landscape influenced directly by gliding. They each possess an atmospheric quality of colour. There was little use now of a drawn line; colour, often mixed with white, sweeps across the surface and provides its own tensions and pressures. Lanyon said of this period:

> I have discovered since I began gliding that the activity is more general than I had guessed. The air is a very definite world of activity, as complex and demanding as the sea . . . The thermal itself is a current of hot air rising and eventually condensing into a cloud. It is invisible and can only be apprehended by an instrument such as a glider . . . The basic source of all soaring flight is the thermal — hot air rising from the ground as a large bubble.[9]

Lanyon's most ambitious effort to express such physical sensations of movement through landscape and water was in 1960, when he executed a mural for the University of Liverpool, in the Civil Engineering Building. Called *The Conflict of Man with the Tides and Sands*, it was painted on white tiles and was twenty-eight feet long by nine feet ten inches high. The difficulties

84.
Peter Lanyon,
Thermal, 1960.
Oil on canvas,
183 x 152.5cm.

85.
Peter Lanyon,
Rosewall, 1960.
183 x 152.5cm.

86.
Peter Lanyon,
Heather Coast, 1963.
122 x 152.5cm.

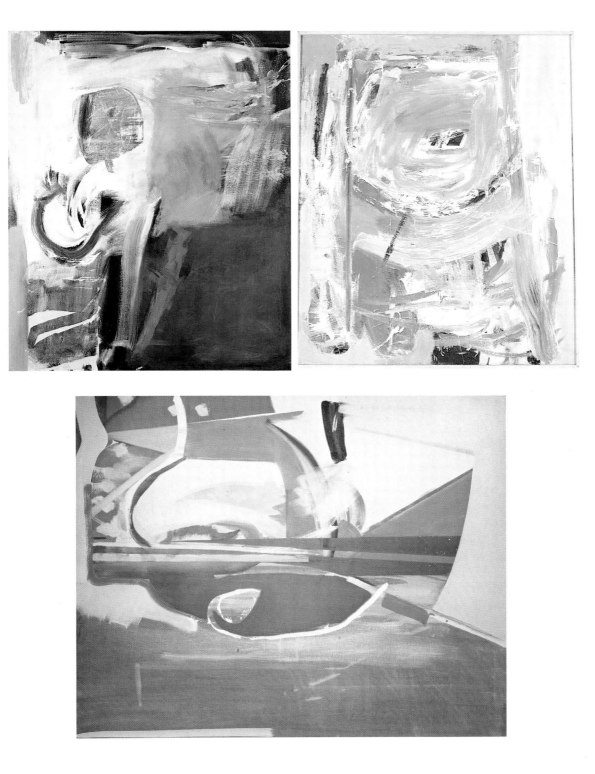

of the medium put artificial constraints upon Lanyon, for he was not accustomed to working within the limitations of the designer. The painting portrays tidal movement, the surge of sea breaking over rock and cliff reduced to free sweeps and textures of paint. Again, Lanyon saw this in allegorical terms, the battle of man's spirit against authority — characterized by the large black breakwater which cuts the centre of the composition.

In 1959 his painting *Offshore* received second prize at the second John Moore's Exhibition in Liverpool. This was painted after a series of visits to Portreath and was a study of the painter's reactions to it, and of organizing and clarifying experience into visual images. Lanyon went through many stages, building up and modifying elements of this painting, to reveal an image that had excited him from the beginning, though partly below the level of his consciousness. He made a series of tape recordings over a ten-day period which charted his work on the picture. They show that from the first day's visit, which was bright and gusty, Lanyon was seeing his subject in terms of the Europa story — 'the white vortex of off-sea wind attacks the protective walls of the harbour'.[10]

1961 was the most productive year of Lanyon's painting life. There is an exhilaration and confidence in the many paintings he produced then. The majority are to do with the sensation of flight: *Airscape, Backing Wind, Calm Air, Cliff Soaring, Drift, Headwind, Rising Air*. They are also essentially attached to Cornwall, and the predominant subject continued to be the landscape of West Penwith and its appearance in different conditions of weather.

The problems and opportunities of working on a large scale continued to attract Lanyon's attention in the last years of his life. In January 1962 he was commissioned to paint a large mural for a music room being converted from a barn by Stanley J. Seeger on his estate in Bois d'Arc, Frenchtown, New Jersey. For this he made three full-size sketches in gouache on paper — *Bois d'arc, Delaware* and *Porthleven* (the last of these, chosen as the base of the final painting, was related to *Porthleven* of 1951, now in the Tate). They were sent to America in May and Lanyon followed to agree the choice of design. The final version, three feet six inches by thirty-one feet, was painted in oil on one canvas in St Ives in July. With further visits to America the painting was completed in February 1963. It was given the title *Porthmeor*.

Also in 1963 Lanyon painted an even larger work, a mural for the Faculty of Arts Building at Birmingham University, which stands nine feet six inches high by twenty feet long. It is a free and expressive interpretation of landscape and sea, vigorous wave movements echo along the long wall, structured by vertical architectural forms. A dark sky, sea and the swept shape of cliffs are broadly indicated. The movement of the painting centres around a yellow eye.

The work of the last two years of Lanyon's life shows a noticeable shift in emphasis. This was clearly the beginning of a new phase, affected by his personal experiences of America and the new developments in art. In both America and England from 1960 onwards new directions were being

formed in hard-edged abstraction and in 'Pop' imagery; the changes in Lanyon's work were a breaking away from those positions. There was also noticeably less reference to Cornwall. Lanyon's visits to the United States had become more frequent and he seriously considered moving there. He also visited Mexico and Czechoslovakia and was planning to go to Australia. Colour became more pronounced, less atmospheric, and realized in terms of primary reds, blues and greens. White was used more frequently as a drawn line, rather than as previously in a mixture with other colours. Shapes were more clearly formed, separating and spatially differentiating parts of the painting. He returned to the use of constructions, either as independent works of art, or more frequently in collage with elements of wood and glass imposed upon the painted panel.

The direct experience of America can be seen in *Eagle Pass* (1963), a painting whose rectilinear arrangement of strong reds with yellow and blue is related to photographs taken by Lanyon of Mexican houses, their doorways and windows strongly outlined in red. It recaptures the vivid experience of travelling by car in Mexico (the car is indicated by a steering wheel that floats in the lower left-hand side of the picture), evidence of the way in which a single experience was translated into a representative symbol for his journey.

In May 1964 Lanyon visited Clevedon near Bristol, with a group of students from the West of England College of Art in Bristol where he had been a part-time teacher from 1960. Several drawings were made on the spot, and a series of colour slides of objects of beach furniture, the boat house, boating pool, bandstand, drinking fountain and memorial. These drawings are direct records of the quiet scene on a still day with few people about. The paintings that resulted translate these simple images into complex and decorative scenes. In *Clevedon Night* (1964) the structure of the pier is submerged beneath wave forms; boats and the long figure of a swimmer glide through the composition. *Clevedon Bandstand* (1964) has a similar sensation of an underwater view, but more abstracted. Elements of the bandstand provide a strong vertical feature, and the decorative ironwork figure appears on the right. There are references again to classical mythology, in this case the myth of Orpheus and Eurydice.

This new phase in Lanyon's work was tragically cut short by his death at the age of forty-six. On 27 August 1964 Peter Lanyon was injured when the glider he was piloting in Somerset made a crash landing. He was taken to hospital in Taunton and died a few days later.

9 The Development of Abstraction; Terry Frost

A characteristic of the late 1940s and early '50s was a return to abstraction, in which a number of the younger St Ives-based artists played a prominent part. There were many close contacts between those who lived in St Ives and others who visited regularly from London. Another meeting point was Corsham Court in Wiltshire. These loose geographical groupings of friends came to the fore in the search for new directions.

The return to abstraction was something of a search for lost treasure — a renewed interest in the Bauhaus, the ideas of the De Stijl movement, and the position taken by English artists in the 1930s as represented in *Circle*. Those artists who had been most centrally involved in the earlier years seemed little interested in repeating these experiences. Nicholson and Hepworth had modified their work in a more relaxed direction, drawing on a wide range of naturalistic and formal sources. Nicholson wrote that 'slightly more or less abstract for me is beside the point'.[1]

The general intentions of the abstract artist of the post-war period were similar to those of the pre-war years: purification of form, harmonization of proportion, simplification and equilibrium, and the lack of direct reference to observed nature. These are the characteristics of the post-war work of Scott, Hilton, Pasmore and Frost, and generally close to the purist abstraction of Mondrian and Nicholson's pre-war white reliefs. However, the manner of execution was very different. Where the earlier painters used geometric forms, calculated and precise, the later group allowed the paint to be thickly laid between roughly drawn boundaries. Lawrence Alloway, who chronicled this return to abstraction, described it as 'a pattern of conversions, with Victor Pasmore as culture-hero'.[2]

Pasmore painted his first abstractions in 1947. He made his first paper collages the following year and his first constructions in 1951. His progress in clearing the ripening growth of romantic painting was watched with alert interest by many of his fellow artists. During the short life of the Euston Road School in the late 1930s Victor Pasmore had explored a type of English Impressionism, with a searching and investigative use of understated space and tonal colour. His studies of the River Thames begun in 1940 show the beginning of his engagement with abstraction. Space is flattened and veiled, the drawn line loses its interest in characteristic detail and seeks structure in the delicate tracing of foliage, or in vertical and horizontal divisions of the picture surface. There followed a further stage of abstraction in which lozenges of dark colour combined with the use of collage contained only a reference to landscape.

Victor Pasmore's contact with St Ives came at a crucial time in this

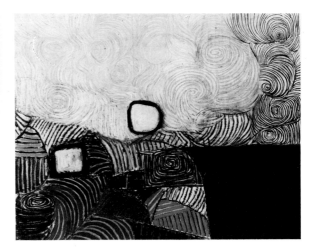

87.
Victor Pasmore,
Porthmeor Beach, St Ives,
1950. 24 x 29cm.
88.
Victor Pasmore,
Spiral Motif in Green,
Violet, Blue and Gold:
The Coast of the Inland Sea,
1950. Oil on canvas,
81.25 x 100.25cm.

development. He was introduced to Ben Nicholson by Terry Frost in 1949. Frost was then a student at Camberwell School of Art, where Pasmore was teaching. Pasmore had admired Nicholson's paintings and was particularly interested in Nicholson's view of abstraction as the vehicle for the artist's intelligence and feeling. Pasmore, who also knew Patrick Heron, arranged to take on the waterfront flat that Heron rented in St Ives each year, and spent part of the summer of 1950 in St Ives. He got to know Nicholson well, and a friendship developed.

During that summer Pasmore made a number of drawings of the sea, of waves breaking on the beach, in which he used the spiral as a central co-ordinating form, an abstract component of essential significance. In the paintings of the next months, such as *The Coast of the Inland Sea* and *Spiral Development: Snowstorm*, he built up the spiral as a large-scale, important motif. Ascending spirals flatten before the spectator's eye and twist upwards, concealing a suggested horizon. The turbulent motion of air and water — visible as in a wind-tunnel experiment — is perceived by the selective imagination of the artist. The largest use of this impressive motif was in the tile mosaic *The Waterfall*, commissioned for the Regatta Restaurant at the Festival of Britain and shown near work by Nicholson and Hepworth.

In London a small but articulate group of artists came together, committed to abstract art of a constructive nature. Victor Pasmore and his friends Kenneth and Mary Martin, Anthony Hill, Robert Adams and Adrian Heath arranged an exhibition at the AIA Gallery in 1951, entitled 'Abstract Art', and at Gimpel Fils 'British Abstract Art' was arranged by Anthony Hill. Kenneth and Mary Martin both made non-figurative paintings and con-structions between 1949 and 1951. Anthony Hill adopted strict non-figuration in 1950 and Robert Adams slowly expunged the human presence from his sculpture in 1949–50. In 1952 and 1953 Adrian Heath, who already had strong connections with Cornwall, arranged three exhibitions in his

London studio at 22 Fitzroy Street, in which this small group was enlarged to include the St Ives artists Terry Frost, Roger Hilton, Barbara Hepworth and Ben Nicholson.

Adrian Heath had first come to Cornwall in 1939. The choice of Cornwall was fortuitous. Heath was then nineteen years old and intent upon a career in art. Britain was clearly under the threat of war and a relation of Heath's had suggested that a few months at Stanhope Forbes' school in Newlyn might be a good way to spend his time before the crisis broke. Consequently, Heath was in Newlyn from January to July. This short training was followed by a few months at the Slade, then in 1940 he joined the RAF. From 1941 to 1945 Heath was a prisoner of war. It was in the POW camp Stalag 383 in Hohenfals, Bavaria, that he first met Terry Frost. After repatriation and eventual discharge from the RAF Heath spent a month painting in St Ives in 1945 before starting the second part of his interrupted course at the Slade.

By 1949 Heath was established in London and his studio in Fitzroy Street became a meeting place. From time to time exhibitions were held there for abstract artists and Constructivists; it was a clearing house for ideas that examined the nature of non-figuration, in which the formal methods of measurement and proportion used by Heath and his London colleagues found common ground with the more intuitive response to landscape practised by the St Ives painters.

Heath had begun to paint in an abstract style and in 1949 made an extended visit to St Ives, staying with Terry Frost for about six months at 12 Quay Street. He came to know Ben Nicholson and in discussion, and later in correspondence, found confirmation for his own views. On this visit, and again two years later, he made many drawings of the sea. His notebooks of this period contain observations of the directions and strength of wind, tide and current, on pages next to calculations of proportionate relationships from which he later made paintings in the studio.

To further define their aims this group of artists approached the writer and critic Lawrence Alloway with a proposal that was to take the form of the book *Nine Abstract Artists*. Those whose work Alloway discussed were Robert Adams, Terry Frost, Adrian Heath, Roger Hilton, Kenneth and Mary Martin, Victor Pasmore and William Scott. Each made statements accompanied by reproductions of recent work. Alloway looked back to the pre-war movements of 'Unit One' and 'Circle', to Nicholson and Gabo, and at the younger artists' desire to revive and continue those principles of the international movement. He made rough divisions between the 'Pasmore Group', which included the Martins, Heath, Hill and Adams, who were generally 'geometric', and the others — Frost, Hilton and Scott, 'who melt, bury or fracture platonic geometry'. He clearly preferred the more orderly artists, and was noticeably uneasy when confronted by the emotional view of abstraction from nature represented by Terry Frost or Roger Hilton. Even Nicholson was suspect for using 'geometry as a means to the high world'. He wrote that 'In St Ives they combine non-figurative theory with the practice of

abstraction because the landscape is so nice, nobody can quite bring themselves to leave it out of their art.' Alloway soon withdrew his support from the abstract painters, finding more comfort in the allusive imagery of Pop painting.

Other meetings which were of great consequence in forming the views and attitudes that connected the St Ives artists to those in London took place at Corsham in Wiltshire. As William Scott remarked, 'one could as well talk about a West Country movement as a St Ives School, for it was at Corsham Court where we all met'.[3] The buildings of Bath School of Art had been destroyed during the war, and in a bold and optimistic gesture, the Principal, Clifford Ellis and his wife Rosemary, persuaded the authorities to create a new school in the house and grounds of the historic Corsham Court, with the active support of the owner, Lord Methuen. The energy and dedication of the Ellises brought together a staff of the most talented and avant-garde painters and sculptors in Britain.

In the early 1950s Corsham Court became a creative centre for art education and an important meeting place for the exchange of ideas, information and attitudes. Teaching in the studio became a matter of creative experiment rather than disciplined tuition, and discussions outside the studio reinforced the views and opinions of those exploring landscape and human imagery through abstraction. Peter Lanyon, who taught there from 1950 to 1957 and later part-time, looked for those principles of unity that exist between all forms of nature. He encouraged students to respond physically, by walking and climbing over the land, exploring the denseness of grass and undergrowth, looking at it from new angles, from between the legs or from a height, and exploring its surface as a map. He made comparisons between its minute detail and its larger dimensions. Students were asked to make collections of pebbles and stones and to see in these the forms of the larger landscape. From 1952 to 1956 Bryan Wynter taught illustration, living in Corsham during term-time, and returning frequently to St Ives. From 1951 to 1954 Terry Frost taught life drawing.

William Scott, who had taught part-time at Bath Academy in 1941–2, before it moved to Corsham, came as senior painting master in 1946 and remained for ten years. Well-informed and responsive to change, Scott was established in the European tradition, but was alert to the roots of image and symbol and to its references back to archetypal form. Never a theoretician, he drew on the same attitudes that affected a number of the St Ives artists. Scott knew Cornwall well, he had spent six months painting in Mousehole in 1936, shortly after leaving the Royal Academy. He had then married Mary Lucas, herself a painter and fellow student at the Academy, and they had spent the next years abroad, first in Italy and then in Brittany where they established the Pont-Aven School of Painting, offering short courses during the summer months to English and French students. The inevitable interruption of war brought to an end what might have been permanent residence in France. In September 1939 William and Mary Scott went to live

in Dublin, and a few months later their son Robert was born. In the early months of 1940 they came to England, to a cottage at Halltrow, Somerset, where Scott divided his time between running a market garden and teaching part-time at the nearby Bath Academy of Art. Some painting was done during these years, but this came to an end in 1941 when he volunteered for the Royal Engineers. He was demobilized in 1946 and returned to teach at Bath Academy, now newly installed at Corsham Court.

William Scott felt a strong identity with primitive art: the magic sign, the fetish object. 'The pictures which look most like mine were painted on walls a thousand years ago,'[4] he said. He also looked back to the images of his youth in Northern Ireland, 'the grey world, the austere world'. The rapid progress of Scott's painting from 1946 to 1951 was based upon his informed understanding of the main directions in French art.

Scott had met Nicholson, Wynter, Lanyon and Frost on short visits to Cornwall soon after the war. From 1952 he and Mary Scott, with their two boys, began to spend each summer in Cornwall. For three years in succession he took a studio on the harbour wall in Sennen, and later came to Mousehole. In a succession of paintings done in Cornwall, the large empty spaces of table tops or sea, sky and harbour wall act as an arena on which the tensions between objects, or the lines of ropes and moored boats, become elements in a powerful game. His move away from realism became clear in 1953. Highly textured grounds, usually of a single colour, blue or brown, give a surface upon which a few oval or roughly square shapes merely hint at pans or jugs lined up on a wall, or the arrangement of a table prepared for a meal. Horizontal and vertical strokes make important divisions of the canvas while acting as slender handles for the oval pans.

During the period 1950 to 1953 Scott's work was closest to that of Roger Hilton, with whom he shared the background of French painting. In the work of both artists the same systems of reduction appeared: the flattening and simplification of form, the dramatic foreshortening of space as the painting became an object in its own right. Both used spare linear forms within a field of white. If colour was used, it was at maximum strength, and in telling areas. There were differences, however. Scott worked in an instinctive way, starting with the visible world, then by simplification and change finding a new reality. He denied the term 'non-figurative'; he 'abstracted', but his interests were the things of life — 'the modern magic of space, primitive sex forms, the sensual and erotic, disconcerting contours'.[5] In the grouping of artists in the early 1950s, William Scott, together with Roger Hilton, Terry Frost and Alan Davie, represented an extreme of non-figuration.

Terry Frost had a need to see and discover, to pursue through line and colour a vigorous search for personal fulfilment, an emotional equivalent for feeling. In 1950 he was still spending part of each year in London as an occasional student at Camberwell School of Art; he also took the intermediate examination of the National Diploma in Design at Penzance School

89.
Terry Frost,
Walk along the Quay, 1950
Oil on canvas,
152.5 x 56cm.

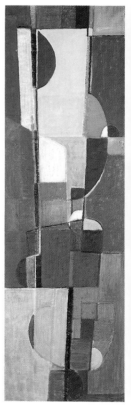

90. William Scott, *The Harbour*, 1948–9. Litho, 33.25 x 41.25cm.

91. Terry Frost, *Movement Green and Black*, 1952. Oil on canvas, 50.5 x 61cm.

of Art, in order to obtain a government grant. In the summer months he worked in St Ives at the Sunset Bar, overlooking Porthmeor beach, much used by artists. He had made his first successful abstract paintings while still a student at Camberwell. His dark-toned lozenges of muted reds and greens clearly reflect Pasmore's experiments of that time. In St Ives, with a studio next to Nicholson's, from whom he received much helpful professional advice, his work took on a new sparkle and colour and advanced with great rapidity. His painting *Walk Along the Quay* (1950) stands at the beginning of an unusual and personal journey which combines observation with intuition. This interpretation of the St Ives waterfront is an abstraction of known elements, the colour and movement of the harbour, reflections on water, the forms of landscape and waves, familiar subjects but seen from new and unexpected viewpoints and expressed with spontaneous vitality.

In 1951 Frost worked as an assistant to Barbara Hepworth for two days a week, at eighteen shillings a day. He recalled of that time:

> That work with Barbara's sculpture affected my own work deeply. It came as a great shock, so much so that I actually stopped painting myself, for about nine months. Up until then I had been so deeply involved in the illusionistic world, of images in paint, and then suddenly there I was being asked to deal with physical shapes . . . So that there followed for me a nine month period of complete uncertainty in my own work. Then I began to experiment with collage, which to a certain extent has been present in my work ever since that time.[6]

The feeling for three-dimensional form which inhabits so much of Frost's painting can be traced to this period working with sculpture. Many of his flattened shapes expressed in colour were first discovered through the use of collage. The weight, balance and movement of his painting have a close affinity with the sculptor's use of physically demanding materials.

This was a truly experimental time for Frost. On his return to painting after the nine-month interval he began to use cut shapes and arrangements of collage on the canvas. This was not sculpture, for to him sculptors avoided the most essential ingredient of the painter's repertoire — colour. It was closer to relief. Each part of the constructed piece had its own identity, but also contributed to the whole. This method of working naturally led him to reconsider the use of colour as a structural component in painting. He wrote of his painting:

> My colours are not so much evocative as associative, linked with my idea. My idea may have a subject or it may not. The subject may have had any colour and form but my idea will be a particular colour and have a particular proportion but it will be liable to change once work is begun on the canvas — change by growth to the form which is the idea in paint. There is nothing at the end of the visual sensation which might have been the starting point of the idea. I have recently painted a blue and brown picture; it started off in good shape and the blues were the best I have ever obtained; but they did not make

the object I was after. So after a long struggle the blues eventually had to be removed and the picture is now true, is now what I wanted. It is! With the blue it wasn't. The blue will have to be made some other time![7]

Frost had now taken a firm decision towards abstraction and began to take part in mixed exhibitions. In 1951 he showed abstract paintings, sculpture and mobiles in the AIA Gallery; he exhibited in '15 Artists from around St Ives' at Heal's Mansard Gallery, and in the exhibition 'British Abstract Art' at Gimpel Fils. The following year he had his first one-man exhibition at the Leicester Galleries, London.

In these early years Terry Frost sought for ways of bringing emotion to his painting. For as he wrote in 1953, 'How can one paint the wholeness of anything without the true experience of one's complete self? . . . How can man create a reality from a white square on white unless he has felt all things that the gods have provided? One cannot discover things without searching.'[8] By this time he was very much part of the St Ives scene, working there and exhibiting with the Penwith Society, while remaining in close touch with his friends in London. He was also teaching life drawing at Bath Academy of Art in Corsham on a part-time basis.

Terry Frost's response to the lively environment of St Ives was typically direct. His abstract paintings included all the movement of the rocking masts and breaking waves and the flight of gulls; elation with the daily spectacle of the harbour filled with bobbing boats, the summer streets crowded with holiday makers. All were described in simplified strong shapes — the crescent of a boat's hull; the verticals of moving masts, the chevron sign of a wave, repeated to make a series of falling shapes impelled with their own movement. Strong feelings for the scene were set suddenly on the canvas, but the emotion of these paintings lies equally in the discipline of shape against shape, and in the use of formal devices, held by a black line on a gridded ground into which are fitted the elements of waves, boats and harbour walls.

As one of those who had shown in the exhibitions arranged by Adrian Heath in his Fitzroy Street studio, Frost was included in the publication *Nine Abstract Artists* edited by Lawrence Alloway. Six of his paintings were reproduced. His statement emphasized intuition before calculation:

Seeing is a matter of looking and feeling, for things do not look exactly like you think they do. To look with preconceived notions of visual experience is to destroy the possibility of creating again that experience in paint. If you know before you look, then you cannot see for knowing.[9]

In 1954 Barbara Hepworth introduced Terry Frost to Peter Gregory, and with the additional support of Herbert Read he was offered the Gregory Fellowship in Painting at the University of Leeds. For two years this gave him studio facilities and a small stipend. He was able to take his family to Leeds and formed a long-remembered attachment to the northern town.

The fellowship brought no teaching responsibilities; he was free to paint and was asked only to be accessible and to show his work from time to time.

His painting responded directly to this new opportunity. The sense of openness of the Yorkshire Dales, the scale of sweeping contours, the calligraphy of blackened stone walls across windswept fields, all were reflected in his new work. The paintings of the first long winter in Leeds when the snow came have a visionary quality that describes those moments of truth when everything seems clear and one is transported from the normal. They have a new vitality and certainty of execution, as if a minute background detail of a hillside had been lifted from a Shoreham drawing by Samuel Palmer and enlarged to enormous scale. Terry Frost described one such moment when he went to Herbert Read's house at Stonegrave:

> we . . . struggled through the snow, so deep it came over the tops of wellingtons; the angle of the hill seemed about 45 degrees and we had to lean to walk and counter the slope. It was a clear bright day and I looked up and saw the white sun spinning on the top of a copse. Afterwards and now I recall that I thought I saw a naples yellow blinding circle spinning on top of black verticals.

The sensation was true. I was spellbound and, of course, when I tried to look again 'it' had gone, just a sun and a copse on the brow of a hill covered in snow.

I don't think I really stopped to see it. I do remember my heart almost stopped at the experience and it was gone. So I came back and I painted *Red, Black and White 1956*. I didn't come back and just paint the picture. I never was able to do that. I never wished to do that. I always have to absorb the moments and let them go for I have to make the idea, the discovery. Sometimes I go for a couple of years before I can get clean as it were and discover the moment again in paint.[10]

The memory of a sledging party was used in a similar manner for a painting now in the Tate Gallery. The long running lines of black which traverse the narrow vertical painting are a celebration of the exhilarating experience of the run of the sledge:

It came from the fact of being in a strong cold black and white environment. A day out with K. Armitage and Rosemary Blackburn. The challenge of a toboggan ride . . . Black figures, strong white and speedy flurry. I went from half way, lost the sledge at the dip (concave form) and sailed right on without the sledge, slid along on my chest, straight into the spectators — bowled several over. Back home 8' x 4' hardboard and the continued excitement of black and white led me to paint *Winter '56*.

To take a line from top to bottom and keep it alive was a real challenge. I have always been concerned with all the possibilities of what you can do with a line when you move it from straight to a circle. Everything can be done with a line.

I had since about 1948 got really interested in the business of taking a line round what I wanted to say. Tone did not interest me — colour did; colour and line, though black and white were my passion at that time.[11]

Terry and Kathleen Frost and their young family spent each summer in St Ives during the Fellowship. When it finished in 1957 they returned to St Ives and Frost was able to give up teaching to paint full-time. He was now one of the leading non-figurative painters of his generation and his work was shown in many exhibitions in this country and abroad. In 1956 and again in 1958 he had one-man exhibitions at the Leicester Galleries. Also in 1956 his work was included in Herbert Read's 'Critic's Choice' at Arthur Tooth & Sons. He exhibited in those definitive exhibitions 'Metavisual, Tachiste and Abstract Painting in England Today' at the Redfern Gallery in London in 1957 and 'Dimensions: British Abstract Art 1948–1957' at the O'Hana Gallery in London. His work was shown in Italy in the 'Prix de Lissone', in New York in 'New Trends in British Art', in Tokyo at the 'Fourth International Exhibition of Contemporary Art', and in Liverpool at the first John Moore's Exhibition. In the next five years Frost's work appeared in international exhibitions toured abroad. It was frequently shown in New York and in Pittsburgh, and also went to Moscow and Leningrad, Eindhoven, San Francisco, Dallas and Santa Barbara.

92. Terry Frost, *Three Graces*, June 1960. Oil on canvas, 197 x 242.5cm.

Like many of his generation during these years, Terry Frost was coming to terms with American painting. He established a repertoire of strong recurring images — the circle, the semi-circle (derived from the boat shapes of St Ives), chevrons and wedge shapes (inspired by a bikini top seen on a Welsh beach), all heavily charged with sexual overtones — bottoms, breasts and nipples — set in a free and inventive geometry. These symbols were further strengthened by their bold colour, black and red predominating, and by their repetition and symmetry. He drew on signs and signals, flags, the formal painting of lorry fronts, and traffic signs. Many of the paintings, especially the smaller ones, still contained references to landscape, particularly in the colour which is strong yet atmospheric, the colour of the evening: browns with ochre, a range of blues from cobalt to ultramarine. Verticals suggested trees or grasses. There were contrasts of explosive colour with split or compressed shapes. This was confident and innovative painting.

Terry Frost also made personal contact with the United States. In 1960 he had a one-man exhibition at the Bertha Schaeffer Gallery, New York. During this first visit he spent three weeks in New York and met a number of artists including Mark Rothko, Barnett Newman, Franz Kline, Willem de Kooning and Robert Motherwell. Clement Greenburg visited Frost's show and was particularly friendly. The warm reception for this and for a second exhibition at the same gallery two years later gave added elation and conviction to his own direction and his painting shows new simplification of form and exuberant colour.

Throughout the 1960s and '70s Terry Frost's work continued to be exhibited internationally. But he found it difficult to maintain a large family from the sale of abstract painting (by now there were six children) and in 1964, to be nearer to London and to take up the opportunities of part-time teaching, he bought a large house in Banbury. For many years he was Professor of Painting at the University of Reading. Away from Cornwall his repertoire of formal shapes — the semi-circle, quarter-circle and chevron — became more simply stated, with increasing boldness of scale and colour, a new monumentality which drew together a wide range of associations. In these large colour abstractions the collage and constructions of earlier years are often recalled, and the pictures have a unique quality of invention and personal expression.

In 1974 Terry Frost returned to Cornwall, to a high studio on Newlyn Hill overlooking the town and the great curve of Mount's Bay. It is here that his work has continued. Much of his inspiration is in the working harbour of Newlyn; the blunt shapes of fishing boats; the tension and movement of their mooring ropes as they swing and dip into the water; the high yellows and reds of buoys and floats. Fragmented ripples make repeated chevron shapes that cross the water, dividing the reflections. The heaviest mooring ropes of the big ships are weighty, falling forms that resemble his dropping loops of colour and the suspended motor tyres that cushion the entry of boats make the overlapping circles of his recent paintings.

10 International Influences: Paris and New York. Patrick Heron

For ten years after the end of the Second World War, Paris remained the focus of attention for the adventurous and forward-looking younger artists in Britain. The eminence of French painting had been re-established in the first years of peace by a number of important exhibitions shown in London including the hugely successful 'Picasso and Matisse' in 1945 and major exhibitions of Braque and Rouault. Other French painters were again shown in the dealers' galleries. These, the greatest artists of the School of Paris, provided the continuity to overcome the cultural breakdown caused by two world wars. The work of Vuillard and Bonnard formed a direct link with the atmospheric play of natural light of the Impressionists. Matisse had discovered an emotional world of strong, clear colour peopled by living beings; Picasso spoke of the agony and suffering of wartime Europe. The medieval passion of Georges Rouault shone even more brightly amid the treacheries of war, a moving record of archetypal judges, clowns and prostitutes united in Christian reconciliation. Léger and Braque had that heroic French personality described by Herbert Read as 'massive clear eyed Normans whose physique never suggested decadence'.[1]

As the 1950s unfolded, new generations of French artists were presented as the successors of these masters. Jean Dubuffet revealed a desolate landscape peopled by monstrous figures which combine the innocence of childhood with the paranoia of the insane, in thickly worked and mutilated accretions of paint, paper and sand. Others were involved in various forms of free or formal non-figuration, in attempts to extract themselves from the trap of Cubism. Roger Bissière, to whose teaching in pre-war Paris Roger Hilton owed so much, together with Jean Bazaine and Alfred Manessier, created a decorative, colourful abstraction based on linear nets into which flecks of Impressionist colour were woven. Of special significance was the Russian-born Nicolas de Staël whose mystical paintings in glowing colours became progressively more literal as Mediterranean scenes in thin, pale washes. The impasse that he reached in this move from abstraction to representation was directly against the flow of the major creative movements of his time, and may have been responsible for his death by suicide in 1955 at the age of forty-one.

Others explored more informal means of expression. 'L'art autre' was the title given to the work of that group of artists concerned with the spontaneous as an assertive form of creation without control or system. Pierre Soulages' massive, low-toned structures hold the light of the primeval forest in their few sweeping brush strokes. The more brittle, Kandinsky-like

abstracts of Hans Hartung, or the theatrical action painting of Georges Mathieu equally contain an abstract mystery.

Artists in England responded directly to the renewed opportunity to seek French sources. In their different ways, Scott, Wynter and Hilton reaffirmed their dedication to French art. As late as 1955 Patrick Heron wrote that the power of Paris 'is undiminished'. 'I believe it is still true that French painting is the best in the world; it still holds the centre of the stage. Indeed it *is* the stage.'[2]

It was therefore a shock and a surprise to many when the work of the American painters, hammered out in New York in the late 1940s and early 1950s, was seen in the Tate Gallery in 1956 to have the character and significance of a major modern movement. In these powerful paintings, tension and ambiguity were expressed in the half-erased forms of de Kooning and a feeling of personal encounter was apparent in the canvasses of Pollock. Here were obsession and inspiration, which although rooted in international Surrealism were wholly American. As Harold Rosenberg, the movement's presenter put it, 'the work represented an individual sensual psychic and intellectual effort to live entirely in the present'.[3]

From the first the work of the New York painters was presented to the world fully grown and developed. Before it was seen abroad the American artists had already established their own positions in relation to their contemporaries. Years of meetings, discussions, seminars and published articles had identified champions and partitioned territories. The personal responsibility of each artist to create only in relation to his own inner needs had been recognized, and individually the artists had begun to gain a large measure of financial independence. In New York the gallery system had been alerted to a possible new commodity and by 1950 had established powerful new forms of promotion.

The reasons why this growth went largely undetected outside the United States are complex. Paris was regarded as the fixed sun of the art world and although the possibility of new centres of artistic activity was considered, it was not to America that attention was directed. The political excesses of the cold war had isolated American artists. The suspicion generated by the McCarthy investigations into 'un-American' activities had produced a climate of opinion in which forward-looking artists were regarded as hostile, possibly subversive elements of society. It was only by political manoeuvre that the Museum of Modern Art placed itself in a position to project these 'alienated' artists upon a world audience, and gave cultural identity to new art forms symbolic of individual freedom.

The principal means by which this was done was the exhibition that came to London, to the Tate Gallery, in January 1956, as part of its tour of eight European capitals. The title of the exhibition, 'Modern Art in the United States', was comprehensive and included many artists whose work was of lesser interest, with Hopper, Feininger, Shahn and Tobey among the best. Only the last gallery contained work by Abstract Expressionist painters,

among them Jackson Pollock's *She Wolf* (1943) and *No. One* (1948); Willem de Kooning's *Woman One* (1952); Franz Kline's *Chief* (1950); Clyfford Still's *Painting 1951*; Mark Rothko's *No. One* (1949) and *No. Ten* (1950); Robert Motherwell's *Granada* (1949), and work by Tomlin, Guston and Gorky.

The first reaction in England to the work of the American painters betrayed uncertainty and lack of enthusiasm. Lawrence Alloway's review was typically ambiguous: 'a new aesthetic which though it is the product of a different culture than ours is no more alien to us than any other art',[4] he wrote of the exhibition. A few unusually well informed artists in England had pre-knowledge of this American invasion. As early as 1948 work by Jackson Pollock had been seen in Venice in Peggy Guggenheim's collection by Peter Lanyon and Alan Davie. Willem de Kooning was one of the United States' representatives at the Venice Biennale in 1948, as were Arshile Gorky and Pollock in 1950. A number of the Abstract Expressionist painters had shown in the São Paulo Biennale exhibitions from 1951. William Scott, who brought wind of developments across the Atlantic to his friends at Corsham had been shown in São Paulo in 1953 (with Patrick Heron) and had made his first visit to New York in that year. In England the Institute of Contemporary Arts had included paintings by Pollock in a mixed show in 1953 and had arranged an exhibition of Mark Tobey's calligraphic paintings in 1955.

Patrick Heron, writing for an American audience, was jubilant in his immediate acceptance of this new art form:

> I was instantly elated by the size, energy, originality, economy, and inventive daring of many of the paintings. Their creative emptiness represented a radical discovery, I felt, as did their flatness, or rather their spacial shallowness. I was fascinated by their constant denial of illusionistic depth which goes against all my own instincts as a painter . . . to me and to those English painters with whom I associate this new school came as the most vigorous movement seen since the war, we shall now watch New York as eagerly as Paris for new developments (not forgetting our own, let me add) — and may it come as a consolidation rather than a further exploration.[5]

Patrick Heron had had the closest connections with Cornwall since his early youth. He was born in Leeds in 1920, one of four children. When Patrick was between the ages of five and ten, the family lived in Cornwall, for the first six months in Newlyn, then in Lelant near St Ives. The winter of 1927–8 was spent at Eagles Nest, a house overlooking the sea above Zennor, rented from the owners, the Arnold-Forsters, which many years later Patrick Heron was to buy. In St Ives he became a boyhood friend of Peter Lanyon. At about the age of nine or ten the two boys set up their own private society – not cowboys and Indians, but the 'Society for the Protection of English Culture'.

Heron's long involvement with Cornwall started with the artistic enlightenment and commercial enterprise of his father, Tom Heron, who in

1925, was invited by the founder of the firm, Alec Walker to join the fabric printing company of Cryséde, then operating from a row of cottage of Newlyn Hill. Under his direction the company developed rapidly and soon established a national reputation for fine colour printing on silk, with innovative designs by Alec Walker and with retail shops in London and the important provincial cities. The company's headquarters moved to a substantial factory in St Ives converted from fish lofts on the Island. In 1929 there was a breakdown in the previously good working relationship that had existed between Alec Walker and Tom Heron, and the Heron family left Cornwall for Welwyn Garden City. Here Tom Heron established his own highly successful business 'Cresta Silks' with designs by such artists as Paul Nash and Cedric Morris. The promotion of its products was assisted by the characteristic modernist design of its shopfronts, designed by the architect, Wells Coates, who later became a founder member of MARS (Modern Architectural Research). Patrick Heron remembers that when Ben Nicholson and Christopher Wood made their historic visit to St Ives in 1928, a few yards away from Alfred Wallis' cottage Wells Coates and Tom Heron were working on designs that were to further the progress of modern architecture.

Patrick showed early talent as a painter and draughtsman. As a schoolboy he was aware of the work of Cézanne and Sickert and was producing creditable work inspired by their example. From 1937 to 1939 he was a part-time student at the Slade School, one of that group which included Kenneth Armitage, Paul Feiler, Bryan Wynter and Adrian Heath. The war was an isolating experience for Heron. In common with a number of his contemporaries (including Bryan Wynter) he became a conscientious objector, and was required to work on the land, digging Fenland ditches in Cambridgeshire. A period of illness prevented him from continuing this manual work, and during the buildup to the invasion of Europe Heron travelled down to St Ives and became an assistant at the Leach Pottery, then producing utility tableware. For fourteen months in 1944 and 1945, Heron had the stimulus of working with Bernard Leach and found many things in his workshop that were to affect his own development as a painter. His use of still life can be traced to this ceramic experience and the manner in which he applies paint to the canvas, in a single stroke, is analogous to the potter's application of glaze. At this time Heron also came into contact with Nicholson, Hepworth, Stokes and Gabo.

Although painting was always his principal activity, for a time at the end of the war and afterwards Heron embarked on the unusual and arduous task of exploring two art forms simultaneously. For two periods during his early career he became a critic and reviewer of exhibitions, and one of the most expressive and articulate commentators upon the current scene. His first important group of articles was published in the *New English Weekly* in 1945, and he was commissioned to give a series of talks on contemporary poetry for the BBC's third programme. From 1947 to 1950 he was art critic for the *New Statesman and Nation*. He wrote widely on the unfolding of the post-war

artistic cycle, with major articles on Picasso, Léger, Matisse, Rouault, Vlaminck and Bonnard, and on Braque.

Heron's own preferences are apparent in his selection of artists. He looked for those whose work contained pronounced elements of abstraction, expressive line and restricted pictorial space, and for whom the function of colour was of special significance. For Heron criticism is an interpretative skill: he transmits the intentions of the artist engaged upon his craft and the reader is given the opportunity to share in this creative act. He is unusually alert to the *matière* of the painter, the flow of paint from the brush, the texture and surfaces of stain or full-bodied paint, the effect of scraping or rubbing the canvas or board, the illusion of space. He is particularly articulate on the function of colour in painting, in the work of others and his own. He is least interested in the literary or descriptive forms of painting that characterized much of post-war British art.

Heron was deeply impressed by the large exhibition of Braque's painting of the war years in Paris, shown at the Tate in 1946, and wrote of it as 'a new development of an immensely powerful art'.[6] He saw these monumental paintings as a secret flowering of a great talent; his admiration for the vigour and intensity of Braque's vision was confirmed when in July 1949 he visited Braque in his studio. Braque's influence is clearly reflected in Heron's paintings of these years.

From 1945 to 1956 Patrick Heron was a regular visitor to Cornwall. From his vantage point as a London critic he presented to the public the significance of the work emerging from St Ives. In a series of articles from 1945 he gave the most important early assessments of Peter Lanyon (*New Statesman and Nation*, 1949), Bernard Leach (*New English Weekly*, 1946), Bryan Wynter (*The Changing Forms of Art*, 1955), Ben Nicholson (*New English Weekly*, 1945), Roger Hilton (*New Statesman and Nation*, 1950) and John Wells (*The Changing Forms of Art*, 1955). Heron's perceptive articles cleared a path through the proliferations of styles and movements with wit, vigour and considerable skill of argument. They were dependent on his own intuitive response to the work; he was clear in his preferences and admitted his prejudices and limitations. He argued strongly for plastic means of expression, allied to the use of colour as a structural element, which led him to value paintings in relation to their 'pictorial space', that perceptual shaping of the apparent depth of the canvas that for Heron was the true measure of an artist's control. His writing on art was felt by some to be obsessive on the subject of 'pictorial space', and in 1950 he was sacked from his post as art critic to the *New Statesman* for this reason.

After his dismissal Heron virtually withdrew from writing, and it was not until 1955 that an invitation from Hilton Kramer, editor of *Arts Digest* in New York (soon to become *Arts*), led him to become its London correspondent, a post he held until 1958. During this period of change he responded to the innovative work coming from London, Paris and New York, and presented the work of his own contemporaries and associates, including Lanyon

93. Patrick Heron, *Azalea Garden*, 1956.
Oil on canvas.

94. Patrick Heron, *Green Painting with Browns:*
3 (Supressed Squares), October 1959 – May 1960, 1960.
Oil on canvas.

95. Patrick Heron, *Scarlet, Lemon and Ultramarine*, March 1957. Oil on canvas, 61 x 183cm.

(February 1956), Frost and Wynter (October 1957), and Roger Hilton (May 1958) to an American audience. Heron's essays identified the strength of the St Ives artists and described work unlike that being produced in London or elsewhere.

Patrick and Delia Heron had married in 1945, and from 1947 began to make regular visits to Cornwall. After a summer in Mousehole they spent two or three months each year in St Ives which became an alternative home to Holland Park, London. They took a flat near St Ia Church, at 3 St Andrew's Street. The long window in four sections of the large, sunfilled sitting room overlooking the sea wall and the harbour became the principal subjects of Patrick Heron's paintings from 1947 onwards. These are still lifes and interiors in flat planes of red, blues and yellows applied at full strength, slotted into the linear drawing. Qualities of calm and stillness were created by the use of the still life and by free-flowing silhouettes based upon the rhythms and cubist devices of Braque.

Heron began to exhibit his work in Cornwall at Downing's bookshop in St Ives in 1947. The following year work was shown in the third Crypt Group exhibition. He had a series of one-man shows in London, at the Redfern Gallery, from 1947 to 1958. The influence of the French, Braque in particular, remained paramount but emphasis changed from an atmospheric tonality to a more linear manner of describing objects and figures. The figure was particularly evident in the Redfern exhibition of 1950 which included important portraits of Herbert Read, T.S. Eliot and Peter Cochrane.

In 1950 Patrick Heron was commissioned by the Arts Council to make a large painting for the Festival exhibition '60 Paintings for '51'. He chose a domestic interior, this time the family house in Holland Park, with the figures of his wife and their young children as his subject for *Christmas Eve*. It was a major effort to contain on a large scale all of those tensions of form and colour that had been effective in the many still lifes or smaller figure paintings. Heron's other work for the Festival was to have been a fifty-foot mural commissioned by the architect Cadbury Brown, who accepted his sketch designs. However, the project was vetoed by the Director of the Festival, Hugh Casson, and never executed.

Heron made many paintings from St Ives subjects which responded to the zestful enjoyment of freely applied colour. For example, in *Harbour Window with Two Figures, St Ives* (July 1950), the boats and jetty form a shining background of pinks and reds. A swinging line defines the walls, furniture and figures, and becomes a grid on which is hung a network of colour — strongly personal blues, vermilions and apple greens, and the warm range from red through magenta to purple. In the large painting *The Room at St Ives* (1952–3), the device of a frieze is again employed, three systems of perspective working across the painting. The fluency Heron achieved in these early paintings is important to his working method. In Braque's words, 'the paintings make themselves under the brush'. The open network of lines freely hung with screens of colour was not arrived at as part of some process

of application, scraping down and refinement, but directly and spontaneously as an emotional sequence of responses.

As evidence of his own developing views about the nature of non-representational art, Patrick Heron devised and selected the exhibition 'Space in Colour', presented at the Hanover Gallery in July and August 1953, in which ten artists, mostly associated with St Ives, each had a group of work in which colour played an operational part. In his introduction to the catalogue, Heron described the two mainstreams of progressive painting in England: that of 'abstraction' from the visual scene, in which he placed Hitchens, Vaughan, Johnston, Lanyon and himself, and 'non-figuration' as expressed in the work of Hilton, Pasmore and Frost, with Scott and Davie alternating between the two modes. Both groups examined or created space by the use of colour:

> In painting, space and form are not actual, as they are in sculpture, but illusory. Painting, indeed is essentially an art of illusion . . . the secret of good painting . . . lies in its adjustment of an inescapable dualism; on the one hand there is the illusion, indeed the *sensation* of depth and on the other there is the physical reality of the flat picture-surface. Good painting creates an experience which *contains* both. It creates a sensation of voluminous spacial reality which is so intimately bound up with the flatnesses of the design at the surface that it may be said to exist only in terms of such pictorial flatness . . . Contemplation of the 'empty' flatnesses in a painting . . . yields a twofold experience at one and the same instant: one enjoys the opaque, gritty, scratched uneven greyness of the pigment as the object, as a fashioned entity, possessing a life of its own . . . But also, one's eye passes through and beyond this painted surface and finds that illusion of a spacial configuration . . . The eye *sinks* through the surface.[7]

Heron's first group of purely abstract paintings had been made in 1952 and are reminiscent of the work of Nicolas de Staël whose first one-man exhibition in England, at the Matthestein Gallery in London, had taken place in February of that year. For Heron this was a short-lived experiment in non-figuration and he quickly returned to more representational still-life subjects. But important changes were soon to come, focussed into the last part of 1955 and 1956 by a number of coincidental events. He had finally made the decision to move to Cornwall and was in the process of purchasing Eagles Nest, the house above Zennor with its vast coastal panorama. Patrick and Delia Heron, with their two daughters, moved in in April 1956. A further powerful effect upon him was the release of energy he saw in the American paintings shown at the Tate. He had not yet visited the United States (he had refused a travelling scholarship offered to him in 1950), but was well aware of the significance of these highly innovative paintings.

From January 1956 Heron's work progressed through a series of experimental phases that separated it from its figurative associations and linked it firmly to principles of colour. He no longer used the linear grid, and with a new sense of freedom applied colour as a purely pictorial device, defining space without reference to external objects or descriptions. Loosely

brushed, vaporous surfaces related only to each other, and not to some familiar setting or event.

The paintings of 1955 have a distinctly 'tachiste' feeling, the freely-applied strokes producing a counterpoint of spatial form. The strokes grew increasingly vertical until later canvasses consisted of vertical bands of thin paint, varied in intensity and breadth. The glowing colour in these innovative paintings sprang from the experience of the flowering azaleas in Heron's newly-acquired garden. They were succeeded by a group of paintings dating from March 1957 which used horizontal bands crossing the whole canvas. The simplicity of this format allowed Heron to concentrate on the play of colour against colour, varied in its strength, although with a strong preference for full saturation, and varied in area. At the same time the paintings had a close relationship to landscape, particularly to the effect of the setting sun seen over the sea from Heron's house, which when he observed it in the paintings made him discontinue the series.

In April 1957 he exhibited in 'Metavisual, Tachiste and Abstract Painting in England Today' at the Redfern Gallery, a large mixed exhibition which showed non-figurative work being produced in England by artists young and old. For Heron this exhibition was the first showing of his colour-striped paintings, the most totally non-figurative work he had made and which pre-dates by several years work by some of the New York painters (for example Kenneth Noland). The striped paintings were later shown in a more developed form in Heron's seventh and last exhibition at the Redfern Gallery in 1958. The lack of any reference to outside reality proved to be commercially unattractive and the exhibition was not well supported by the gallery. An important painting shown in that exhibition was *Vertical Light* (March 1957), a long, narrow horizontal canvas in which broad areas of light yellows, creams and acid greens were offset against intense purple, red and violet. The interaction of these vertical stripes of colour, simply brushed on without reworking, provides a radiant and spatial movement.

Heron continued these colour experiments by combining the horizontal and the vertical into paintings which he described as 'a sort of fractured tartan'. From 1956 much of his work explored this horizontal–vertical tension, in which one or many squares covered the picture area, softly painted, floating on a dark ground, pushing up into the corners or moving magnetically along one of the canvas edges.

Heron was always concerned to plot his own progress against changing artistic events as they unfolded. In commenting upon the 1957 Guggenheim Selection (Tate Gallery) he was concerned for the future of painting and was sketching out a programme for his own use:

> Painting must return to its fullest range: non-figurative painting must now flower into richness and subtlety. Out of its strident freedoms must now grow structures of classical weight and beauty; the profoundly considered must now be permitted to glow where only the rawness of the 'spontaneous' has been allowed, 'spontaneity' has become a disease![8]

In 1959 the British art public was again presented with painters of the New York school, this time exhibited without the support of their earlier compatriots. The Tate exhibition 'The New American Painting' gave more complete coverage to the work of Mark Rothko, Barnett Newman, Clyfford Still, Willem de Kooning and Jackson Pollock. By now the art press was more prepared to assess the radical redirection that these paintings represented. A number of the artists had been shown in London since the Tate exhibition three years before. Lawrence Alloway renounced his earlier support for the English abstract painters in favour of the new American forms. He characterized the English as 'contentedly fogbound', writing of 'the usual lousy definitions of our national capacity', which he defined as 'the picturesque, linearism, love of country, the light of St Ives'. It is hardly surprising that this brisk turn about did little to endear him to the artists he had previously championed.

In one of Patrick Heron's last published reviews he wrote of the considerable distance that had been travelled towards total rejection of the subject:

> The Americans had abolished the image — that is to say the depiction of events outside the canvas itself, and replaced it with a new type of activity in which the painting became its own subject, without meaning apart from itself, there simply is not available at the present moment, it seems to me, a valid figure or mode of figuration which is not retrogressive in some way or another.[9]

In 1958 Heron finally made the decision to give up professional art criticism, and resigned as the London correspondent of *Arts Magazine*. Since then he has written only occasionally for publication on specific matters, generally those concerned with his activities as a painter. In August of that year he took over Ben Nicholson's painting studio in St Ives, the long, top-lit studio in the Porthmeor block which had earlier been one of the galleries of the St Ives Arts Society and earlier still Julius Olsson's studio.

In 1959 Heron was awarded the Grand Prize of £1,000 in the second John Moore's Liverpool Exhibition. Also that year Leslie Waddington arranged an exhibition of English middle generation painters, 'Four Painters', at his Cork Street Galleries, which included Frost, Hilton, Wynter and Heron. In his introduction to the catalogue, Patrick Heron wrote of this group who had lost valuable years in the war, and who had since been laboriously building something out of the remnants of modern art left in Europe in the late 1940s. They were the first European painters to come to terms with modern American painting, they were all aware of the importance of the American achievement and also, as they were no longer the youngest generation (being now aged between thirty and forty), they had something to make up.

By the time of this exhibition, Heron had found the broad form that his work was to follow from then on. The paintings were non-figurative, based on the abstract elements of the square and circle, freely drawn and

increasingly irregular as though Platonic geometry were being eroded and the shapes of the rock and sea of Cornwall insisted on making their appearance. His strong colour contrasts are reminiscent of the flowering shrubs surrounding his house in Zennor: hot reds with orange, violet and purple; strong yellows and blues, all of them straight from the tube. The occasional use of black serves as a colour among other colours, unexpected and vivid, with combinations of strong contrasts of tone.

Patrick Heron has repeatedly emphasized the central importance of colour to his work, and in the 1960s wrote:

> Colour is both the subject and the means; the form, and the content, the image and the meaning in my painting today ... It is obvious that the colour is now the *only* direction in which paintings can travel ... Painting, like science, cannot discover the same things twice over; it is therefore compelled in those directions which the still undiscovered and the unexplored dictate ... we are still only at the beginning of our discovery and enjoyment of the superbly exciting facts of the world of colour. One reels at the colour possibilities now: the varied and contrasting intensities, opacities, transparencies; the seeming density of weight, warmth, coolness, vibrancy; or the superbly inert 'dull' colours — such as the marvellously uneventful expanses of the surface of an old green door in the sunlight, or the terrific zing of a violet vibration ... a violet violet flower, with five petals, suspended against the receptive furry green of leaves in a greenhouse! Certainly I can get a tremendous thrill from suddenly seeing two colours juxtaposed — anywhere, indoors or out (but I am no landscape painter in disguise incidentally).[10]

From 1959 Patrick Heron's work was shown by the Waddington Galleries, and he has had a succession of one-man exhibitions of paintings and prints (an activity in which his fluent colour is well translated) in London, New York (including the Bertha Schaeffer Gallery), Montreal, Toronto and Australia. In 1965 he was awarded the Silver Medal at the eighth Biennale in São Paulo. He made two lecture-tours in Australia and in 1977 was created a Commander of the British Empire, for his services to the arts. The main developments in recent years have been in the control of large colour areas, often in paintings of considerable size, and in a greater freedom for the forms he discovers. A change in his work came in 1963 when, after years of direct painting, he returned to drawing on the canvas in charcoal, before applying paint, with a swinging, meandering line reminiscent of the contour of the coastal landscape, the necks of rock reaching into an encroaching sea, rounded boulders or pinnacles of wind-eroded granite surrounding his house in Zennor. This line became a frontier against which strong colour areas meet and turn. Heron retains maximum brilliance by the use of transparent colour, by a direct application of paint and by the 'wobbly hard-edge' at the meeting of the two colour areas. His choice of colour, and the use of the nervous, quickly-drawn lines are wholly instinctive, and allow him the greatest freedom of expression.

11 Bryan Wynter, Alan Davie and Paul Feiler

By choosing to live in a remote and exposed place Bryan Wynter submerged himself in an environment in immediate contact with weather and sea. In 1962 he wrote:

> The landscape I live among is bare of houses, trees, people; is dominated by winds, by swift changes of weather, by the moods of the sea; sometimes it is devastated and blackened by fire. These emotional forces enter the paintings and lend their qualities without becoming motifs.[1]

The paintings of the first ten years of Wynter's time in Cornwall were mostly small gouache drawings, his subjects the more remote farms or coastal villages nearby, to which he brought a sense of place heightened by the drama of unexpected events, a barren landscape invested with a special power by the bird and animal life that peopled it. *Raven* (1946) is a celebration of the bird that lived in the chimney of Wynter's own cottage. *Birds Disturbing a Town at Night* (1948) and *Foreshore with Gulls* (1949) have a dark melodrama. The birds are predatory, animated yet abstracted as they terrify the settled cottages. The late 1940s saw a new elegance of drawing, a vivid patterning of the surface, fragments of landscape and buildings dissected and re-assembled with authority and conviction. They contain an inventive association of ideas, with all the crisp assertiveness of Wynter's French counterparts, Picasso or Braque.

It was not the fellowship of the artists' colony of St Ives that had attracted him to Cornwall, but rather the character of the West Penwith peninsula with its open and abrasive qualities of coast and moor. Bryan Wynter was a true countryman, with a fondness for rough places. He was friendly and sociable, but had a great desire for solitude. Reflective by temperament, he had strong practical interests in nature, in science, particularly physics, and in canoeing and underwater swimming in which he risked the elements and at times exposed himself to danger. He had a countryman's understanding of animals, particularly wild animals and birds. An elegant, slightly mysterious man, he was thinking, cultured and aware of his *métier*. His work has a visionary quality, blended with a quizzical surrealism.

In 1948 Bryan Wynter married Susan Lethbridge. They shared their time between Carn Cottage and Susan's workshop, The Toymakers, in the Digey, St Ives, where she made colourful and inventive wooden toys for children. They had one son, Jake. Wynter participated fully in the artistic activities of St Ives. He took part in the three Crypt Group exhibitions and was a founder member of the Penwith Society. During this period he began to make frequent visits to London, and for a year had a room in Richmond where he painted. His work had some affinity with the expressive descriptions of

landscape and figure of Minton, Colquhoun, MacBryde and those artists who formed the neo-Romantic group, and he was friendly with many of them. From 1951 to 1956 he also taught at Bath Academy of Art, staying in Corsham village during term time and returning to Cornwall for the vacations. During this time his marriage to Susan broke down. He later married Monica Harman who had been a student at Bath Academy.

It was Bryan Wynter's unique qualities as a draughtsman that first attracted attention, and in the early years he worked a great deal out of doors, making direct drawings from nature. But as the structure of his ideas became more complex, the external world was more likely to be remembered than recorded. Photography contributed to the wealth of imaginative material from which he drew to record the detail of landscape and its population of birds and animals. The drawings with which he established his early reputation in London are abstractions based on his close acquaintance with the Cornish coast and landscape, the forces of sea and air cut by the razor flight of sea birds, full of lyrical invention and evocation of mood. These were shown in six exhibitions at the Redfern Gallery in London, the first in 1947, the last ten years later. His work was toured by the British Council in Spain, the USA, Israel, Portugal and Canada in a number of group exhibitions of drawings and watercolours arranged between 1951 and 1955. In 1951 Wynter was invited to exhibit in the Art Council's important exhibition '60 Paintings for '51'. He showed a large oil (now in New Zealand) called *Blue Landscape*. This was the largest (4' long x 8' high) of his paintings in the neo-romantic manner, and one of the last.

6.
Bryan Wynter,
Cornish Farm, 1948.
Gouache, 33 x 53.25cm.

Patrick Heron, a close friend since student days at the Slade and soon to be his nearest neighbour at Zennor, described the significance of the work done by Bryan Wynter during this first phase of his career:

> These early figurative works . . . were remarkable in having brought together, in the crisp and lucid design of their surfaces, two distinct worlds of pictorial experience never previously found together; namely a poetic (there's no other word unfortunately) evocation of landscape that was then still typically English, and a purely formal strength and discipline identified, in those days, only with Paris . . . The Wynter of this period fused an intense feeling for landscape with a cubist vocabulary that was totally literate by Paris standards.[2]

For a time in the mid 1950s Wynter's work faltered. In common with many of his friends he felt that the impetus of the immediate post-war years had given way to lack of direction. In 1953–5 he came to an almost complete standstill, and for a time painted little, mainly laboured landscapes about which he was unhappy.

The change, which came early in 1956, was unexpected and radical. Wynter's new work was wholly non-figurative, and there was an impressive increase in scale. From gouache paintings of up to twenty inches, he began to make oil paintings as large as sixty or eighty inches high. There was also a change in the subject — landscape themes gave way to more general ideas of movement through water, reflected in such titles as *Deep Current* (1956) and *Sea Journey* (1958), and there was a much more introspective investigation

97. Bryan Wynter, *The Interior*, 1956.
Oil on canvas, 127 x 101.5cm.

98. Bryan Wynter, *Forest Journey*, 1961.
Oil on canvas, 119.5 x 94cm.

99. Bryan Wynter,
Seedtime, 1958–9.
Oil on canvas,
142.25 x 111.75cm.

100. Bryan Wynter,
Fuente De, 1969.
Oil on canvas,
184 x 144.75cm.

101. Bryan Wynter,
Sandspoor VII (penumbra),
1963. Oil on canvas.

apparent in, for instance, *Terrestial Shadows* and *Impenetrable County* (both 1957).

The explanation for these changes lies partly in Wynter's personal life, partly in the developments taking place in the world of art. The point of change can be marked with some precision, as it is clearly seen in two paintings, *The Interior* and *Prison*, both from the first months of 1956. Each painting is without a subject — unless the 'interior' is that of the artist's mind, and 'prison' refers to the sense of confinement which he saw so well described in the 'Prison' series of etchings by Piranesi. In each of these paintings he created a curtain of paint through which we look into the depths beyond. Each separated brush-stroke is calligraphic, and in these veiled vertical layers, which Patrick Heron called 'bead curtains', he created a nebulous, floating space, in front of which he hung further veils of paint. The action of painting had now become the subject. In this claustrophobic self examination (these paintings were made away from Cornwall, in a rented studio in Chelsea that he took for three months) was revealed the mysticism that was a strong element in Wynter's personality, a search for some inner communication with the subconscious, and the idea that the artist could be an unconscious agent who could give form to the forces of nature.

It was not coincidental that these new forms of painting became possible for Wynter only weeks after he had seen the exhibition 'Modern Art in the United States' at the Tate in January 1956. His emotional rejection of his earlier means of expression had reached a point at which he was actively searching for new directions, and the American example came as confirmation of a new approach. What stirred him was the new freedom to compose a painting in terms of continuous response, as he saw in the oriental mark-making of Mark Tobey and the calligraphic sign and letter forms of Bradley Walker Tomlin. The energetic stream of Wynter's paintings over the next few years also owed something to the tachisme of the French. A particular debt that he acknowledged was to the last major series of paintings by Braque — the studio interiors — which contain the great bird that flies through the artist's studio as a mysterious symbol of the act of creation.

The sale of the family laundry business in 1956, following the death of Bryan Wynter's father, enabled him to buy Carn Cottage which until then he had rented for five shillings a week, and to build a studio on the land. For the first time he had the means to paint on a large scale with first-class materials, and to engage in more experimental work without the continuous need for teaching or the sale of small pictures.

The process of self-discovery also led him to experiment with the drug mescaline, prompted by reading Aldous Huxley's *The Doors of Perception* which was published in 1954. The principal effect of the drug is to greatly intensify visual impressions and to recover in the eye a form of perceptual innocence. Furniture and the folds of clothing, for instance, take on a

heightened appearance, as if seen for the first time; interest in space is diminished and time falls almost to zero. The taker of mescaline becomes a passive visionary, incapable of decisive action. Bryan Wynter read a correspondence in the *Guardian* shortly after the publication of Huxley's book, and, interested in the visual effects of the drug, he offered himself as a subject for a research experiment. His first trial took place in William Brooker's studio in London, attended by a qualified nurse and his painter friend. Wynter observed that objects changed form and assumed a new importance: the table top dissolved into components, its grain stratified in space. The experience of mescaline was not for Wynter 'a blinding light on the road to Damascus', as it had been for the near-blind Huxley. It was rather a new technique of looking, analogous to the recording of dreams or the use of automatic writing by the Surrealists. Drawings he made under the influence of mescaline, usually when the effect of the drug was wearing off, were disappointing. The drug is not addictive, but as a visual stimulant Wynter used it perhaps two or three times a year for several years.

The large, assertive paintings made by Wynter after 1956 continued to contain references to natural situations. The forces captured in his vigorous vertical or horizontal brush strokes produce an impression of deep space, the strength and movement of the wind as it bends grasses or whips across the surface of the sea. Networks of brush strokes reveal, yet at the same time hide this movement. Colour is not naturalistic, it is black, with strong reds and yellows and veils of earth colours. These are explosive paintings, with flashing lights and loud bangs.

Bryan Wynter required that each painting was valid in time, place and feeling, and that it gave tangible existence to a particular event experienced by the artist. It was to this sense of an imaginative reconstruction based upon clues and past traces that he referred when talking of the series of paintings called 'Sandspoor'. Wynter described this as

> a generic title of a series partly descriptive (traces left by water, wind, etc. on sand), but mainly concerned with the spoor as a record of an action. A tracker in Wilfred Thesiger's *Arabian Sands* having examined tracks in the desert is able to say correctly: 'they were Awamir. There are six of them. They have raided Januba on the southern coast and taken three of their camels. They have come here from Sahma and watered at Mughshin. They passed here ten days ago'.[3]

For Bryan Wynter the 'spoor' in the paintings were evidence of his own search for a form unknown at the commencement of the work, a record of his progress as the paintings were completed. These free calligraphic paintings brought Wynter firmly into an area of public attention and gained him an important reputation both nationally and internationally. They are large, assertive and essentially English; in every way as telling a statement of their time as the best work of Paris or New York.

From 1959 Bryan Wynter's work was shown by the Waddington

Galleries, with that of other St Ives artists — Terry Frost, Patrick Heron and Roger Hilton — now characterized as the 'Middle Generation'. His work of the early 1960s had about it an urge and an energy; there was very considerable production. But in 1962 Bryan Wynter suffered the first of several heart attacks. On regaining his health he began a series of experiments in visual phenomena which appealed to the practical side of his personality. These constructions were built in open-ended boxes in which were suspended simple paper cut-outs — the curves of boats or barges, strong zig-zags and hooks in black and white and a few simple colours, balanced in pairs before a large concave mirror, originally from a wartime searchlight. The painted shapes, moved by air currents in the room, were free to rotate; their greatly enlarged and distorted reflections appeared to move in the reverse direction, and gave the effect of being within one of Wynter's earlier paintings. He called these constructions 'Imoos' — 'Images Moving Out Onto Space'. His comment is revealing:

> My painting has long been concerned with metamorphosis and movement. My kinetic work extends but does not replace it. It is a matter of submitting to necessary mechanical restrictions to gain a new particular freedom because no other way is open.[4]

Important changes had taken place in Bryan Wynter's life in the early 1960s. The family (there were now two sons, Tom and Bill) had moved to Treverven, a fine stone-built house near the coast, south of St Buryan, and although his health was not good he continued an active physical life. He started canoeing, and this became an obsessive relaxation which found its way into his paintings. The sensation of moving on or under water informed much of the late work. For a time he turned to the mediums he had used in earlier years — drawings and gouache watercolours. A large number of drawings in Pentel pen describe the flow and turbulence of water. His last series of large paintings, and there are many of them, with titles such as *Meander, Red Streams* and *Deva* (Deva is a river in Spain which he and his family explored by canoe), have the mystery and movement of the earlier 'veils', but a clearer vision and mobility. The subject again is water, seen from above and at close quarters. The ground of the canvas (often blue) may represent the bottom of a river or the sea, crossed by the rippling motion of water passing over rocks, or disturbed by paddles. Near to the observer, the strongest shapes in primary red, blue or black give shape and structure to the surface, struck by the sun and its shadow. Yet for all their clear references, these majestic paintings are not descriptions of nature. They parallel its activities and are reflections of the artist's own experiences of it.

Bryan Wynter suffered his last and fatal heart attack while working in his garden: he died in Penzance Hospital in 1975.

A phenomenon of the mid 1950s was a change in the message of painting, from an examination of the visible world to the magic world of the

102. Bryan Wynter,
Red and Black Streams,
1973.
Oil on canvas,
183 x 274.25cm.

imagination. Forms of growth, germination from the seed and biological reproduction were expressed with mystery and understatement, suggested rather than precise. There was a preoccupation with chaos and with a dreamlike state of weightlessness. It was a version of the Surrealist 'protozoic garden' shared with the painters of Europe, particularly Miró and Braque, and with the Americans Rothko, Pollock, Baziotes and Gottlieb. Many of the artists working in Cornwall passed through this state before they discovered more personal forms of expression. This is evident in Wynter's 'curtains' of paint of the late 1950s, in Heron's free colour abstractions of the same period, and in a great deal of the work of Alan Davie from 1950 onwards.

Cornwall's fascination for Alan Davie was its association with the most distant past. He had a strong feeling for the magic of the place — for the spiritual, dynamic energy in a timeless context of its standing stones and prehistoric graves. He knew many of the Cornish-based artists, particularly Peter Lanyon, with whom he shared the experience of gliding, and Patrick Heron who helped him to find the cottage near Land's End which he acquired in 1959. He was never a member of a group, however; his independent Scottish personality refused that, but he exhibited in many of the same exhibitions from 1950 onwards, and his work shared qualities of

expressive abstraction based on his intuitive response to the world of the imagination. Alan Davie showed early talent. He was born in Grangemouth, Scotland, in 1920, the son of a painter and etcher, and had family connections with Muir Matheson the conductor and Cedric Thorpe Davie the composer. He was still a student at Edinburgh College of Art on the outbreak of the Second World War, and for a time was able to continue his studies. In 1941 he was called up, and for the remainder of the war served in the Royal Artillery on various gun sites in the British Isles.

Davie's interest in art, poetry and music continued to develop during his war service, and he turned naturally to the work of Klee and Picasso shown in London after the war. For a time he was a jazz musician, playing tenor saxophone with Tommy Sampson's orchestra. He married Janet Gaul, an artist-potter, and as an alternative to touring with a professional band, made and sold silver jewellery. Davie was awarded a travelling scholarship from Edinburgh College of Art, and from April 1948 he travelled in Europe for a year, hitch-hiking, walking in the mountains, visiting galleries and art collections.

In Zurich he saw work by Arp and Ernst in the collection of Carola Giedion-Welcker. He visited Milan and at the time of the 1948 Biennale was in Venice. Here he was able to paint, and at the same time to study the Romanesque paintings and mosaics in Padua and Torcello. Visits to Florence and the northern cities of Italy were followed by a journey south to Rome and Naples. He had an exhibition in the Galleria Michaelangelo in Florence, followed by another at the Galleria Sandiri in Venice. It was on this second visit to Venice that he made the acquaintance of Mrs Peggy Guggenheim who bought a painting to add to her important collection of modern American and European works, built up during the years in New York when she ran the Gallery 'Art of this Century' which did so much to advance the then struggling artists of the New York School. Coming as it did as part of the wealth of new influences of this remarkable tour, the sight of the collection, which included work by Rothko, Motherwell and Jackson Pollock, had a pronounced and lasting effect upon Davie. He spent the last part of the year abroad in France, visiting the south, including Picasso's studio in Antibes, and went on to Spain, to Barcelona, Madrid and Valencia.

In October 1950 Alan Davie had his first exhibition at Gimpel Fils in London. The paintings were dense, writhing forms, drawn freely in thick paint on board; overlapping, dark images of primitive intensity, with themes of blood, birth and creation, and a boldness not known in England at that time. Little attention came immediately from this first exhibition, but he continued to work with enormous energy, painting directly and in large quantity. He showed in 'Space in Colour' in 1953 and three years later had his first and highly successful exhibition in New York, at the Catherine Viviano Gallery, which in the following year held the first American exhibition by Peter Lanyon. He was one of five British artists to be chosen for the Guggenheim International Award — to be won later by Ben Nicholson.

Davie had two successful shows at Gimpel Fils during 1956, and, following Terry Frost, was offered the Gregory Fellowship at Leeds University. During a productive three years he worked through a large range of abstracted and personal forms. The paintings were sometimes dark, tormented, visceral, products of anger and confusion, but all had undoubted energy. As the long series of works progressed, so certain forms became clearer, not as evidence of the outside world, but as an understandable expression of inner life. It was during this time that Davie began to study Zen Buddhism. He found that the ability to sublimate rational process through the discipline of ritual activity had meaning both in painting and in Zen philosophy.

103. Alan Davie, *Entrance to a Red Temple,* 1960. Oil on canvas, 213.25 x 172.75cm.

104. Alan Davie, *Image of the Fish God*, 1956. Oil on wood, 153 x 122cm.

Bryan Wynter, Alan Davie, Paul Feiler

The paintings done in Leeds were shown at the Whitechapel Art Gallery in June 1958. The unassailable power, conviction and energy of the work were immediately apparent, and it was also evident that Davie's intentions and methods lay close to those of the painters working in St Ives. It was in the following year that he took a cottage near Land's End. Cornwall has affected his work from that time, but Davie does not work directly from nature. He paints spontaneously, a multitude of ideas freely expressed by direct activity, a search for something magical and mysterious, dependent neither on subject, nor on well arranged colour or line. His work is an attempt to discover within himself some truth, basically the stuff of religion, an expression of the unknowable, through signs, symbols and rituals. He finds this same direct relationship with the natural environment in other activities where he loses himself in the elements — in gliding, underwater swimming and sailing.

Another artist who shared fully in the artistic developments of the 1950s, and for whom Cornwall was an important stimulus, was Paul Feiler. His first visits to the county in the 1940s recalled childhood memories of the mountains of Bavaria. In the buildings and coasts of Cornwall he found subjects that led him from naturalistic painting to a highly disciplined form of abstraction. His concern was with the subtle and ambiguous manner in which we see and perceive. His paintings are careful constructions of space and light, with a tension and purity that lead naturally to simplification.

Paul Feiler was born in Frankfurt-am-Main in 1918, son of Professor E. Feiler, MD. There is something of the doctor about him in his precise phraseology and intent gaze; in his spare use of words and silences, reflective pauses before he defines an independent and gently assertive point of view. His childhood was secure, but, born into a family of Jewish stock he shared in the troubled circumstances of Germany in the 1920s. To escape these pressures, his parents decided to educate the children abroad. Paul went to school for a time in Holland, and at the age of fifteen came to England, to Canford School in Dorset. As the Nazi grip tightened, his father, mother and two sisters left Germany. Paul was called up for the German army, but was able to avoid conscription.

Painting had interested him from his earliest years and school had offered no practical alternatives. His father agreed that he should be given a year to try his talent as an art student; if this did not succeed he was to train for medicine — but art won. He had been in London at the Slade School for two years when in 1939 it was evacuated to Oxford. He went with fellow students to the Ruskin School.

Without British nationality, Paul Feiler was interned as an enemy alien and shipped to Canada, and during the next eighteen months was moved from camp to camp with a bizarre collection of political undesirables. This period was perhaps the most important experience of his life, a struggle for personal survival, an effort to retain will and courage in the face of deprivation. The internment came to an end with the intervention in

167

London of Randolph Schwarbe, his professor at the Slade. In 1941 Paul Feiler was released, one of a small number of artists and scientists so treated because of their unusual talent.

Returning to England, Feiler was fortunate in being offered a job teaching painting in the combined schools of Radley and Eastbourne, to replace the art master who had been called up. He remained there for four years. In 1945, conscious of the escapes he had made, he was very much aware of being a survivor. He took every opportunity to show his work in London. The controlled observation of his earlier painting had been replaced by a study of structure in landscape, based upon Cézanne, a first move towards abstraction, for him a crossing of the Rubicon.

In the following year Paul Feiler joined the painting staff of the West of England College of Art in Bristol, where in 1963 he became head of painting. The move to Bristol gave him greater contact with contemporary art activities and with those progressive artists teaching at nearby Corsham Court. From the early 1950s a great many Cornish subjects began to appear in his work, from Falmouth and the area around Mousehole and Lamorna which he had visited. Thirty-two of these paintings, together with some from Wales, were shown at his first one-man exhibition at the Redfern Gallery in January and February 1953. As a result of this successful exhibition he made the grand profit of £320, enough to buy the chapel at Kerris, in West Penwith, where he still lives. He was married now with a young family at school in Bristol, and was able to spend from four to six months each year painting in Cornwall.

From 1953 Feiler had five successive annual exhibitions at the Redfern Gallery, and American shows at the Obelisk Gallery, Washington, in 1954 and 1958. His work was included in most of those important mixed shows collating the new abstract view of painting then being formed. As successful exhibitions came one after another, he came to feel he had had too much exposure during this stimulating period. He admits that he over-produced and was over-enthusiastic for the success of the next phase. Recognizing the effect of these pressures upon his painting, he withdrew from the London gallery world for a time.

It was again Cornwall that gave Paul Feiler great satisfaction. The character of the Cornish coast connected closely with his earliest childhood experience of the Alps. The whiteness of glacier was replaced by the foam of the sea. There was the same sensation of vertigo in valley or cliff, and the same elusive quality of strong light reflecting from snow or sea, a non-space that produced unconscious echoes.

The paintings that Feiler did in Cornwall from 1954 were free, gestural abstractions infused with this quality of light reflected back from the sea. In the later years of the decade they became more formal and less dependent upon the observed world. He felt very much part of that team that had striven to make abstraction in art an accepted component in modern life, sharing with Peter Lanyon and others the sense of presenting the world with

105. Paul Feiler,
Nanjizal, 1958.
91.5 x 122cm.

a new and relevant comment. The paintings of the early 1960s have a clear, concise use of abstract forms. The colours are those of the Cornish landscape — light, clear blue, slate grey, bracken brown and green; the shapes circular and tombed like the boulders. The titles of his paintings of 1960 read like a gazeteer of west Cornwall: *Porthleven, Nanjizal, Porthcadjack, Porth Ledden, Gwithian, Portheras, Porthglaze, Botallack* and *Godrevy*.

By the mid 1960s a formal non-objectivity had developed, close to the language of Kandinsky, with pure colour sparingly used in a heavily larded white surface: the ingredients of later work laid out for use. The circle was developed into groups of concentric circles with varying contrasts of colour and tone. The square and concentric squares were used with a ladder-like progression of tonal steps to describe deepening space.

Since 1970 Paul Feiler has worked on a series of paintings which explore a progressive series of images, each a variation of the other, with carefully planned changes of emphasis. The basic components, the square, the circle and the rectangle, are chosen to produce that element of mystery that is central to his purpose. The paintings are spatial and all concerned with the relationship between the horizontal and the vertical. He has no secrets about the method of his painting; it derives from a vast formula worked out over his lifetime, which he keeps to, or occasionally breaks. He continually starts from the same premise, but at the finish each painting is different.

The titles given to the recent series — *Adytum, Aduton, Ambit* — are from the Greek or Latin, meaning a shrine or sacred place, a confrontation with mystery; the space surounding a building, or the area for action of thought. Some of his paintings are references to openings: the window in a granite wall; the mirror, a framing of space; a fire, flickering light, partly closed curtains revealing the dark night outside. They show preference for those periods of dusk or late evening when colour almost ceases to be visible, in a series of steps towards the centre which are stopped by a disc of colour or by a strong vertical band. These are wholly non-representational objects for contemplation, products of a long and sustained search.

12 St Ives in the 1950s

For those who were young and wanted to be painters, St Ives in the 1950s provided an exciting and stimulating atmosphere. The optimism of the post-war years was still evident, and the successes of the older and more established artists added fresh vigour to the ambitions of those who had come more recently. There was an expansion of thought and of opportunity reminiscent of the 1930s. The number of artists working in the town had grown considerably, and there was an exhilarating feeling of community. However strong their personal differences and rivalries, they shared an overriding feeling of participating in an important time of innovation, of discovering new art forms and of finding previously untried means to respond to the coastal landscape. They were not an inward-looking and provincial group. The range of contacts in this country and abroad had brought a certainty of participation in a larger, important international movement in art, and each was able by individual effort to affect its direction.

The Penwith Society continued to prosper, and full-scale exhibitions were held in spring, summer and winter at the Penwith Galleries. The younger artists greatly valued having work selected, for the Penwith maintained a high standard, and many established artists, including Henry Moore and Victor Pasmore (who now had little connection with St Ives) exhibited regularly. There was disagreement over Barbara Hepworth's proposal to move from the long white gallery in Fore Street to smaller premises in Academy Place, and the decision to move led Patrick Heron and Bryan Wynter to resign; both had been members of the Penwith committee and prominent exhibitors. More traditional work continued to be shown by the St Ives Art Society in its large gallery in Porthmeor Square, supplemented by one-man shows in the bookshop in Fore Street, the saloon bar of the Castle Inn, the Sail Loft Gallery run by Eleanor Gaputate in Back Road West, and in individual studios. The tradition of show days continued, with as many as thirty studios showing the work of about sixty artists at the beginning of March each year. The annual Arts Ball was a colourful spectacle.

The St Ives artists were presented to the public in London by a small number of galleries prepared to exhibit abstract art: foremost among them Alex Reid and Lefevre, the Redfern Gallery and the recently-formed Gimpel Fils. The prominence given to abstract art at the Festival of Britain brought recognition and opportunities to older and younger artists alike, and the controversial exhibition '60 Paintings for '51', toured extensively in Britain, brought the sign of official approval. The artists with Cornish connections now formed a well-defined group. Heron's 1953 exhibition 'Space in Colour' included work by Lanyon, Davie, Scott, Frost, Hilton, Heron and Pasmore. Barbara Hepworth and Ben Nicholson led the international successes with Hepworth's award in 'The Unknown Political Prisoner'

competition (1953) and Grand Prix in the fifth São Paulo Biennale (1959), and Nicholson's successes with major prizes in Pittsburgh (1952), the Ulisse prize in the twenty-fifth Venice Biennale, the Brussels Critics' Prize (both 1954), and the largest prize of his career, the 10,000 dollars International Prize of the Guggenheim Foundation in New York for his painting *August '56 (Val d'Orcia)* (1956). Their work was widely shown in Britain and abroad.

In 1956 the American exhibition 'Modern Art in the United States' was at the Tate, and two years later American artists had been widely shown in London. 1959 was marked by the slightly ominous ring of the newly-coined phrase 'Four Middle Generation Painters' to describe the work of Frost, Hilton, Wynter and Heron at the Waddington Galleries. By now it was possible to see new groupings of younger artists, who were soon to challenge St Ives for the attention of the art world.

In the 1950s many young artists came to St Ives and the surrounding area. Some, like swallows in summer, stayed for only a season. Peter Blake, Joe Tilson and Jack Smith were in the Nancledra area (between St Ives and Penzance) for a time before finding other directions for their work; Sandra Blow lived for a year in Zennor, in the remote cottage occupied by D.H. Lawrence during the First World War. The sculptors Robert Adams and F.E. McWilliam, and the painter and printmaker Merlyn Evans were all regular visitors to St Ives. For others, the St Ives experience came at an important period of formative development, and was to have lasting effect on their work. The painters Trevor Bell, Keith Lennard and John Forrester; and draughtsman Anthony Benjamin, all began to show their work with the Penwith Society in the mid 1950s, and their presence in St Ives gave added energy and enthusiasm.

Other creative talents sought a release in west Cornwall. That soaring, scathing poet Sydney Graham, who was so closely in touch with many of the painters, came to live in Madron, near Penzance; the writers George Barker, John Heath Stubbs and David Wright lived on the moors above Zennor (one of Stubbs' poems about Zennor began 'This is a hateful country'!). Other writers including Phyllis Bottome and the Canadian Norman Levine; Paul Hodin, international art critic and historian, and the eminent historian of Cornwall, Frank Halliday, all helped to create a climate of informed opinion at the highest level of attainment. J.P. Hodin observed: 'There is certainly not in this country and probably not in any country — except in large cities — such a concentration of artistic talent as we encounter on the St Ives peninsula.'[1]

St Ives in the late 1950s had an enlivening atmosphere of internationalism; it was in contact with the most progressive of the art capitals, New York no less than London. It was regularly sought out by a large number of leading New York painters, and by gallery directors, dealers and writers on art from all over the world. Many distinguished overseas visitors came to Barbara Hepworth's studio, including A.M. Hammacher (Director of the Kröller Müller Museum) who arranged a permanent outdoor collection of her

sculpture in Holland; the Director of the São Paulo Museum, and her friend Dag Hammarskjöld (Secretary General of the United Nations) who discussed a monumental sculpture for the United Nations building in New York. Patrick Heron's articles were appearing regularly in *Arts* (New York) from 1955, and international visitors also came to the studios of the younger artists. The British Council, as part of its promotion of British artists abroad, arranged many of these visits. David Lewis, the writer, who was at different times curator of the Penwith Galleries and secretary to Barbara Hepworth, acted as a guide on the Council's behalf. Those who came included Mark Tobey (a close friend of Bernard Leach who had visited in the 1930s), Larry Rivers, Jack Bush (from Canada) and Helen Frankenthaler. New York dealers visited studios and exhibitions at the Penwith, among them Catherine Viviano, Bertha Schaeffer, Elinor and David Saidenberg, and Eleanor Ward of the Stable Gallery. Martha Jackson, who made several visits was seriously interested in establishing a home for her own collection of work in a large fisherman's loft on the site of the present Barnaloft flats overlooking Porthmeor beach, and went so far as to interview possible gallery managers. The New York critics Milton Kramer, of the *New York Times*, Max Kosloff and Clement Greenberg also came. Mark Rothko's two visits to St Ives in the 1950s made a particularly strong impression on its artists, and he considered working there, but no studios were available and the idea came to nothing.

Success is seldom equally distributed, however, and some left Cornwall with a feeling of despair. Under the microscopic examination of the artists' colony, all were scrutinized and found wanting. In the words of Sven Berlin, 'everybody knew everybody; no one could live in the town for more than a week without being gutted like a herring and spread out in the sun to dry and for all to see.'[2] Berlin had been drawn deeply into the affairs which split the Penwith Society; he was temperamentally unsuited to dealing with maddening, wasteful discussions and felt the formation of laws and constitutions led to destruction of the individual. In the first Penwith exhibition he saw the selection operating as he had predicted. Most of the representational artists were out and the non-figurative people were in. He kept his membership by the acceptance of one drawing; his carving was not included (leaving Barbara Hepworth as the only exhibiting sculptor), nor was his painting shown.

Sven Berlin resigned from the Penwith Society. This meant that his work was not shown in the Society's exhibition of 1950, and more importantly was not included in the tour of members' work arranged by the Arts Council that year, nor in later British Council exhibitions. He later wrote of this period:

> with logical precision the consequences came. I was dethroned and destroyed; shunned; no one bought my work, official bodies and organisations left me alone, no council exhibited my work, no gallery was interested. My status as a

national artist had gone; in a very short time I had no influence whatsoever, or only as a trouble-maker, bad artist, a phoney, which last hurt more than any one thing.[3]

His second marriage had broken up and his first wife, Helga, who had continued to live in St Ives died of cancer. In 1960 the Town Council put a compulsory purchase order on Sven Berlin's studio standing on open ground on The Island. The studio was demolished, and a public lavatory was built. For Sven Berlin this became a symbolic act, the ceremonial destruction of artistic creation by bureaucratic forces. Two years later his house at Cripplesease, a few miles from St Ives, was destroyed by fire. Broken by his disputes with the Penwith Society and these personal tragedies, Sven Berlin decided to leave Cornwall. 'The fight with the landscape and the forces there, coupled with the fight in one's own soul was too great; that is why no one stays there, all have left as pilgrims leave a haunted city, and only in later dreams of that experience have done great work.'[4]

Sven Berlin later expressed all his turbulent feelings for St Ives in a disturbing autobiographical novel, *The Dark Monarch*.[5] The story is set in a town called Cuckoo — clearly St Ives — and tells of the artists, the relationships and shared experiences of close friends. It contains exaggerated caricatures of the different communities of the town — fishermen, commandos, artists living on whisky and phenobarbitone, children, girls, drunks, poets, tradesmen, factory workers, publicans, Salvationists, police and visitors. It is compounded of cynicism and distrust, the product of a strange state of mind produced by the war, imbalanced by the daily visitations of death, the breaking of families, the loss of children and friends. In Sven Berlin's Bohemian portrait nothing matters but to remain drunk and to indulge in riotous and exhibitionist behaviour. It is also a portrait of a town in the process of change from fishing to tourism, threatened by the figure of destruction — the 'Dark Monarch'. People of this bizarre yet familiar landscape are intentionally recognizable; his characterizations are barbed and malicious. Yet behind his wild exaggerations he succeeded in uncovering some of the less savoury aspects of the town and its artists.

In 1953 Sven Berlin left St Ives in a gypsy caravan and headed for the New Forest. The life of the gypsies held a fascination for the vagabond part of his nature. Earlier he had met Augustus John in Mousehole — in fact they were distantly related through the Slade family. In the New Forest he came to know John and his numerous family and spent time with him at Fryen Court, a form of gypsy encampment in the New Forest. He began to find friends among the gypsies and new subjects for drawing, painting and writing, and travelled with them to fairs and races, camping, coursing and poaching with them.

Another artist who left at this time was Guido Morris who in 1953 was forced to sell the Latin Press. The seven years of its existence in St Ives were the most creative period of his life. With hand-set type and antique

equipment he had produced work of great freshness and originality, ranging from the crisp 'printings' shown in the early exhibitions, catalogues for many of his artist friends and the series of 'Crescendo' poetry pamphlets, to the bread-and-butter work of trade-cards and leaflets. Financial stability was never assured, however, and Morris' artistic talents outstripped his business sense. He did not always keep to delivery dates and could not make ends meet. He became a guard on the London Underground, making a brief return to printing in 1969 following the renewed interest aroused in his work by the quarterly *Private Library*, which devoted virtually a complete edition to it. But this too failed and he returned to work for London Transport until his death in 1980.

Others continued to be drawn to the town for long periods or to settle. For them St Ives became a second home, retaining all its natural magic, yet providing a cultural base unsurpassed in the British Isles. Alexander McKenzie had moved to Cornwall in 1951 and soon became a leading member of the Penwith Society. His turning forms of landscape, the texture or rock and lichen and the white light of Penwith are expressed with elegance and economy. His work owes much to Nicholson in its pared-down spareness.

Breon O'Casey, son of the Irish writer Sean O'Casey, worked for a time as assistant to Barbara Hepworth and Denis Mitchell. From their example he trained himself as an artist and now works equally as a painter, jeweller and weaver. The forms he brings to these materials are those of primitive man, the early signs and symbols that represent birds or fish, the very essence of life. He explores a language between the drawn and the written word.

Tony O'Malley received his main training in St Ives from 1957 to 1960, in the school started by Peter Lanyon in St Peter's Loft. Born in Ireland in 1913, he began to paint in hospital after a long illness. After several visits to St Ives, as an alternative to working in a bank, he moved there permanently in 1959. His work shares the attitude to abstraction that he found in the paintings of Lanyon, Wynter and Heron, continually reinforced by his own visual curiosity. His dark-toned paintings reflect a lyrical, spontaneous feeling for the textures and surfaces of everyday objects and the sea and hills, and are invested with the poetry of a Celtic imagination. His sense of light is the light of St Ives, heightened by his frequent visits to the Bahamas, the Scillies and many other parts of the world, which have also provided inspiration for his work.

People more than places interested Alan Lowndes. He was born in Stockport in 1921 and came to St Ives in 1954, living there from 1959 to 1970. His paintings, in clear, crisp colour have an intimacy and enjoyment of the detail of everyday life. He described the ordinary events of work or recreation – the display of bathers on the beach, gulls around the fishing boats; places and events connected with people, their physical appearances (this he shared with L.S. Lowry) and bizarre occupations, as lion tamer, clown or bandit, and the places in which they lived — Albert Square,

106. Tony O'Malley, *Hawk's Landscape*, 1965. Oil on board, 61 x 122cm.

107. Tony O'Malley, *A Table*, 1959. Acrylic and collage on board, 43 x 55.75cm.

Manchester, or Smeaton's Pier, St Ives. His style of painting was far removed from the abstraction of many of the St Ives painters, but his friendly tolerance and knowledge of the art of the past and the present, his love of conversation and sharp wit made him very much part of the artists' group.

With the notable exception of Peter Lanyon, few of the artists were native-born Cornish. Those who were added a personal dimension, based on close identification with their subject. Jack Pender is a Mousehole man. The war, then art training and teaching kept him away for twenty years, but the obsession of Cornwall remained and in the late 1950s he was home again, to work in Mousehole and to play a leading part in the exhibiting societies of St Ives and Newlyn. The activity of his native fishing village has been his pre-occupation and the main subject of his painting. The walled semi-circle of Mousehole's tiny harbour has been a subject for many generations of painters, from the early days of Newlyn to Christopher Wood and William Scott. It is with the work of Scott and Robert Colquhoun that the abstraction of Pender's painting may be compared. His black-outlined analysis of the quays, boats, ropes and rigging emphasizes their weight and bluntness of shape, and each has a structural part to play in the painting.

Margo Maeckelberghe was a Penzance girl. She studied at Corsham Court when Scott, Lanyon, Wynter and Frost were teaching there, and her paintings of the landscape of West Penwith search out the high places and wind-swept moors, the effects of weather and the closed shadows of the coast, all based on her observation of a well-known scene.

Bryan Pearce was born in St Ives, into a family long connected with the town. He received his training at the St Ives School of Art, initially as therapy for phenylketonuria, the nervous disease from which he has suffered since birth. He accepts the familiar world of St Ives with quiet pleasure, and has the ability to express himself in paint with an intensity and conviction that escape many more sophisticated painters. To the streets of Downalong, the busy life of the harbour and the spectacle of working boats and pleasure craft (all subjects he shares with Alfred Wallis) he brings a heightened awareness of incident and detail that make up the changing scene. His view of places he has known since childhood is precise yet unexpected: each granite boulder forming the wall of a cottage, each sea-worn pebble is valued for the shape and colour it adds to his inventive compositions, and expressed with a bold sense of design and clear, strong colour.

John Milne had come to work for Barbara Hepworth in 1952 at the age of twenty-one. He began to exhibit his own sculpture in the early 1960s. By choosing to remain in St Ives and setting up his workshop there, John Milne drew upon similar sources to Hepworth — organic abstractions from the elemental forms of nature. His sculpture is massive and solid, frequently made in highly polished metal which dissolves the surface by its reflections. The most powerful and personal forms in Milne's sculpture are those which echo the inspiration he found in the culture of exotic places. From his earliest youth he had travelled extensively in Mediterranean countries and

108. Bryan Pearce
St Ives Harbour from Smeaton's Pier, 1950s

109.
Jack Pender,
Pregnant Punt, 1950s

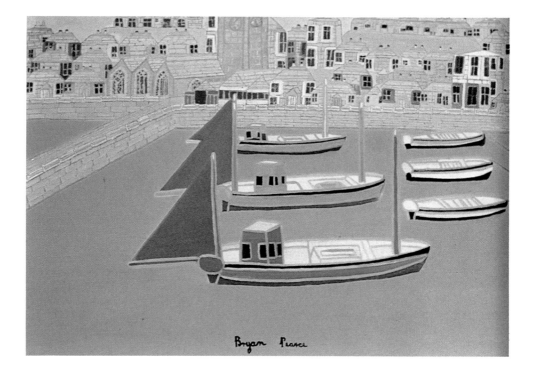

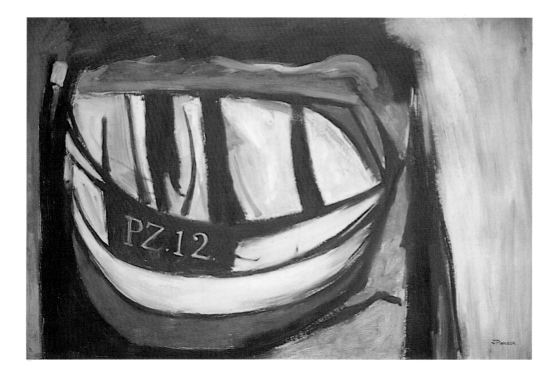

was much influenced by the landscape, architecture and early art forms of Morocco, Persia, Turkey and North Africa. Their powerful associations found a central place in his work. His energy and considerable output were cut short by his early death in 1979.

Brian Wall, one of the earliet of the minimal sculptors to work in Britain, was an assistant to Barbara Hepworth from 1954 to 1959. It was during this time that his work developed an abstract aesthetic. He began to construct open wooden boxes painted in primary colours which demonstrate a pre-occupation with architectural forms and are as abstract as Mondrian's paintings or Nicholson's most austere reliefs. The black, welded steel boxes that appeared next have the elegance of an engineering diagram, regular squares and rectangles, floating circles or rings; a spare description of open space that owed little to Hepworth's more organic carving. Brian Wall returned to London where he played an important part in the new forms of abstract sculpture that parallelled American Abstract Expressionism in the 1960s. He later moved to Berkeley, California, and has since established an important reputation in the United States.

In 1958 west Cornwall attracted another sculptor, Paul Mount, who had spent several years working and teaching in Nigeria. He was drawn not by the presence of other artists, but because the area was remote and beautiful. He set up a sculptor's workshop in St Just in Penwith. Paul Mount had trained as a painter at the Royal College of Art during its wartime evacuation to Ambleside and later after war service, but naturally practical he worked as an architectural sculptor and interior designer in West Africa. In Cornwall he worked on a smaller scale in cast metals, brass or bronze, iron and stainless steel, and his highly polished cast forms soon began to attract the attention of dealers and critics in London. His work takes two main forms: open constructed mobiles free to turn in complex motion, whose thorny, spiky growth is that of the moors above his home, and massive cast metal forms, dull, weathered and grained by exposure, or highly polished to reflect the colours and light of the environment.

The darker and more turbulent moods of Cornwall had been seen by David Bomberg, who had painted a number of canvasses during a summer visit to the north coast of the Penwith peninsula in 1947. His paintings speak of the changes of weather, scorching heat or driving wind and rain, the most extreme movements of the sea, and the strength of form in the granite landscape. In *Pendeen* (1947) he sees the bleak hills and strong late summer sun in red and ochre, a form of expressionism unfamiliar to most of the St Ives artists.

Francis Bacon spent four months in St Ives, preparing for his first exhibition at the Marlborough Galleries in 1960. It was not the landscape of West Penwith that attracted him; the paintings he made in a borrowed Porthmeor studio were of the human figure as a tormented being, rent by strong emotional forces. Karl Weschke, who had recently come to live in Zennor, came to know him well, and found him surprisingly generous in

110. Paul Mount,
Pièce Héroique, 1964.
Cast iron,
height 76.25cm.

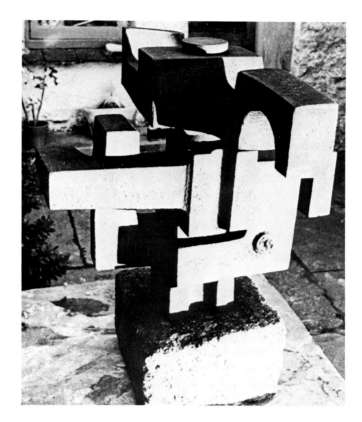

his comments for one who had already acquired such an aura of remoteness. Weschke shared Bacon's concern for suffering and violence. He felt that Bacon, who had a sheltered existence, had sought out violence, whereas he, Weschke, who had experienced violence, sought shelter.

Karl Weschke was born in Thuringia in Germany in 1925. His childhood was unsettled and deprived, and his upbringing was mainly in children's homes. In the early 1930s it was natural for Weschke to become involved in the sweeping, militant optimism that erupted in Germany; but he was too young to join the army on the outbreak of war and, unable to follow his wishes to become an ornamental blacksmith, was put into a government insurance office. In 1942 he joined the German Air Force and two years later transferred to the paratroops, to a unit making raids on English and Canadian positions. In 1945 he was taken prisoner in Holland and brought to Britain.

It was then that he began again to paint and to sculpt. In the summer of 1948 he was civilianized in Scotland, and because of his marriage to Alison Devere was allowed to remain in Britain. His formal art training was limited to one term at St Martin's School of Art in 1949. He soon became convinced of the truth in the remark of one of his tutors, that artists are not made in

colleges. While at St Martin's he met Dorothy Mead and through her Cliff Holden, both members of the Borough Group. He resisted meeting David Bomberg, their teacher, because he did not wish to accept his sytem of teaching.

In the next years Weschke earned his living by odd jobs as he slowly discovered his direction as an artist. He wrote to Bryan Wynter, whom he had met in London, asking if he knew of a cottage in Cornwall. Wynter replied that Tregerthen Cottages in Zennor were a possibility, and Weschke came to Cornwall. He showed the first group of work painted in Cornwall in his first one-man exhibition at the New Vision Centre in London in 1958. The critic John Berger wrote an enthusiastic review describing Weschke as 'a young painter worth going to see and worth remembering for a long time. Heavy coarse pigment, a little like Bomberg'. (Berger's later book, *An Artist of our Time*, whose central character was a European *émigré* finding his way through the complex world of London galleries, and trying to keep unbroken certain spiritual threads, was based partly on Weschke.)

Weschke remained somewhat apart from the artistic groupings in and around St Ives, although he had many personal friends there. His decision to live by the sea and to pit himself continuously against it is revealed in his paintings. In 1960 he moved from Zennor to the remote and ruggedly exposed headland of Cape Cornwall. This has been mined for copper and tin since prehistoric times, and is intruded by the deep seams of the Wheal Edward zawn and the mines of Levant, Geevor and Botallack. To the south are the terrible rocks of The Brisons and the cliffs of Land's End, scenes of many wrecks. Karl Weschke's large canvasses describe this landscape and the extreme turbulence of storms and gales which in the winter months converge on his cottage. *Sturmflöten* (*Gale*, 1965–6) describes the gathering forces of the wind approaching from the sea, a wind god reminiscent of the vignette drawings on old maps, blowing pan-pipes to produce a raging wind. The shapes of pipes and jets of wind echo the unseen geometry of the gale, a combination of the observed and the visionary.

Weschke portrays the relationship between people and places, often by sexual analogies — the action of water falling over rounded rocks; the motion of the sea; towering verticals of cliff face, with which he surrounds the naked female figure. He emphasizes the vulnerability of the individual against brooding nature, informed by observation and the recall of a particular moment. In the routine of existence something suddenly strikes: a man astride a horse against the setting sun may be transformed into an apocalyptical vision of a knight in armour. There is also an ambiguity: the lying figure may be sunbathing, or it may be sacrificial. Hooded, standing figures have an air of ritual, while a snarling dog adds tension to the painting. Weschke is fascinated by the relationship between man and animal, and horses and dogs occur frequently. (His borzoi, Dankoff, whom he painted many times, lies buried in a cave below the house.) His landscape has a fatalistic primitiveness and bareness.

13 Roger Hilton

A regular visitor to Cornwall from 1956 was Roger Hilton. For some years before this he had been associated with the St Ives painters through personal friendships, in particular with Patrick Heron, Terry Frost and Bryan Wynter, and by showing with them in many of the important mixed exhibitions in London that established their work in the public eye. The free, expressive qualities of his work reflect his training in Paris in the 1930s, and in post-war London he became a one-man French outpost. With wit and intelligence he explored the basis of his art and forever questioned the means of its expression. In 1965 he came to live in Cornwall, and as his association with the place deepened his work became less abstract and more figurative. Emotional intensity was combined with a relaxed, casual freedom and improvisation. His paintings were witty, often with a healthy eroticism, and his natural talent responded to the scratched charcoal mark, the ragged brush stroke, the loose scumble of paint, and the immediate response of a full brush.

Roger Hilton was born in 1911, the son of a prosperous doctor, and brought up in the fast-growing suburb of Northwood near London. The family had a keen interest in the visual arts, Roger's mother had trained at the Slade, as had his father's brother who became an art teacher. Roger's early training was in medicine, but it soon became clear that his main talent was in art. It was natural that he should look for training in London at the Slade School, and in 1931, the last year of Henry Tonks' professorship, Hilton began a slow and somewhat unsatisfactory training. He was by nature reflective and hesitant about his work: thought could precede action to the extent of long unproductive periods in which his ability was in doubt. Towards the end of his second year at the Slade he decided to continue his training in Paris, and with an allowance of £150 a year from his father was able to 'live like a Prince'. Over the next six years he made many extended visits to the French capital, working mostly at the Académie Ransome under Roger Bissière. From Bissière's teaching he gained a solid constructional foundation for his painting, based upon French logic and simplification of form. Although Bissière's own work verged on abstraction, his teaching emphasized the more traditional forms of observation, the value of restrained, considered colour and the importance of the mark made 'first time'. Hilton realized the need to assemble his ideas before committing them to canvas, and above all to trust in his own sensibilities. His experience of Paris familiarized him with other aspects of French culture, and he acquired an independent Bohemianism and originality of thought and action.

On his visits to England, Hilton began to exhibit his work. He had his first one-man show in 1936 at the Bloomsbury Gallery, London, and his work

was selected by Duncan Grant and Vanessa Bell for a Coronation exhibition at Agnews in London in 1937. The experience of Paris was to be of the greatest importance throughout Hilton's working life, for it was at this formative time that he came to terms with his own existential situation. He later wrote, 'There is no difference between painters and any other creative individuals. They are all conducting a life and death struggle with existence.'[1]

During the Second World War, Hilton was a member of Commando Intelligence and was in action in Yugoslavia and in the raids on Norway. He was captured at the Allied Commando raid on Dieppe in 1942 and spent three years as a prisoner of war in Silesia, which ended with a forced march on starvation rations before he was released. For Hilton the war was a taxing experience and his resumption of painting after the long interruption was not easy. In his self-portrait drawing of 1946, a thin-faced, fair-haired young man looks coldly at the mirror. There is an understated quality about the central features: small mouth and nose, eyes large and searching behind rimless spectacles, a wide, furrowed brow. The drawing has an air of enquiry and self doubt, a belief in his own intelligence, yet an awareness of his vulnerability. It has a durability of expression and character, subtly built up with strongly-drawn contours.

In 1947 Hilton married Ruth David, a violinist and teacher of music. The following year their first son, Matthew, was born and in 1950 a daughter, Rose. Hilton's paintings of these years began as a continuation of the work done before the war and were close to his French sources. They have a light touch, impressionist cubism based on observed or remembered situations. Then he began to establish a more personal style with a sensuous disorder, 'light glowed and ripe fruit sploshed in an overgrown Klee garden'.[2] He used a more subdued and sombre range of tones with patches of rich colour embedded in black, spiky forms.

At a time when a new spirit of romanticism was clearly seen in British art, Hilton chose the radical alternative of abstraction, a decision that was to bring him into close contact with many of the painters in Cornwall. His first abstract paintings dated from 1950 — sombre impressionist colour with a broken paint surface, and a loose arrangement of lightly-stated forms. His first post-war work was hung in a mixed show at the AIA Gallery in London, and in 1951 he exhibited in 'British Abstract Art', also at the AIA, with the group including Victor Pasmore, Kenneth and Mary Martin, Terry Frost and Adrian Heath.

The paintings in Hilton's first one-man show since the war, at Gimpel Fils in 1952, were essentially inspired by the School of Paris. Strong colour was freely applied with a loaded brush, shining as jewels in his charred and blackened structures. This successful exhibition was followed by further one-man shows at Gimpel Fils in 1954 and 1956, and by work in a number of mixed exhibitions in London. During these years Hilton taught art at Port Regis Preparatory School and at Bryanston. From 1954 for two years he

taught life drawing one day a week at the Central School of Arts and Crafts in London.

In 1952 Patrick Heron introduced Hilton to a Dutch artist, Niewenhuys Constant. Constant had been associated with the Cobra group of artists, mostly Scandinavians, whose work, characterized by their leader Karel Appel, made use of strong colour freely applied in emotional, intuitive statements; later, influenced by Mondrian's rationale of total abstraction, Constant painted large, spare abstracts, angular forms in black, red or brown on a field of white, the colour thickly laid with a knife. Hilton was much attracted by the freedom of this work and became a close companion of Constant's, returning with him to Holland to see the Mondrians in the Hague and Amsterdam. This visit motivated an immediate and radical simplification in Hilton's own painting. The multitude of spiky crossings and intense coloured areas of his earlier paintings gave way to a few linear divisions roughly following the vertical and horizontal — spare, spiky Mondrian grids of black lines in webs of solid white, with occasional flashes of colour intruding upwards from the edge of a painting.

Hilton had reached this stage in his development when he participated in Alloway's review of avant-garde directions, the publication *Nine Abstract Artists*. His paintings illustrated there have a clumsy alertness, their roughly geometric areas echoing and resounding off each other. They are not repetitive, for Hilton had an ability to ring changes within the simplest group of improvisations, as he himself put it, 'in such a way as not to interrupt the flow of space; so they will as it were, bear witness of space'.[3] This phase in Hilton's work was a rich and necessary development, but he began to feel its limitations. He wrote:

> I embraced neo-plasticism and continued in this way until 1954 when the fear of being driven out of painting altogether by its too cold and limiting ideas drove me back again gradually towards paintings of unabashed sentiment. From this it is but a step to unabashed figuration; though this is not easy to integrate with the new ways of painting acquired during the preceeding more abstract phase.[4]

With the reduction of his work to a linear structure, Hilton felt that a possible choice lay within constructed work, a course chosen by Victor Pasmore and Anthony Hill. Yet this rationality lay outside his own intuitive search. He put his dilemma succinctly: 'For an abstract painter there are two ways out or on: he must give up painting and take to architecture, or he must re-invent figuration.'[5] Hilton chose the latter course. In place of architectural purity, his work developed a looser, more relaxed, sometimes casual air. His paintings were no longer purist icons, they took on a new crude identity, uncomfortable and abrasive, but with great presence and character, and increasingly included references to landscape or figure. Scribbled and noted forms gave personality and identity to the pictorial elements. The few figurative components were allowed to emerge from the architecture of the

111. Roger Hilton, *February 1954*, 1954. Oil on canvas, 127 x 101.5cm.

112. Roger Hilton, *October 1956*, 1956. Oil on canvas, 75 x 90cm.

painting. There was an emphasis on sexual identities — loosely-scribbled genitalia, breasts and buttocks — and a relaxed, scrawled indication of pose or fragmented limbs and torso emerged, as he explained it, 'a synthesis of Mondrian and Picasso'.

Hilton spent Christmas 1956 with the Herons in Cornwall. From then on his visits to St Ives and Newlyn were increasingly frequent. However, he was sceptical of much that he heard about the qualities of the peninsula, and afraid of being 'sucked into a provincialism'. But he soon saw that it was 'easier and cheaper to live there, a great landscape to move about in, and always somebody to talk to about the work'.[6] In May 1957 Patrick Heron wrote a highly complimentary article about Roger Hilton, who in his opinion was 'destined in time to enjoy an international status as high as that of any painter of his generation yet known to me'. Heron went on to describe Hilton, 'his own wry humour, his thin, tall, slightly round-shouldered figure, his small bird-like head with its small, very sharp, slightly down-turning beak of a nose that pecks its way into anyone else's arguments till they resemble torn bits of paper'.[7]

Hilton possessed a leaping logic that constructed experimental ideas upon traditional foundations, a sense of moving from a principle not fully understood, but strongly felt, wondering at an event about to happen. Abstraction had been a cleansing experience, but for Hilton:

> Abstraction has been done, not so much to a positive thing, but to the absence of a valid image.
> Abstraction in itself is nothing. It is only a step towards a new sort of figuration, that is, one which is more true.
> At the frontiers of what had been done and what is about to be done stands the creative artist. The unknown facing him like an abyssal orifice.
> He must jump!
> Freedom?
> That he has.
> But such freedom as not many can stand.
> The adventure of pursuing into that which can only be speculative is the daily drudgery of the painter.[8]

113. Roger Hilton.

114.
Roger Hilton,
March 1960 (Ochre),
1960. Oil and charcoal
on canvas, 76 x 64 cm.

A new, more clearly human figuration entered his work in the late 1950s, clearly suggested by torso or legs, by signs for breasts and genitals. These components were freely made — the assertive yet casual marks of a loaded brush; the scratch and scrape of charcoal drawn hesitatingly through drying paint, a loose and jagged contour across a cloud of freely-brushed colour. These were the seemingly simple means he employed to explore his highly personal view of the world. A secondary feature, increasingly revealed, was the levels of interpretation placed upon features in the paintings. A floating, freely-brushed shape might carry implications of the figure — usually female — an aquatic animal, or even some feature of landscape. Paintings of the early 1960s such as *Oi Yoi Yoi* and *Dancing Woman* (both December 1963) rejoice in the human figure, free and full, lying, leaping or posing erotically.

115. Roger Hilton, *Black and Brown*, 1958. Oil on board, 23 x 30.5cm.

This was Hilton's answer to the Pop movement then assuming ascendency in England and America. But he did not look to American culture and continued to draw on his French sources. Here he was closest to Matisse.

From 1960 Hilton's work was shown frequently by the Waddington Galleries. It was also toured in a succession of exhibitions arranged by the British Council, to the United States, Canada, Mexico, the USSR, Italy and Holland. In 1963 his large, landscape-based painting *March 1963 (blue)* won the John Moore's competition in Liverpool. The following year a selection of his work was shown in the Venice Biennale.

In the late 1950s Hilton took a cottage in Nancledra and used a studio in Newlyn overlooking the harbour. By now he had met Rose Phipps, soon to become his second wife, and in 1965 he moved with his second family, including the two boys Bo and Fergus, to a small cottage close to the sea, on Botallack Moor, near St Just. From this time he scarcely ever left Cornwall.

In Hilton's paintings of Cornwall, rubbed or brushed areas of paint describe coast and misty sea, foliage or rock. A few looping lines indicate

116.
Roger Hilton,
*Large Orange, Newlyn,
June 1959.*
Oil on canvas,
153 x 137cm.

the roundness of a hill or the rising disc of the sun. The continuous
metamorphosis of the figure and its environment reveal a deeply-felt
sexuality, the juxtaposition of the erect male shape with the serpentine line
of the female. This synthesis of free abstraction with the physical world is
among the most personal and satisfying of Hilton's work. He used the
shapes of boat (a crescent) and pier (a projecting band of colour), and sea,
sky and land mass indicated by textures of thin or thick paint. The essential
was to escape banality by discovering expressive arrangements which fused
landscape with animal forms. Groups of softened colour, umber and azure
blue, were overlaid with sweeps of sizzling ochre; a shorthand calligraphy
of black dashes span the surface. There is surprise and innovation from
picture to picture, and an awkward, self-searching quality as abrasive and
perverse as the artist's own character. The architecture of the painting is
ravaged by time, archetypal and primitive, eroded or assaulted by graffiti.
Miraculously it retains its proportion, balance and strength.

117. Roger Hilton, *Drawing of a Young Girl*, n.d. Charcoal on paper.

118. Roger Hilton, *A nuedina*, n.d. Charcoal on paper.

Hilton's last years in Cornwall took on a more fevered pattern. In the mid 1950s a noticeable change had taken place in his personality. The wit and humour he had always displayed became increasingly remorseless to family and friends. Always unimpressed by reputation and success, his own and others', his behaviour became more outrageous in public. Alcohol contributed to the deterioration of his health and his work was affected. By 1966 he had peripheal neuritis and a skin condition which gave him extreme discomfort. He was unable to paint on a large scale and by 1972 could walk only with difficulty. Working from his bed he began to produce a large number of small gouache paintings on paper. This medium gave his work a totally informal character and he produced drawings of the nude, comments on his own situation and jokes against his family. Circus-like in colour and movement, sometimes erotic or black and violent, at other times they were

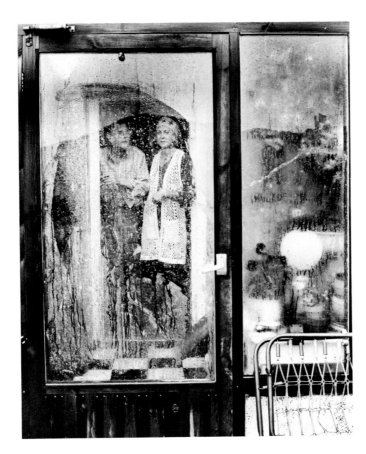

119.
Roger and Rose Hilton,
1975.

sunny or very funny. His bedroom on the ground floor became a studio living room, a meeting place for those friends prepared to accept the cruel wit that so frequently entered his conversation. His horizons were bounded by the small bedroom, a view through a narrow window, food, drawing materials and painting, his radio, friends and animals, and above all his wife, Rose.

Naturally left-handed, he was forced to learn to paint with his right hand, because of the need to relieve pressure on an infected elbow. A succession of images poured from his bedroom studio during the last years of his life: clowns and circus characters, pet animals, wild beasts, the artist himself, sometimes helpless in a wheelchair or pulled along in a boat; above all, and centrally, the female nude. These recurrent themes had an extraordinary duality: pleasure in sexuality and relationships; anguish at the human predicament. Matisse-like in their spare, nervous line, the limbs of the figures spread in a classical regularity, solid against void.

During his long illness, in the sleepless hours of the night, Roger Hilton wrote to his wife Rose, or to one or two friends, a series of letters — a

120.
Roger Hilton, *September 1963 (figure and bird)*, 1963. Oil on canvas, 117 x 178cm.

revealing, moving self-portrait in the last stages of physical deterioration. Decorative and highly personal, they were at the same time a commentary upon the trivial details of his dependent life and a psalm for its agony. Long lists of purchases to be made and instructions were strewn with perceptive comments on life and art. A typical letter is interspersed with drawings: Rose Hilton in a new dress, pheasants conversing politely, and as a tailpiece a dog leading an ornamental Bath chair which carries the recumbant artist holding a flower. The carriage called 'a Nuedina' is pushed by a nude figure past a mine engine-house. Throughout this tormented period, aware of his failing body, yet hopeful for recovery, there was no deterioration of mental attitude. Fantasy entered the drawings, but as part of his struggle to find expression through work; there was some self-doubt and frequent exasperation at his crippled state. At times the letters expressed sheer despair. In a letter written at 3.45 a.m.:

> My God, 4 hours to go. How is it I have run so low? Potters window is rattling. In short I am miserable, I have lost faith in myself and my work.[9]

In 1974 the Serpentine Gallery in London arranged a retrospective exhibition of Roger Hilton's work: one hundred and thirty-two paintings and drawings, spanning his working life from a Slade painting of 1931 to a large group of gouaches done in 1973. The overriding impression was of vitality and pleasure in the expression of colour and inventive line. Hilton was able to attend the exhibition, but by this time his body was exhausted. He continued to refuse treatment, and in defiance of the advice of doctors

121.
Roger Hilton,
Oi Yoi Yoi!, 1963.
Oil on canvas,
152.5 x 127cm.

and friends, he decided to pay a last visit to France. With an advance from his dealer, he arranged for a small private aeroplane to take him and his family from St Just Airport to Cannes, and from there they went to Antibes by car. The little seaport and its strong associations with Picasso gave him many subjects. He was able to work and produced a succession of gouaches of the boats, the holiday scene on the beach and a small visiting circus. This journey to France was the last occasion on which he left his bed. Some six months later, in November 1975, shortly after the death of Bryan Wynter, he had a fatal stroke. He is buried in the cemetery of Carn Bosavern above St Just.

14 The importance of St Ives

The 1960s produced a sub-culture that had a powerful effect on the visual arts. A new generation had grown up with no memory of the war, and with new-found economic independence. American imports — clothes, magazines and rock music — put the emphasis on youth. Older artists, whose careers had been interrupted by war, faced a generation with its own alternative culture: the world of the Beatles, Carnaby Street and Mary Quant.

Meetings at the Institute of Contemporary Arts in the early 1950s had resulted in the formation of the Independent Group, whose members included painters, sculptors and a number of distinguished architects and critics. Many of them were preoccupied with the integration of the arts, but their ideals were far removed from those of the Abstractionists of the 1930s. In the exhibition 'This is Tomorrow' at the Whitechapel Gallery in 1960, twelve groups of artists and architects, members of the Independent Group, put forward their views. Richard Hamilton, working with John McMabe, and architect John Voelcker based their section of the exhibition on the evidence of mass commercial culture portrayed by the American cinema and magazines, a culture with its own mythology of style and its own art forms, established through hard-selling advertising. This essentially urban culture was far removed from the landscape-based art of the St Ives artists.

Two main directions in painting grew out of this exhibition. Pop painting, as proposed by Richard Hamilton, Peter Blake and others, was an intelligent eclecticism that drew upon the American life-style: an expanding society of consumer goods and sanitized sex. The other direction was that of the American Abstract Expressionists. The formal, large-scale work of the non-representational painters, Newman, Reinhardt, Rothko and Still, rather than the earthy atmospheric painting of de Kooning, Pollock and Kline, interested some of the young British painters, many of whom had recently been students at the Royal College of Art. When in 1960 a group of these, including Robin Denny, Richard Smith, Harold Cohen and John Hoyland, arranged the London exhibition 'Situation', it was to demonstrate their adherence to this totally abstract and large-scale format for painting. It was significant that the work of the St Ives artists, which in so many ways answered this description, was omitted. In his introduction to the catalogue, Roger Colman referred to the 'landscape, boats-figures' of the St Ives painters as evidence of their avoidance of the real problems of abstraction.

The changes that affected British art and attitudes in the 1960s led to a withdrawal of support for much of the painting and sculpture by then identified as 'St Ives'. Ironically, this happened just as a number of artists were about to embark on some of the most ambitious work of their careers. From about 1960 the St Ives artists were in a sense an embattled group. In

the John Moore's Exhibition of 1963, the first prize in the open section went to Roger Hilton; none of the other St Ives artists was among the prize-winners.

The reputations of the St Ives artists had changed dramatically with the passing years. The leaders of the 1930s, Nicholson and Hepworth, then admired by only their close friends and supporters, and within the narrowest of avant-garde groups, had emerged into the post-war world, seen by many as ivory-towered intellectuals. As their outrageous claims were seen to be justified, so they became establishment figures of great influence in the measurement of cultural taste. As individuals their work and reputations were by then little affected by changes of style or public appreciation.

When the revaluation of the new American painting was seen in the mid 1950s, the 'middle generation' of St Ives artists — Lanyon, Wynter, Hilton, Heron and Frost — were better prepared than those of any other European country to meet the challenge. In many ways they shared the same influences as the Americans, a direct experience of the innovative discoveries of the 1930s abstraction, but modified by the soft climate of Cornwall. In the exhibitions in New York in the late 1950s and 1960s, the English artists met the Americans as participating equals. Patrick Heron is deeply conscious of the two-way influence between American and British artists and has argued at length that the British contribution has been considerably undervalued. In 1974 he detailed his views in a series of extended articles in the *Guardian*,[1] noting that in the ten years from 1956, those British artists most closely associated with St Ives (Davie, Lanyon, Scott and Heron) had held a total of fourteen one-man major exhibitions in New York, showing New York their most recent discoveries before London. This, and the high regard that American artists had for their British colleagues, is an indication of the international significance achieved by the 'middle generation'. It was they who now did so much to bring the group to the fore in British art. A continuous search for new forms of expression with powerful and under-standable analogies, drew together the earlier forms of free abstraction welded with the hidden currents of Surrealism.

In the late 1950s and 1960s the town of St Ives began to attract summer visitors as never before. Townsfolk and artists alike felt the pressure, as from June to September the town was overwhelmed by cars and visitors. Under this invasion much was eroded, yet the artists still sought to provide an environment in which they could continue to work.

In 1960 a new phase of activity began for the Penwith Society, with an ambitious scheme for a complex of exhibiting galleries and studio-workshops. In the centre of Downalong, the Society took on the premises in Back Road West of an old pilchard-packing factory, an open yard surrounded by lean-to buildings supported by rough granite pillars. With great energy on the part of the committee, and the notable support of Barbara Hepworth

and Bernard Leach, an imaginative scheme of alterations was prepared by Henry 'Gillie' Gilbert, an architect long associated with the artists of St Ives. The open yard was roofed to form a gallery and the asymmetric design formed by the granite pillars made an exceptional viewing space for pictures and sculpture, with light pouring in through its central area. Three studios for working artists were created above, and a print workshop on the site of St Peter's Loft School. These improvements were made possible by generous grants from the Gulbenkian Foundation, the Arts Council and St Ives Borough Council. Further improvements were made in 1968 and in 1970 it was decided to acquire the large adjacent property used as a garage, and a row of cottages fronting on to Back Road West. Again the artist members, led by Barbara Hepworth, sought funds to create this unique complex of galleries, studios, workshops and living accommodation, which continue to play a major role in the artistic life of St Ives and its area.

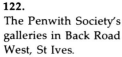

122.
The Penwith Society's galleries in Back Road West, St Ives.

In assessing the role of 'St Ives' in national and international art, is it possible to talk of a St Ives 'school'? There was no agreed artistic policy or set of principles shared between members of the group: artists from in and around St Ives have included many differing talents, loosely bound by friendship or artistic direction. Strong-minded individuals have produced statements of great conviction, and equally strong disagreements have taken place. Yet there was definitely a recognizable 'St Ives' character, one that brought abstraction into free play with landscape elements. It was non-formal, atmospheric and energizing, and typified by the use of bold and vigorous shape and colour. In British art it added the dimension of the wilder and more remote outdoors; internationally it shared fully in the liberating ideas that radically changed the artistic climate of New York,

London and Paris in the 1950s and early 1960s.

The first decision by Nicholson and Hepworth in 1939 to come to St Ives was taken by chance and in haste, when the invitation of a friend offered the possibility of continuing their work and providing shelter for themselves and their children in wartime. The second decision — to remain in St Ives — was taken more slowly, as they gradually came to know the area. They did not come to St Ives from any sense of continuity with the artistic tradition that had preceded them, and had little interest in the work of earlier painters there. They paid little attention to the individual artists still in the town, with the notable exception of Alfred Wallis who, with the direct expression of an untutored eye, conjured up that earlier dream state to which Nicholson had responded so strongly when he first saw Wallis' work. Nicholson's early impressions of St Ives and its surrounding villages share that toy-like quality and wonder which 'left images in the mind', as his work developed in new and unexpected ways.

The works of art produced by Nicholson and Hepworth were not only descriptive of their environment. Although they drew deeply on the light of St Ives, and the natural grandeur of its surrounding scenery, they were not content only to comment upon these features, as many had done before them. They placed a higher value on their work, and saw art as one of the great unifying principles capable of affecting the lives of all people, a force for order and a constructive principle which could overcome differences of race and culture. This was the message they had discovered in the 1930s, when for a short time London had been at the centre of the international movement, and they had helped to form an art which included all aspects of design, architecture and town planning, in addition to painting and sculpture. In this sense the work they did in St Ives must be seen in the larger context of their whole working lives, and as an important part of their developing experience.

During the war years the enlivening friendship of Adrian Stokes, and the intellectual support of Naum Gabo helped their work to evolve into a new dynamism of shape, in a constructive art form in which geometry was created from the waves and the wind. During this investigative period Ben Nicholson softened the severity of his earlier abstractions with the informality of his new surroundings. In a long series of paintings he fused a remarkable combination of this new and relaxed abstraction with the light and landscape of St Ives. After he left St Ives in 1958 he had a further full career. His paintings and abstract constructions continued to be shown world-wide, and the important work done during his seventeen years in Cornwall reached even wider audiences.

In St Ives after the war, Barbara Hepworth discovered new and personal responses to the coastal landscape and its ancient associations:

> A thousand facts induced a thousand fantasies of form and purpose, structure and life, which had gone into the making of what I saw or what I was.[2]

She spent longer in St Ives than Nicholson, and was more dedicated to its beauties and more selective in her responses. She saw herself as a channel through which the magic qualities of the place could find permanent form.

When in the post-war years art was again a possible aspiration, and as young artists gathered in and around St Ives, a style began to emerge, drawing upon the powerful themes of coast and sea, tempered by an organic abstraction. Nicholson scraped the surface of a board, and in his understated description of still life or landscape created constructions with their own inner activity. Hepworth and Gabo shared in this spatial enquiry with forms of classic purity. The younger artists, searching for other means to express their shared environment, began to make their own independent contribution. When their work was shown in London, St Ives began to be seen as an alternative artistic centre to the capital, capable of adding a new and more exotic flavour to the painting and sculptures of the time and giving a new dimension to British art. There was an optimistic belief that by personal achievement they could make an important contribution with a new relevancy to new art forms. St Ives offered a number of advantages: for some it gave security and privacy to recover the threads of a career laid bare by war, to others the feeling of community and something of the atmosphere of the Mediterranean in the hot summers after the war. The grandeur of its rocky coast and the clear light remained a great attraction. Studios and cottages were available cheaply and the artistic links with London were good enough to keep alive a flow of information and a feeling of participation.

A characteristic of some of the artists who have worked in Cornwall has been to dissent from established forms — to opt out in order to remove themselves from the pressures of the art establishment. This tendency was furthered by remoteness from the centre and the unique physical characteristics of their chosen territory. They caused no trouble to others, yet attracted opposition from those who had not sought this freedom. Their nonconformity gave them strength, and being removed they were invulnerable. But it also made them enemies. They could not be passed over for their contribution was significant, but they were not accepted because they did not conform.

So St Ives gained its reputation for 'otherness'. It also became a central part of the post-war art revival in England, for who could deny this great contribution to landscape painting that was continually seen in the London galleries — essentially English, yet fully informed to the level of the best continental examples. The art of St Ives replaced that of France in offering new forms of linking man with natural landscape — so long a theme of the painters of provincial France, yet strangely absent in much post-war French art. Furthermore, the paintings of Wynter, Wells, Barns-Graham, Lanyon and others were clear and legible, despite their structured complexity.

If St Ives is looked upon as a movement, cohesive activity can no longer be seen after 1960. Yet it was a movement made up by the sum of the high

creative endeavours of a large number of individuals, brought together with a special shared feeling of optimism and sense of rediscovery in the post-war years. For a time they had an identity of group activity. The fruit of their talents is in the accumulation of powerful works of art produced within a few years in Cornwall, which united the dramatic coastal landscape with an internationally signficant movement of abstraction.

Peter Lanyon's death in 1964 removed him from the artistic scene at a time when his work was changing and would undoubtedly have produced important new developments. He will be remembered in his painting for that strong emotional union of freely abstracted landscape and the mytho-logy of his Cornish homeland. No group could survive the three deaths of

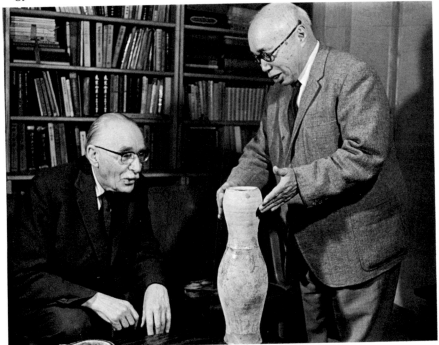

123. Bernard Leach and Shoji Hamada in Japan, 1971.

1975 — those of Barbara Hepworth, Bryan Wynter and Roger Hilton. Yet after 1975 the work of a number of individuals continued to develop to the highest level. Hepworth had long been the undisputed leader of the artists in St Ives. After her death her studio and garden were opened as a permanent exhibition of her work.[3] Bryan Wynter died at a time when he had fully resolved many of the ambiguities of form and content that had led to his experiments in kinetic art, and had found an even more powerful form of expression in the large paintings which allude to the movement of water, yet are powerful abstractions. In the work of Roger Hilton abstraction and figuration came together, especially after his move to Cornwall, when the

figure was more erotically revealed and landscape was used as an analogy for sexual experience. The move to Cornwall brought to his painting a relaxed and vibrant use of form and colour, which changed to the emotional and personal themes of the gouaches when his health broke down.

Bernard Leach had given great spiritual support to the St Ives artists. In the 1960s he continued to travel and to exhibit his work in Europe and the Orient. In 1966 he received the Japanese Order of the Sacred Treasure (an unusual honour for a non-Japanese). In 1972 his sight failed and he could no longer work as a potter. The following year he was made a Companion of Honour and visited Japan for the last time. He died in St Ives in 1979 at the age of ninety-two.

The journey made by the St Ives artists has drawn deeply from that granite landscape, with its age-old associations that speak of a troubled past, through coastline and carn, earthwork and standing stones, mine chimney and lichen-covered rocks. They have also seen this landscape flooded with light, weathered and softened and capable of great benevolence. As painters and sculptors they have responded to the variety with expressive freedom, characterized by inventive and bold analogies of form, and strong and often fully saturated colour. There is a feeling for the unexpected, not descriptive but an emotional abstraction. This has resulted in a major art form of great originality which has made its own powerful contribution nationally and internationally.

The work of the many St Ives artists is perhaps best celebrated in the words of one of their number — from which the title of this book was taken. In a letter to Sven Berlin, written while sitting in the sunshine on a rock, John Wells described the strong feelings that he tried to capture:

> so all around the morning air and the sea's blue light, with points of diamond, and the gorse incandescent beyond the trees; countless rocks ragged or round and of every colour; birds resting or flying, and the sense of a multitude of creatures living out their minute lives . . . All this is part of one's life and I want desperately to express it; not just what I see, but what I feel about it . . . but how can one paint the warmth of the sun, the sound of the sea, the journey of a beetle across a rock, or thoughts of one's own whence and whither? That's one argument for abstraction. One absorbs all these feelings and ideas: if one is lucky they undergo an alchemistic transformation into gold and that is creative work.[4]

Notes and references

INTRODUCTION
Early times

1. A visitor to St Ives, *c.* 1832.

2. Stanley Weintraub, *Whistler* (New York: Wey-bright-Talley, 1974).
3. Ben Nicholson, 'Notes on "abstract" art', *Horizon* (October 1941), reprinted with revisions in Herbert Read (ed.), *Ben Nicholson* (London: Lund Humphries, 1948).

CHAPTER 1
Nicholson, Wood and Wallis

1. Dr Roger Slack of St Ives has made many interviews and tape recordings of local inhabitants and relatives of Wallis. He quotes Jacob Ward, a relative, who remembers that Wallis 'used to do lots of sketching when he had the Marine Stores', i.e. before 1912.
2. From recorded reminiscences of Alfred Wallis made by Dr Roger Slack.
3. Ben Nicholson, 'Alfred Wallis', *Horizon* (January 1943).
4. Lawrence Gowing (ed.), *The Critical Writing of Adrian Stokes*, vol. I (London: Thames & Hudson, 1978).
5. *Winifred Nicholson*, catalogue to her exhibition at the Crane Kalman Gallery, London, 1975 (London: Crane Kalman Gallery, 1975).
6. Ibid.
7. Ibid.
8. Sven Berlin, *Alfred Wallis: Primitive* (London: Nicholson & Watson, 1949).
9. Ben Nicholson, 'Alfred Wallis', op. cit.
10. *Christopher Wood*, catalogue to an exhibition arranged by the Arts Council, 1979 (London: Arts Council of Great Britain, 1979).
11. Ibid.
12. Christopher Wood, typescript in the Tate Gallery archives.
13. Ibid.
14. Ibid. Based on a conversation with Sir Francis Rose and Gerald Reitlinger.

CHAPTER 2
Traditional and modern: St Ives and London

1. Augustus John in an introduction to the catalogue to an exhibition by Matthew Smith at the Mayor Gallery, London, 1926, quoted in John Rothenstein, *Matthew Smith* (London: Beaverbrook Newspapers, 1962).
2. Alan Bowness, *Barbara Hepworth: Drawings from a Sculptor's Landscape* (London: Cory Adams & Mackay, 1966).
3. Herbert Read, introduction to *Barbara Hepworth, Carvings and Drawings* (London: Lund Humphries, 1952).
4. Barbara Hepworth, *A Pictorial Autobiography* (Bradford-on-Avon: Moonraker Press, 1970).
5. Ibid.
6. Ibid.
7. Ben Nicholson, letter to John Summerson, dated 3 January 1944, reproduced in Maurice de Sausmarez (ed.), *Ben Nicholson* (London: Studio International, 1969).
8. Ben Nicholson, 'Notes on "abstract" art', *Horizon* (October 1941).
9. Minutes of the Seven and Five Society, 1934.
10. Herbert Read, 'A nest of gentle artists', *Apollo* (September 1962).
11. Ibid.
12. Paul Nash, letter to *The Times*, 2 June 1933.
13. Herbert Read, *Unit One* (London: Cassell, 1934).
14. Ben Nicholson. Ibid.
15. Herbert Read, introduction to *Barbara Hepworth, Carvings and Drawings*, op. cit.
16. Barbara Hepworth, *A Pictorial Autobiography*, op. cit.
17. Herbert Read, introduction to the exhibition 'Living Art in England', London Gallery, 1939.

CHAPTER 3
Wartime in St Ives

1. 'Adrian Stokes on his painting', *Studio International*, vol. 185, no. 954 (April 1973).

2. 'Naum Gabo talks to Maurice de Sausmarez', in *Ben Nicholson* (London: Studio International, 1969).

3. Naum Gabo, in an exchange of letters with Herbert Read, *Horizon*, vol. X, no. 53 (July 1944).

4. Ben Nicholson, 'Notes on "abstract" art', *Horizon* (October 1941).

5. Barbara Hepworth, *A Pictorial Autobiography* (Bradford-on-Avon: Moonraker Press, 1970).

6. Herbert Read, *Barbara Hepworth, Carvings and Drawings* (London: Lund Humphries, 1952).

7. Ibid.

CHAPTER 4

Artists gather in St Ives

1. Sven Berlin, 'Alfred Wallis', *Horizon* (January 1943).

2. Sven Berlin, 'My world as a sculptor', *Cornish Review* (Spring 1949).

3. Guido Morris, *Prospectus for the Latin Press* (St Ives: Latin Press, 1946).

4. Peter Lanyon, tape recorded interview with Lionel Miskin, Falmouth School of Art, *c.* 1961, unpublished.

5. Ibid.

6. Ibid.

7. Reproduced in 'British Avant Garde Painting, 1945–56', Part 1, *Artscribe*, no. 34 (March 1982).

8. Aldous Huxley, *Ends and Means* (London: Chatto & Windus, 1937).

9. Bryan Wynter, 'Notes on my painting', in a catalogue to an exhibition at the Leinhard Gallery, 1962 (Zurich: Leinhard Gallery, 1962).

10. Patrick Heron, introduction to the retrospective exhibition 'Bryan Wynter, 1915–1975' at the Hayward Gallery, August 1976 (London: Arts Council of Great Britain, 1976).

11. 'Terry Frost', interviewed by Molly Parkin, *South West Arts News* (November/December 1976).

CHAPTER 5

The Crypt Group and the Penwith Society; the Festival of Britain in London and St Ives

1. Alfred Munnings, from the text of the Royal Academy banquet, 28 April 1949. Reprinted in A.J. Munnings, *An Artist's Life* (London: Museum Press, 1950).

2. Ibid.

3. David Haughton, letter to Norman Levine, 1961, quoted in *David Haughton*, catalogue to an exhibition at Newlyn Orion Galleries, 1979 (Penzance: Newlyn Orion Galleries, 1979).

4. Sven Berlin, 'An aspect of creative art in Cornwall', *Cornish Review* (Spring 1949).

5. The first committee consisted of Leonard Fuller (chairman), David Cox (honorary secretary), Bernard Leach, Guido Morris, Barbara Hepworth, Ben Nicholson and Sven Berlin. (Minutes of the meeting, 8 February 1949, in the Castle Inn.)

6. The first page of the minute book of the Penwith Society gives the foundation members as Herbert Read (president), Leonard Fuller (chairman), David Cox (honorary secretary), Shearer Armstrong, Wilhemina Barns-Graham, Sven Berlin, Agnes Drey, Isobel Heath, Barbara Hepworth, Marion Grace Hocken, Peter Lanyon, Bernard Leach, Denis Mitchell, Guido Morris, Marjorie Mostyn, Dicon Nance, Robin Nance, Ben Nicholson, Henry Segal and John Wells.

7. Catalogue to the first exhibition of the Penwith Society of Arts in Cornwall, St Ives, summer 1949. The grouping of members was the subject of many meetings and discussions. The critical meeting at which objections were raised (by Sven Berlin, Isobel Heath and Henry Segal, among others) was probably the General Meeting of Members on 29 November 1949. At that meeting the 'A' members were Shearer Armstrong, Leonard Fuller, Marion Hocken, Marjorie Mostyn, Misome Peile and W. Seton ('Fish'). The 'B' group consisted of Wilhemina Barns-Graham, Agnes Drey, Tom Early, David Haughton, Barbara Hepworth, Mary Jewels, Hilda Jillard, Peter Lanyon, Denis Mitchell, John Wells and Bryan Wynter. No list was agreed for group 'C'. Twelve artists refused to be allocated to groups.

8. Mary Benham and Bert Millar (eds.), *A Tonic to the Nation: the Festival of Britain, 1951* (London: Thames and Hudson, 1976).

9. Ben Nicholson, 'Letter to the Editor', *Daily Mail*, 7 August 1951.

10. Julian Trevelyan, writing in the *London Bulletin*, no. 12, 15 March 1939.

CHAPTER 6

Nicholson's growing reputation

1. Letter from Graham Sutherland, quoted in *Graham Sutherland: the War Drawings* (London: Imperial War Museum, 1983).
2. Ibid. See also John Hayes, *Graham Sutherland* (Oxford: Phaidon, 1980) and Rosalind Thuillier, *Graham Sutherland: Inspirations* (Guildford: Lutterworth Press, 1982).
3. John Minton's *Harbour*, exhibited in the Royal Academy's summer exhibition in 1949, was described in the *Cornish Review* as 'the year's sensational picture'.
4. Annual report of the Arts Council of Great Britain, 1954–5.
5. Ibid.
6. Summerson, John, *Ben Nicholson*, in the series 'Penguin Modern Painters' (London: Penguin Books, 1948).

CHAPTER 7

Barbara Hepworth, Bernard Leach and Denis Mitchell

1. Herbert Read, introduction to *Barbara Hepworth, Carvings and Drawings* (London: Lund Humphries, 1952).
2. Barbara Hepworth, *A Pictorial Autobiography* (Bradford-on-Avon: Moonraker Press, 1970).
3. Ibid.
4. Ibid.
5. Herbert Read, op. cit.
6. Denis Mitchell, conversation with the author.
7. *Sunday Times*, 23 January 1955.
8. *The Times*, January 1955.
9. Denis Mitchell, catalogue to his exhibition at the Glynn Vivian Gallery, Swansea, 1980.
10. Bernard Leach, 'Belief and Hope', in the catalogue *Bernard Leach, Fifty Years a Potter* (London: Arts Council of Great Britain, 1961).

CHAPTER 8

Peter Lanyon

1. Peter Lanyon, recorded talk, 1963, edited by Alan Bowness for the British Council.
2. Ibid.
3. Tate Gallery acquisitions 1968–9.

4. Peter Lanyon, recorded talk, op. cit.
5. John Berger, in the *New Statesman* (15 March 1952).
6. Peter Lanyon, lecture notes, 1963, published in the catalogue by Andrew Causey to his exhibition at the Whitworth Art Gallery, Manchester, 1978.
7. Peter Lanyon, letter to *St Ives Times* (15 April 1955).
8. Peter Lanyon, recorded talk, op. cit.
9. Ibid.
10. *Peter Lanyon*, catalogue by Andrew Causey, op. cit.

CHAPTER 9

The development of abstraction: Terry Frost

1. Ben Nicholson, 'Notes on "abstract" art', *Horizon*, vol. IV, no. 22 (1941).
2. Lawrence Alloway, *Nine Abstract Artists: their Work and Theory* (London: Tiranti, 1954).
3. William Scott, conversation with the author.
4. Lawrence Alloway, op. cit.
5. Ibid.
6. 'Terry Frost', interviewed by Molly Parkin, *South West Arts News* (November/December 1976).
7. Terry Frost, from the artist's notebook.
8. Terry Frost, 'What I think today', *Penwith Society Bulletin*, no. 4 (summer 1953).
9. Lawrence Alloway, op. cit.
10. Terry Frost, 'Paintings, Drawings and Collages', *South West Arts*, 1976–7. 11. Ibid.

CHAPTER 10

International influences: Paris and New York. Patrick Heron

1. Herbert Read, *The Politics of the Unpolitical* (London: Routledge, 1943).
2. Patrick Heron, *The Changing Forms of Art* (London: Faber & Faber, 1955).
3. Harold Rosenberg, *The Anxious Object: Art Today and its Audience* (New York: Horizon Press, 1964).
4. Lawrence Alloway, in *Art News and Review* (21 January 1956).
5. Patrick Heron, 'Americans at the Tate', *Arts* (New York, March 1956).
6. Patrick Heron, 'Braque', *New English Weekly* (4 July 1946).

7. Patrick Heron, 'Space in Colour', introduction to the catalogue to the exhibition at the Hanover Gallery, London, July–August 1953.
8. Patrick Heron, 'The Guggenheim Selection', *Arts* (New York, 1957).
9. Patrick Heron, *Arts* (New York, 1958).
10. Patrick Heron, 'A note on my painting', catalogue to the exhibition at the Leinhard Gallery, Zurich, January 1963, reproduced in 'Colour in my painting', *Studio International* (December 1969).

CHAPTER 11

Bryan Wynter, Alan Davie, Paul Feiler

1. Bryan Wynter, 'Notes on my painting', catalogue to an exhibition at the Leinhard Gallery, Zurich, 1962.
2. Patrick Heron, introduction to the exhibition catalogue *Bryan Wynter, 1915–1975*, Hayward Gallery, London, 1976 (London: Arts Council of Great Britain, 1976).
3. Bryan Wynter, 'Notes on my painting', *op. cit.*
4. Bryan Wynter, statement in the catalogue to the exhibition 'Kinetics', Hayward Gallery, 1970 (London: Arts Council of Great Britain, 1970).

CHAPTER 12

St Ives in the 1950s

1. J.P. Hodin, in *Art News and Review*.
2. Sven Berlin, *The Dark Monarch: a portrait from within* was published on 7 September 1962 by the Gallery Press, London. It was withdrawn on 16 September due to successful libel actions by a number of people represented in the book. 575 copies had been sold, but the publishers wrote to the bookshops who had ordered copies, requesting them to return them for pulping. Some copies survived.
3. Ibid.
4. Ibid.
5. Ibid.
6. Karl Weschke, artist's statement.

CHAPTER 13

Roger Hilton

1. Roger Hilton, artist's writings.

2. Lawrence Alloway, *Nine Abstract Artists: their Work and Theory* (London: Tiranti, 1954).
3. Roger Hilton, artist's statement in *Nine Abstract Artists*, op. cit.
4. Roger Hilton, artist's writings.
5. Roger Hilton, artist's statement in the catalogue to an exhibition at the Leinhard Gallery, Zurich, 1961.
6. Letter from Ruth Hilton, dated 30 September 1981, to Adrian Lewis, quoted in Adrian Lewis, 'British Avant Garde Painting, 1945–56', Part 2, *Artscribe*, no. 35 (April 1982).
7. Patrick Heron, 'Introducing Roger Hilton', *Arts* (New York, May 1957).
8. Roger Hilton, artist's statement, quoted in Alan Bowness, 'Roger Hilton', *Cimaise*, vol. 63 (January/February 1960).
9. Roger Hilton, *Night Letters and Selected Drawings*, edited by Michael Canney (Penzance: Newlyn Orion Galleries, 1982).

CHAPTER 14

The importance of St Ives

1. Patrick Heron, 'The British influence on New York', *Guardian* (10, 11, 12 October 1974).
2. Herbert Read, introduction to *Barbara Hepworth, Carvings and Drawings* (London: Lund Humphries, 1952).
3. In 1980 this museum (Trewyn Studio) and twenty-seven of Hepworth's sculptures were handed over to the Tate Gallery for permanent safe-keeping.
4. John Wells, letter to Sven Berlin. Quoted by Sven Berlin in 'An aspect of creative art in Cornwall', *Facet*, vol. III, no. 1 (winter 1948–9).

Select Bibliography

A. Exhibition catalogues

General

Art in Britain, 1930–1940, centred around 'Axis', 'Circle' and 'Unit One', notes and documentation by Herbert Read and Jasia Reichardt (London: Marlborough Fine Art, 1965).

Artists of the Newlyn School, 1880–1900, notes by Caroline Fox and Francis Greenacre (Penzance: Newlyn Orion Galleries, 1979).

British Art and the Modern Movement, exhibition planned and organized by Tom Cross, notes and documentation by Philip Barlow, introduction by Alan Bowness (Cardiff: Welsh Committee of the Arts Council, 1962).

Cornwall 1945–1955, introduction and chronology by David Brown (London: New Art Centre, 1977).

Modern Art in the United States: a selection from the Museum of Modern Art, New York (London: Arts Council of Great Britain, 1956).

Space in Colour, introduction by Patrick Heron, for an exhibition at the Hanover Gallery (London: Hanover Gallery, 1953).

Individual artists

Alfred Wallis, introduction by Alan Bowness for an exhibition at the Tate Gallery, 1968 (London: Arts Council of Great Britain, 1968).

Art of Bernard Leach, exhibition at the Victoria and Albert Museum, 1977 (London: HMSO, 1977).

Barbara Hepworth, exhibition at the Tate Gallery, 1968 (London: Tate Gallery, 1968).

Barbara Hepworth: a guide to the Tate Gallery collection at London and St Ives, Cornwall (London, Tate Gallery, 1982).

Ben Nicholson, exhibition at the Tate Gallery, 1969 (London: Tate Gallery, 1969).

Bernard Leach, fifty years a potter, introduction by J.P. Hodin (London: Arts Council of Great Britain, 1961).

Bryan Wynter, 1915–1975 (London: Arts Council of Great Britain, 1976).

John Tunnard, introduction by Mark Glazebrook (London: Arts Council of Great Britain, 1977).

Peter Lanyon: paintings, drawings and constructions, 1937–1964, exhibition at the Whitworth Art Gallery, 1978 (Manchester: Whitworth Art Gallery, 1978).

Roger Hilton, exhibition at the Serpentine Gallery, 1974 (London: Arts Council of Great Britain, 1974).

Sven Berlin, an artist and his work (Wimborne: Wimborne Bookshop, 1981).

Terry Frost, paintings, drawings and collages (London: Arts Council of Great Britain and South West Arts, 1976).

Tribute to Herbert Read, 1895–1968 (Bradford: Bradford Art Galleries and Museums, 1975).

B. Books

Alloway, Lawrence, *Nine Abstract Artists, their work and theory* (London: Tiranti, 1954).

Berlin, Sven, *Alfred Wallis: Primitive* (London: Nicholson & Watson, 1949).

Bowness, Alan (ed.), *Alan Davie* (London: Lund Humphries, 1967).

Bowness, Alan, *The Complete Sculpture of Barbara Hepworth, 1960–1969* (London: Lund Humphries, 1971).

Bowness, Alan; Hodin, Paul, *Barbara Hepworth, 1925–1960* (London: Lund Humphries, 1961).

Causey, Andrew, *Peter Lanyon*, introduction by Naum Gabo (Henley-on-Thames: Aidan Ellis, 1971).

Gardiner, Margaret, *Barbara Hepworth, a memoir* (Edinburgh: Salamander Press, 1982).

Heath, Adrian, *Abstract Painting, its origins and meaning* (London: Tiranti, 1953).

Hepworth, Barbara, *A Pictorial Autobiography* (Bradford-on-Avon: Moonraker Press, 1970).

Heron, Patrick, *The Changing Forms of Art* (London: Routledge & Kegan Paul, 1955).

Heron, Patrick, *Concerning Contemporary Art, The Power Lectures, 1968–1973*, edited by Bernard Smith (includes 'The shape of colour') (Oxford: Clarendon Press, 1975).

Hodin, J.P., *Ben Nicholson: the meaning of his art* (London: Tiranti, 1957).

Leach, Bernard, *Beyond East and West* (London: Faber & Faber, 1978).

Leach, Bernard, *A Potter's Book* (London: Faber & Faber, 1940).

Read, Herbert, *Barbara Hepworth: Carvings and Drawings* (London: Lund Humphries, 1952).

Read, Herbert, *Ben Nicholson* (Paris: Fernand Hazan, 1962).

Read, Herbert, *Ben Nicholson, Paintings, Reliefs and Drawings*, vol. I, 1911–1948 (London: Lund Humphries, 1948, 2nd edn 1955).

Russell, John, *Ben Nicholson* (London: Thames & Hudson, 1969).

Sausmarez, Maurice de (ed.), *Ben Nicholson* (London: Studio International, 1969).

Stokes, Adrian, *The Critical Writings of Adrian Stokes*, introduction by Lawrence Gowing (London: Thames & Hudson, 1978).

Summerson, John, *Ben Nicholson*, in the series 'Penguin Modern Painters' (London: Penguin Books, 1948).

Val Baker, Denys, *Britain's Art Colony by the Sea* (London: George Ronald, 1959).

C. Newspapers and periodicals

Heron, Patrick. Among his many articles in the *New English Weekly* from 1945 to 1947, the *New Statesman and Nation* from 1947 to 1950, and *Arts*, 1956, 1957 and 1958, must be mentioned 'Braque', 4 July 1946, *New English Weekly*; 'Americans at the Tate Gallery', *Arts*, vol. 30, March 1956, and 'Peter Lanyon', *Arts*, February 1956, and 'The British influence on New York', *Guardian* (10, 11, 12 October 1974).

Acknowledgements

The author and publishers would like to thank the following for permission to reproduce works and photographs: the Arts Council of Great Britain: plates 45, 64 and 91; W. Barns-Graham: plates 13 and 14; Sven Berlin: plate 47; Andrew Besley Photo Library, St Ives: plates 24, 106 and 107; the British Council: plate 62; the Central Office of Information, London: plate 54; City of Bristol Museum and Art Gallery: plates 65 and 98; Crafts Study Centre, Holburne Museum, University of Bath: plates 34, 78 and 123; Paul Feiler: plate 105; Fitzwilliam Museum, Cambridge: plate 116; Terry Frost: plate 50; Adrian Heath: plate 89; the trustees of the estate of Dame Barbara Hepworth: plates 27, 28, 38–40, 53 (collection: Harlow Town, Essex; photographer: Anthony Panting), 66, 67 (collection: the Royal College of Surgeons, London), 68 (collection: the University of Minneapolis), 69, 70, 71 (collection: National Gallery of Wales, Cardiff), 72 (collection: State House, London), 73 (collection: the United Nations), 74 and 75; Patrick Heron: plates 55 and 94; Rose Hilton: plates 117 and 118; the Hunterian Art Gallery, the University of Glasgow: plate 11; Kettle's Yard, University of Cambridge: plate 61; Andrew Lanyon: plates 12 and 82; Sheila Lanyon: plates 44, 48, 51, 52, 80, 81; Leeds City Art Gallery: plate 19; Jorge Lewinski: plates 1 and 119; Tony O'Malley: plates 106 and 107; Manchester City Art Gallery: plate 18; Roger Mayne: plates 92 and 113; Denis Mitchell: plates 76 and 77; Paul Mount: plate 110; the trustees of the estate of Ben Nicholson: plates 16, 17, 26, 29, 35–7, 56 and 61–5; Anthony d'Offay: plates 58 and 59; Bryan Pearce: plate 108; Jack Pender: plate 30; Penwith Society of Arts: plate 122; Penzance Town Council: plates 8 and 9; Pier Arts Centre, Orkney: plates 28, 33, 38, 86 and 115; Plymouth City Museum and Art Gallery: plates 7, 20 and 23; *Punch*: plate 69; Roy Ray: plate 21; Royal Institution of Cornwall: plate 22; Salford Art Gallery: plate 36; Humphrey Spender: plate 26; Studio St Ives: plates 56 and 122; Sir John Summerson: plate 15; the Tate Gallery, London: plates 2, 5, 6, 25, 29, 32, 35, 37, 39, 41–3, 46, 58, 63, 66, 70, 79, 83, 84, 87, 88, 90, 93, 95, 99, 103, 104, 111, 117 and 121; H. Tempest, St Ives: plate 4; Ulster Museum, Belfast: plate 85; Valerie Wilmer: plate 75; Eric Wynter: plate 100; Monica Wynter: plates 3, 49, 96, 97, 101 and 102. Plates 10 and 60 are from the collection at the Laing Art Gallery, Tyne and Wear County Council Museums. Plates 16, 17, 24, 39, 112, 114 and 120 are from private collections.

The publishers have made every effort to trace copyright of photographs, and regret that in some cases, due to the age of photographs, this has not been possible.